Composition

Digital Field Guide

Composition

Digital Field Guide

Alan Hess

WILEY

Wiley Publishing, Inc.

Composition Digital Field Guide

Published by
Wiley Publishing, Inc.
10475 Crosspoint Boulevard
Indianapolis, IN 46256
www.wiley.com

WILEY

About the Author

Alan Hess is a San Diego-based commercial photographer specializing in concert and event photography but has photographed everything from portraits to products. He is the author of three previous *Digital Field Guides,* including the best-selling *Exposure Digital Field Guide.* His concert and backstage images have appeared in numerous online and print publications and have been used for promotional purposes and music packaging.

Alan is a key contributor to the Digital Photo Experience Web site (http://dpexperience. com) and has written articles on concert photography and technology for them. He has also written for *Photoshop User Magazine* and teaches concert photography and workflow at Photoshop World.

He is a member of the National Association of Photoshop Professionals, and Nikon Professional Services. You can contact Alan through his Web site, www.alanhess photography.com, where he writes a regular blog, or on Twitter @ShotLivePhoto.

Credits

Acquisitions Editor
Courtney Allen

Project Editor
Chris Wolfgang

Technical Editor
Haje Jan Kamps

Copy Editor
Marylouise Wiack

Editorial Director
Robyn Siesky

Editorial Manager
Rosemarie Graham

Business Manager
Amy Knies

Senior Marketing Manager
Sandy Smith

Vice President and Executive Group Publisher
Richard Swadley

Vice President and Executive Publisher
Barry Pruett

Project Coordinator
Lynsey Stanford

Graphics and Production Specialists
Andrea Hornberger
Jennifer Mayberry
Ronald G. Terry

Quality Control Technician
Lindsay Littrell

Proofreading and Indexing
Jacqui Brownstein
Steve Rath

For Nadra.

Acknowledgments

First and foremost I would like to thank my parents, brothers, sisters-in-law, nephews, nieces, and friends for their support and patience as I was writing this book. I know having me photograph everything all the time can get a little tiresome. Thanks for your patience and understanding.

I want to thank the great crew that made this book possible: Courtney Allen who brought me into the Wiley family; this is our tenth project together, can you believe it? Haje Jan Kamps, my technical editor for the second time who tries to keep me on track; thanks for all the suggestion and helpful advice. Thanks to Chris Wolfgang for making sure I was meeting my deadlines, sorry for driving you crazy, and Marylouise Wiack for making me sound better than I really do.

Thanks to Rick Sammon and Juan Pons and the rest of the gang at the Digital Photo Experience (one of the best resources for digital photographers on the Internet) for allowing me to be part of the team. I learned so much from you two and every one of the contributors at www.dpexperience.com.

Special thanks to the following photographers who have helped me with writing this book and in becoming a better photographer myself:

▶ Kenny Kim (www.kennykim.com) for the help and use of his images in the wedding chapter. Kenny is an amazing lifestyle and wedding photographer I was lucky enough to work with. He is author of the *Digital Photographer Wedding Planner*.

▶ Jeremy Pollack (www.jeremypollack.net) for his help and images, especially in the landscape section. He has a great eye, and if you are planning to photograph around New York, check out his *Photographing New York City Digital Field Guide*.

And to Scott Kelby and everyone at Photoshop World who gave me a chance to reach a bigger audience, I can't thank you enough.

And to my lovely wife, Nadra, thank you for understanding the long hours and the crazy schedule. I couldn't have done this without you.

Contents

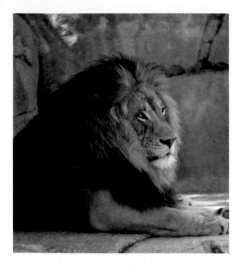

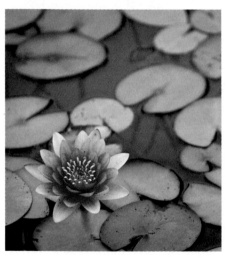

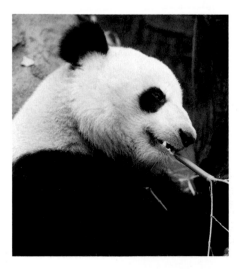

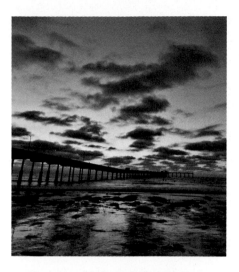

CHAPTER 8
Landscape Photography 91

CHAPTER 9
Portrait Photography 107

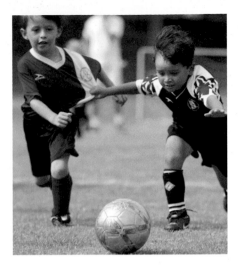

CHAPTER 10
Sports and Action Photography 131

CHAPTER 11
Travel Photography 147

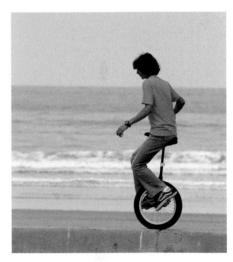

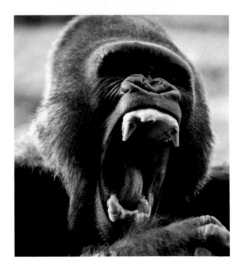

Introduction

There are a lot of photography books on the market today; I should know since I have written three others and been involved as an editor on a half dozen others. There are even a few that are specifically geared to help you improve your composition, but what I noticed about most of these is they talked in generalities. While they all want to help you find your vision, they don't really give you a solid starting point. I hope to change that with this book.

Let me be upfront with you right now, this book is not for everyone. There are some of you out there who don't really need this type of book. You already have your own style, and you really like the image you take. You are happy with the composition and are probably following a lot of what is laid out here without even knowing it.

This book is for the photographer who is frustrated, frustrated that they can't seem to get a great photo. You take plenty of good photos, but you are wondering why they just don't seem to be great. Now, please don't page through the book expecting every photo in here to be great; some of the photos in this book are here to illustrate a point or are part of a before-and-after series.

In the first chapter, I discuss focal lengths, lenses, the basics of picking the right focus point along with the basics of recomposing images, and even the differences between the full-frame sensors and the cropped sensors so prevalent in today's digital cameras.

Next in Chapter 2 is an overview on light and the basics of exposure, including a brief discussion of shutter speed, aperture, and ISO.

Then we get to the four chapters that deal with composition rules and techniques that can help to improve your images: the rule of thirds, leading lines, symmetry and balance, and color. Each of these four chapters covers the best time to use its respective rule and what to look for in your images.

Then, like all the *Digital Field Guides,* I discuss specific situations in the last eight chapters, including events, landscapes, portraits, sports and action, travel, wedding, and wildlife photography. Each of these chapters covers the specific composition tips for the subject matter along with general advice for that type of photography. Each chapter has plenty of full color examples and, even though this book isn't about the exposure settings, each image has the ISO, aperture, and shutter speed used.

The final chapter deals with creative composition. While this is about breaking the rules and starting to find your own look, Chapter 14 still shows when and where to break the rules for the best results.

I have also included an appendix that shows you how to use popular software to easily recompose your images in post production. This is as simple as selectively cropping images that just weren't quite right in the camera. A second appendix includes a gray card and color checker, which is included with all the newer *Digital Field Guides.*

I want to just tell you a little about what this book doesn't cover. There is not a lot of talk about specific camera gear; I don't care what camera brand you use or what memory cards you favor. Most of these photos could be taken with a good point-and-shoot compact camera, even though they weren't.

It also doesn't matter if you have top-of-the-line lenses or are using the kit lens that came with your camera. That lens is great, until you feel limited in what you can and can't do. Then I recommend buying the best lens you can afford. Chances are you will change cameras in two to three years, but a good lens, if taken care of, will last a life-time. Some of the images taken in this book were with lenses I have owned for more than a decade.

If you want to learn more about specific camera settings, then I recommend that you read my *Exposure Digital Field Guide.* If you already own it, then thank you from the bottom of my heart, and I hope you enjoy this book just as much.

Composition Basics

All photographs are made up of two parts: the exposure and the composition. The *exposure* deals with the amount of light that reaches the camera's digital sensor.

The *composition* deals with what is and what isn't in the photograph and that is what this book is about. But before you learn how to compose an image, you need to look at the differences in lenses, focal lengths, focus points, and even sensor sizes.

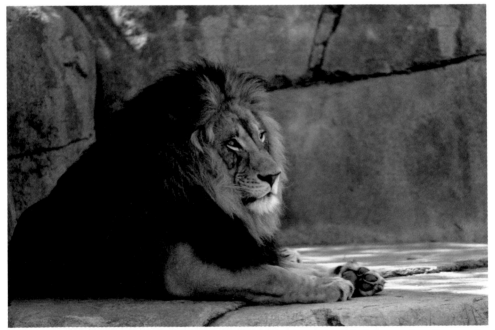

Before I raised the camera to my eye, I had to make a series of decisions when it came to photographing this lion. What lens would I use? Would the shot be a close-up or would it be a wide-angle? How would the background look? Which focus point would I use? Would I need to recompose? Taken at ISO 400, f/2.8, and 1/800 second.

Focal Lengths and Lenses

One of the first choices any photographer makes when it comes to composition is what lens and focal length to use. The focal length is defined as the distance from the optical center of the lens when it is focused at infinity to the camera's focal plane (sensor); it is described in millimeters (mm). But what exactly does this mean in plain English?

The same scene can look vastly different, depending on what focal length you use. For example, Figures 1.1 and 1.2 both show the same scene. The camera didn't move at all, but by deciding what is and isn't part of the scene, the images are completely different.

Your choice of focal length determines how much of the area in front of the camera is captured in your photograph. The longer the focal length, the less of the scene is captured.

> **NOTE** Lenses are broken up into groups by their focal lengths.

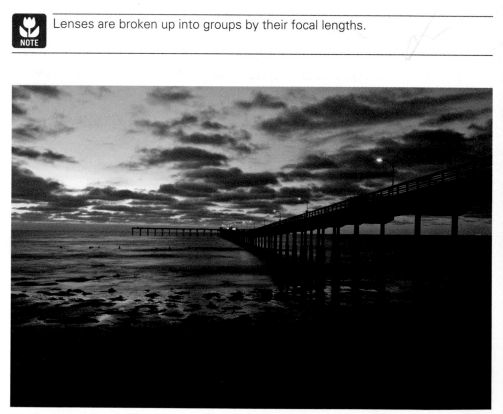

1.1 The Ocean Beach Pier, taken at ISO 100, f/16, and 5 seconds, using a 12-24mm lens at the 24mm focal length

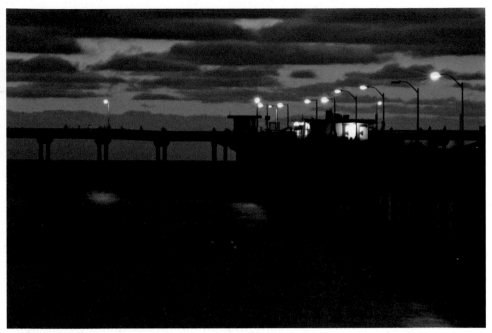

1.2 The same pier as in Figure 1.1 was photographed this time at ISO 100, f/16, and 10 seconds using a 70-200mm lens used at the 200mm focal length.

Wide-angle

Wide-angle lenses are those that capture scenes that are wider than a normal lens. Wide-angle lenses can cause distortions with the perspective, making those objects that are closer to the camera appear disproportionately bigger than other objects in the scene. Another feature of these lenses is that objects can start to appear distorted as they get closer to the edge of the frame. This is especially true of *fisheye lenses*.

Normal

Normal lenses have focal lengths with an angle of view of roughly 50 degrees, or 50mm on a full-frame sensor or 35mm on a cropped sensor. These lenses capture a scene in roughly the same way as the human eye, hence the *normal* designation. When you shoot a scene using a normal lens, everything seems to be in the correct perspective. Many of these normal lenses are used for portraits, as they have no distortion, but as you will see in Chapter 9, many telephoto lenses work great for portraits.

Telephoto

Telephoto lenses are those with focal lengths that are longer than a normal lens. These are the lenses that can get you in close to your subject without actually getting physically closer. Professional sports photographers and wildlife photographers use these lenses to get really close to the action without getting in the way.

Prime Lenses and Zoom Lenses

There are two different types of lenses: those with a single focal length, called *fixed-focal-length lenses* or *prime lenses*. The other type of lens covers a range of focal lengths; these are known as *zoom lenses*.

There are a few things that you need to understand before you continue with lenses. The first is *aperture*. Aperture is discussed in Chapter 2 in more detail, but it is important to know that the range of apertures available at any given time is completely dependent on the lens being used, and not on the camera.

The aperture is the hole in the lens that lets the light through to the sensor; this aperture or hole is measured using *f-stops*. The smaller the f-stop, the bigger the opening and the more light is allowed through. F-stops are fractions so f/2.8 is bigger than f/5.6.

TIP The f-stop is the size of the opening in the lens that lets light reach the camera's sensor, and it is shown as f/n, where n is the f-stop number.

Fixed focal length

Fixed focal-length lenses or *prime lenses* only have one focal length. The only way to change what you see through the lens is to actually move the camera closer or farther away from the subject. These lenses have one huge advantage over zoom lenses: Because of the way prime lenses are manufactured, it is possible to have a greater maximum aperture. This allows prime lenses to be used in lower-light situations than their zoom counterparts, and, since the aperture controls the depth of field, prime lenses can have a much shallower depth of field than zoom lenses.

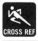 For more on depth of field, see Chapter 2.

Prime lenses can also be much smaller than their zoom lens counterparts, making them easier to carry and use. I often use a 35mm f/2.0 or 50mm f/1.4 lens as a general walk-around lens on my camera.

Zoom lenses

Zoom lenses are those that cover a range of focal lengths. These are the most common lenses used today, probably because they are usually packaged with the camera, are cheaper than ever, and most people like having a range of focal lengths available. It is much more convenient to carry a single lens that can cover a wide range of focal lengths than it is to carry a bunch of prime lenses.

In the past, zoom lenses were much heavier and the quality of the images wasn't as good as with prime lenses. Manufacturing has improved and now there are zoom lenses that are just as good as prime lenses when it comes to image quality, and because manufacturers use newer materials, these lenses can also be lighter and more compact.

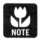

Most compact cameras and point-and-shoot cameras have zoom lenses.

There are two types of zoom lenses: *constant aperture* and *variable*. While they can both cover a wide range of focal lengths, the difference, as you probably can tell from their names, is in the aperture of the lenses.

Constant aperture lenses

All prime lenses are *constant aperture lenses*; this constant aperture size is one of the advantages of using prime lenses.

There are also zoom lenses that have constant apertures, meaning that the maximum aperture of the lens stays the same no matter what focal length you use (see Figure 1.3). That means that the aperture remains constant throughout the entire range of focal lengths. These lenses are usually more expensive than their variable aperture counterparts but are also much more versatile.

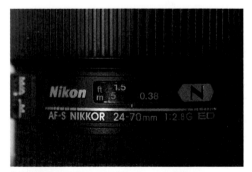

1.3 Here are the markings on a Nikon 24-70mm lens. As you can see, there is only one aperture listed, 1:2.8. This means that the lens has a maximum aperture of f/2.8, regardless of which focal length you use.

The constant aperture zoom lenses are usually considered professional lenses and are priced as such. These lenses usually have better construction, are larger (to be able to have a maximum aperture of f/2.8, for example), and are usually heavier. Many professionals use these lenses for the following reasons:

▶ A constant aperture throughout the full range of focal lengths means that the exposure settings will be the same through the full range of focal lengths if the light is the same.

▶ These lenses work better in low light because they usually have a wider maximum aperture than their variable-aperture zoom lens counterparts.

Depending on what you want to photograph, these lenses are either a necessity or a luxury. If you usually photograph in low-light situations, like concerts or weddings, or if you are going to be shooting fast-moving subjects that are not really close, like sporting events, then you will want to use a constant aperture zoom lens.

Variable aperture lenses

Variable aperture lenses are zoom lenses where the maximum aperture changes depending on which focal length you use. As the focal length of the lens is changed, the widest the aperture in the lens can open also changes. The range of apertures that these lenses use is marked on the lenses themselves.

Take, for example, the popular Nikon 18-200mm f/3.5-5.6 lens (see Figure 1.4). The lens has a focal length range from 18mm (wide angle) up to 200mm (telephoto) and a maximum aperture range of f/3.5 to f/5.6. This means that when the lens is used at 18mm the maximum aperture is f/3.5, and when the lens is used at 200mm the maximum aperture is f/5.6.

When you use one of these lenses, the aperture automatically changes as you change the focal length. When these lenses zoom out, the physical

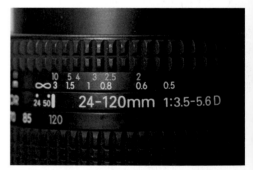

1.4 These are the markings on the Nikon 24-120mm lens. As you can see, there are two apertures listed, 1:3.5-5.6. This means that the lens has a maximum aperture of f/3.5 when used at 24mm but slowly changes so that when used at 120mm, the maximum aperture is f/5.6.

length changes, which in turn cause the aperture to decrease. In very simple terms the opening gets smaller as the lens zooms out, and bigger as it zooms back in. This can cause havoc with the exposure if you don't know that the lens is doing this.

Figures 1.5 and 1.6 show what happens when you zoom in using a variable aperture lens.

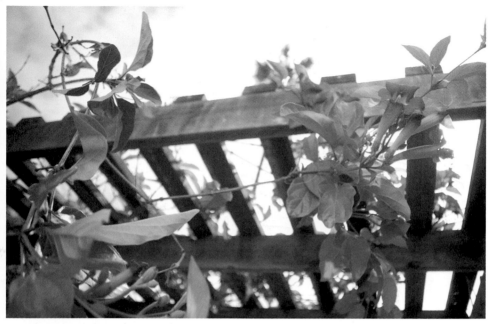

1.5 This shot of trumpet-shaped flowers on a trellis was taken at ISO 200, f/3.5, and 1/1600 second.

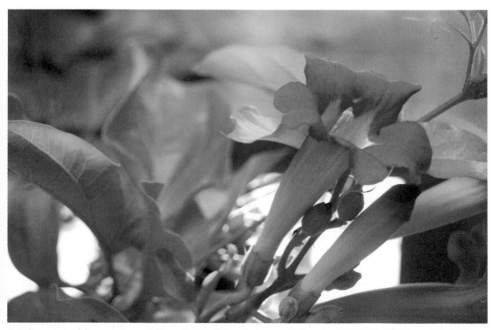

1.6 A zoomed-in version of Figure 1.5, this shot was taken at ISO 200, f/5.6, and 1/200 second. The only thing I did was zoom in; because the aperture changed from f/3.5 to f/5.6 automatically, the shutter speed dropped drastically as less light was available to the sensor.

Variable aperture lenses can cause a lot of work for photographers, but they are very popular for two reasons: The first reason is cost; variable aperture lenses are cheaper to make and cheaper to buy. Because these lenses are so much cheaper, they are used by many more photographers than ever before. You are no longer limited to expensive prime lenses or very expensive constant-aperture zoom lenses.

The second reason has to do with size. Many times you will see variable-aperture zoom lenses called *compact zoom lenses*. This is because they take up a lot less space than their constant-aperture equivalents.

I can tell you from personal experience that it is a lot easier to carry around the 18-200mm f/3.5-6.3 lens than it is to carry around the 17-35mm f/2.8, the 24-70mm f/2.8, and the 70-200mm f/2.8 lenses, which would give me the same focal length coverage as the single compact-zoom lens. When it comes to point-and-shoot or compact cameras, they usually have variable-aperture zoom lenses.

The one area where the variable-aperture lenses can be used to the best of their ability is in landscape photography. Because you will probably use a deep depth of field, the aperture setting that you use will usually be much smaller than the widest aperture available on a variable aperture lens.

 You will find more information on landscape and nature photography in
CROSS REF Chapter 8.

Picking the Focal Length

There are two things to keep in mind when picking the focal length. The first is how much of the scene in front of the lens you want to capture. I changed the focal length in each of the images shown in Figure 1.7, but the distance between the camera and the subject never changed.

If all that your lens did was capture the scene in front of it, then life would be easy; however, your image can change drastically depending on the focal length you use.

The second thing to pay attention to when choosing a focal length is that the longer the focal length, the more compressed an image will seem, and items in the background will appear to be much closer to your subject. The opposite is true when it comes to wide-angle lenses.

The best way to explain how focal length affects your images is with a series of examples.

1.7 These five images were all taken using the same camera setting except for the focal length. Neither the camera nor the model moved. The first shot was taken at 24mm, the second at 35mm, the third at 70mm, the fourth at 102mm, and the fifth at 200mm. All the photos were taken at ISO 200, f/7.1, and 1/125 second.

In each of the following photos in Figure 1.8, the model didn't move at all. As I changed the focal length, I moved farther away from the model so that she would stay the same size in the frame.

As you can see, the difference between 24mm focal length and the 200mm focal length is amazing. The shutter speed, aperture, and ISO stayed the same for all the images; the only thing that changed was the focal length and the distance between the camera and the model.

1.8 These four images were all taken using the same settings, but in this case, the camera was moved farther away with every image so that the model remained the same size in the frame. The first shot was taken at 24mm, the second at 35mm, the third at 70mm, the fourth at 105mm. All the photos were taken at ISO 200, f/2.8, and 1/1000 second.

As you can see, the shorter focal lengths tend to make the scene look bigger with much more distance between the foreground and the background, while the longer focal lengths tend to compress the image, making it seem that there is very little space between the foreground and background. This is something that you can experiment with easily at home; just set up a subject at a middle distance and photograph it using different focal lengths.

As you can see by Figures 1.7 and 1.8, there is a lot to keep in mind when picking the focal length. Fortunately, today there are many great zoom lenses that cover a huge range of focal lengths so that you can experiment easily to find what works best for you.

 Focal length choices are touched on throughout the book, but they are discussed in-depth in Chapter 9.

Focus Settings

Focus has come a very long way since the beginnings of photography, with most cameras now having lightning-fast autofocus and the ability to track moving objects. Digital single lens reflex (dSLR) cameras have three focus settings: Single, Continuous, and Manual (see Figure 1.9).

Check your camera's manual, as the names might be slightly different.

▶ **Continuous.** In Continuous autofocus mode, the camera will start to focus on whatever is under the selected focus point when the Shutter Release button is pressed halfway down, but will continue to autofocus until the Shutter Release button is pressed all the way down. This lets you focus on moving subjects and is great for most situations (see Figure 1.10). It is the default setting on my camera.

1.9 The focus mode selector on the Nikon D2x showing the Continuous (C), Single (S), and Manual (M) settings.

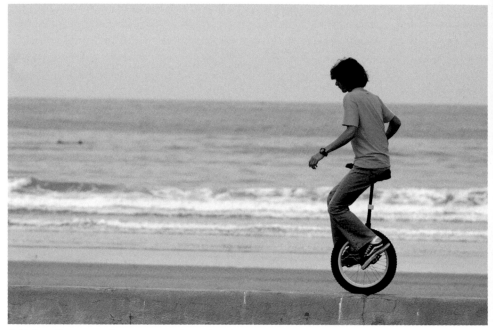

1.10 I really wanted to capture the unicyclist as he rode along the sea wall. I used Continuous autofocus to keep the subject in focus as he moved from right to left. Taken at ISO 200, f/5, and 1/1600 second.

▶ **Single.** In Single autofocus mode, the camera locks the autofocus when the Shutter Release button is pressed halfway down, and doesn't change, even if the subject moves. This is great for shooting things that don't move, like inanimate objects such as buildings and landscapes.

▶ **Manual.** In Manual mode, the photographer does all the focusing. While this might not seem very useful, it is key when trying to focus in dimly lit areas or when the autofocus is not able to lock on to the subject (see Figure 1.11).

To switch between the focus modes, check your camera's manual; usually, there is just a little lever that you can easily access to switch between the modes on Nikon and Sony and by pressing a button and turning the wheel on Canon. Some lenses will also have a focus switch on them allowing you to switch between autofocus and manual focus.

1.11 One situation where manual focus is very helpful is with macro photography. To make sure the focus was exactly where I wanted it, I used Manual focus mode. Taken at ISO 200, f/10, and 1/200 second.

Picking the Focus Point

Cameras now have focus points that allow the photographer to pick a spot, not necessarily in the middle of the frame, and have the camera automatically focus on that point.

For example, the Nikon D700 and D3 have 51 focus points (see Figure 1.12), while the Canon 1DMKIV has 45 focus points; some cameras have 11 or 9. To find out how many focus points your camera has, check the manual.

I use a Nikon D700 and the examples in the figures are based on the layout of the focus points in that camera; however, the concept is the same for all cameras.

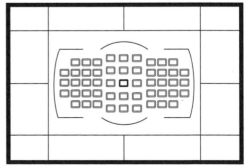

1.12 The layout of the 51 focus points used in the Nikon D700 DSLR camera. Notice how all the focus points are clustered in the middle of the frame.

When you compose your image, the idea is to put the focus point on the area that you want in focus and to press the Shutter Release button. So if the area you want to have in focus is within the area where you can use one of the focus points, then everything is good. All you do is select the best point and use it.

As you can see in Figure 1.13, all I did was put the focus point on the gorilla's face and waited to take the shot.

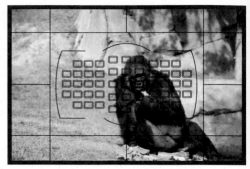

1.13 The gorilla was having his mid-morning snack when I shot this. Taken at ISO 400, f/6.3, and 1/640 second.

The really great thing about today's dSLRs is the ability of the camera to lock the focus on a subject. This *focus tracking* calculates the speed at which a subject is moving and keeps adjusting the focus as the subject moves. This is really great for photographing fast-moving subjects, such as during sporting events.

With all these advances in autofocus, the one thing that seems to have fallen by the wayside is the composition. Because the focus points are clustered in the middle of the sensor, the inclination is to place your subject right in the middle of the frame.

The real challenge is to focus on something that falls outside of the focus point area (see Figure 1.14). The solution to this is covered in the next section.

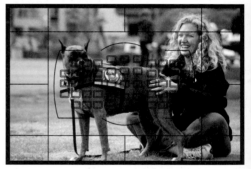

1.14 I really wanted to focus on the woman's face but, as you can see, from the focus point locations, that was not possible without doing some recomposing. Taken at ISO 200, f/4.5, and 1/500 second.

Recomposing Images

One of the keys when it comes to getting the composition that you want is the ability to focus on a subject and then recompose the image with the focus staying on the selected subject. I know this sounds complicated, but in reality it is fairly simple.

The key to recomposing your images is the focus lock that is available on today's cameras. To find the button or setting on your camera (see Figure 1.15), check the camera's manual.

When composing a scene where the subject is not covered by the focus points, do the following:

1. **Position the subject under the selected focus point (see Figure 1.16).**

2. **Press the Shutter Release button halfway down to focus.**

3. **Press the Auto Focus Lock button.**

4. **Recompose the scene (see Figure 1.17).**

5. **Press the Shutter Release button all the way down.**

For this to work effectively, the distance between the camera and the subject needs to stay the same. If either the subject or the camera moves, the camera does not adjust the exposure and causes the subject to be out of focus.

This takes a little practice to get right but once you get the hang of it, it makes recomposing the scene quick and easy.

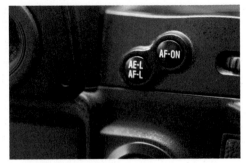

1.15 Focus Lock button/Exposure Lock button on the Nikon D2X

1.16 I wanted to have Mia all the way on the right of the frame, but to do that I first had to get her in focus. I placed her in the center of the frame and focused on her face. As you can see from the overlay, the focus point was placed directly over her. Taken at ISO 200, f/7.1, and 1/200 second.

1.17 I locked the focus (and exposure) by pressing the Auto Focus Lock button, re-composed the scene with Mia all the way to right, and took the photograph.

Sensor Sizes

Digital cameras come in a variety of sizes, and so do the sensors that capture the light and create the image. The size of the sensors is broken down into two distinct groups: cropped sensors and full-frame sensors. While there are a lot of differences among the various sensors, the only difference that I am concerned with here is the effect that the sensor size has on the focal length of the lens.

In the past, focal lengths of lenses were measured in relation to a 35mm frame of film. A full-frame sensor is the same size as a 35mm frame of film, so a camera with a full-frame sensor produces an image that is the same size and aspect ratio as a 35mm film camera.

When you use a camera with a cropped sensor, the smaller sensor records less of the scene than a full frame sensor would with the same lens (see Figure 1.18).

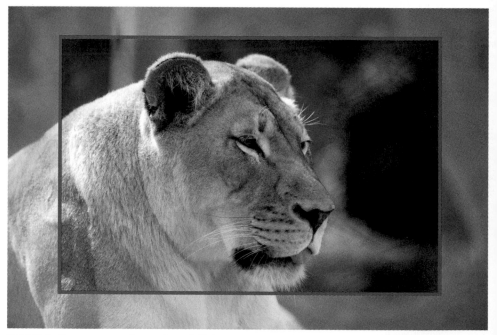

1.18 This lioness was shot with a full-frame camera. As you can see from the crop marks, the result would have been very different if it was taken with a cropped-sensor camera. Taken at ISO 200, f/2.8, and 1/1000 second.

What this means for you is that, when using a camera with a cropped sensor, the focal length numbers used to describe your lenses will seem to be wrong; it will seem like every lens is actually capturing a magnified version and many times this is referred to as the *lens multiplier.*

But in fact, the lens is capturing the exact same amount of the scene; the sensor is just recording less of it, which causes objects to appear closer. This can be useful because zoom lenses will seem to have more reach, that is, a great zoom, when used with a cropped sensor. On the down side, wide-angle lenses won't seem to be as wide.

There is a lot of discussion on the equivalent focal length when you talk about cropped sensors versus full frame sensors, and this length is pretty easy to work out: Just multiply the current focal length by 1.5 to get the rough equivalent focal length. For example, if you use a full frame camera with a 100mm lens and then put the same lens on a cropped sensor, the equivalent focal length is 150mm, while a 20mm lens becomes a 30mm lens.

The number that you need to multiply the current focal length by is dependent on the camera. Check your camera manual for the size of your sensor, if you want to get the most accurate translation. Some common multipliers are: Nikon's APC-C sensor is 1.52 and Canon's is usually 1.62 while the new FourThirds cameras is 2.

Fortunately, because composing a photo through the viewfinder shows the way the sensor will record the scene, the crop sensor does not affect your composition.

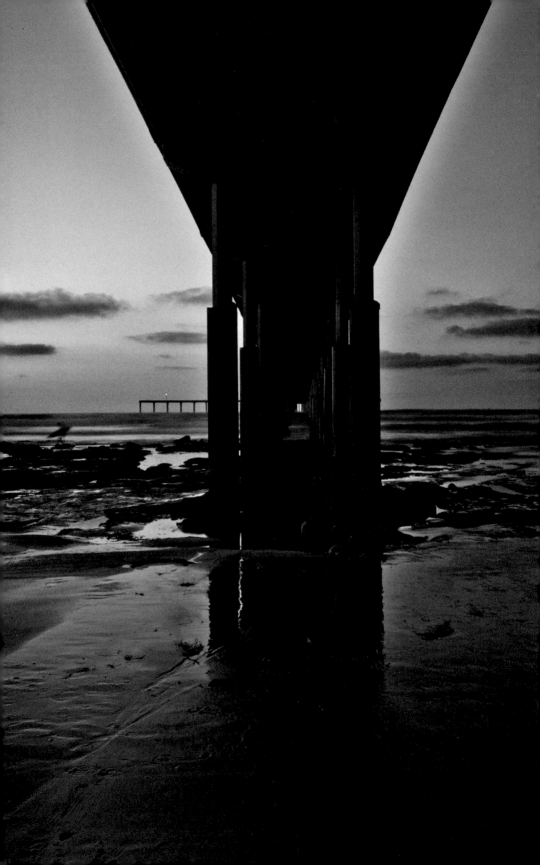

Light and Exposure

No book on photography would be complete without discussing the basics of light and exposure. It is important to understand how light creates your photos, the direction and color of the light, as well as the different options you have to control exposure. Knowing how to select the right combination of shutter speed, aperture, and ISO, and understanding what effect they each have on your image will let you concentrate on the actual composition. Getting the right composition but the wrong exposure can ruin an otherwise great image.

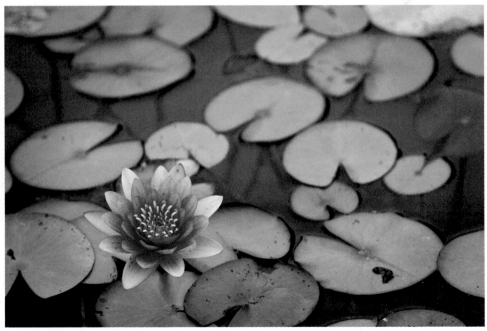

Taken in the early morning as the sun started to light the plants in the pond. The exposure was determined by the built-in light meter in the camera. Taken at ISO 200, f/4.5, and 1/250 second.

Light

Photography is all about capturing the light; actually, *photo* is from the Greek word for light. The camera's sensor captures the light that is reflected off of your subject.

Direction of light

Light has to come from somewhere, like the sun or a flash mounted on a camera. This means that the light that is illuminating your subject has direction, which determines where the shadows in your scene fall. The shadows are what give the scene depth (see Figure 2.1). If all the lighting is perfectly even, then your scene will have no depth and will look flat. The four most common distinct directions of light are front lighting, back lighting, side lighting, and overhead lighting.

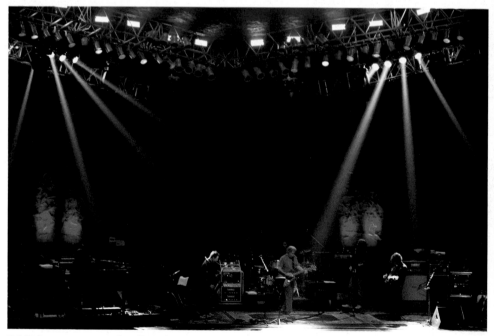

2.1 It is easy to see the direction and color of the light when shooting at a concert. Taken at ISO 1600, f/2.8, and 1/30 second.

Front lighting

Most people's first memories of having their photos taken were probably when they were children. They may have been told to go stand in the direct light because that's the best light. This little bit of photography wisdom has been passed down from

generation to generation; unfortunately, it is wrong. This *front lighting* causes subjects to squint, and washes out all the color and texture from the photograph. While front lighting is still used in the studio, it is controlled and mixed with other light sources to help define the subject.

Back lighting

When the light strikes the subject from behind, the results can be very dramatic. Silhouettes are created with strong backlighting (see Figure 2.2). This type of lighting can be difficult to expose for correctly, but the results are worth it. Images taken at sunrise and sunset can be great examples of back lighting.

Side lighting

When the light is off to the side and strikes the subject from the side, it creates shadows that emphasize the subject's form and texture. Look at the direction of the shadows to judge the direction of the light. Changing your orientation can drastically change the angle at which the light appears to be striking your subject.

Overhead lighting

When the light is directly above your subject, like the sun shining down in

2.2 These buildings were backlit by the setting sun. The resulting silhouette shows the form of the building without any of the color and detail. Taken at ISO 400, f/11, and 1/125 second.

the middle of the day, this is called overhead lighting. Because shadows define the shape of objects, this flat overhead lighting is not great by itself. A quick way to see if the light source is coming from directly overhead is to look at the ground and look at the shadows. If the shadows are really small and seem to be right under you, then the light source is right above you.

When you are composing a scene, the direction of the light can be very important. Watch the light and see how it interacts with the environment. In the case of using natural sunlight, watch how things that were hidden are revealed and how what was once revealed becomes hidden as the light changes in direction throughout the day.

Color of light

The light illuminating your photograph has a color, and that color can affect the look and feel of your image (see Figure 2.3). It is easy to see that the light coming from a candle creates a warm, orange cast, while photographing in deep shadows gives your images a blue cast. The color of the light can be affected by the source of the light, but it can also be affected by anything the light passes through and any surface the light bounces off of before it illuminates your subject.

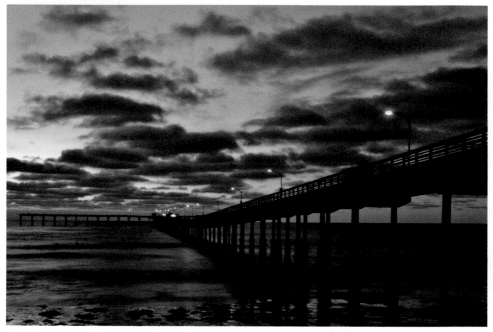

2.3 The sun had just set and the light started to turn a golden orange when I took this photo. Because there really wasn't very much light in the sky, I used a very slow shutter speed. Taken at ISO 100, f/16, and 5 seconds.

The color of light is determined by the source of the light, and while it might all look the same to your eyes, it doesn't to the camera's digital sensor. As a result, photographers use a temperature guide to describe the various types of light.

Color temperature

You use the color temperature of the light as a standard way to describe the color of the light and how it relates to pure white. Your eyes adjust to the different colors of light automatically but the sensor in your digital camera can't. While a white piece of paper looks the same to you under a variety of light sources, it doesn't to the camera. The color temperature is measured on the Kelvin scale, as seen in Table 2.1.

Table 2.1 Kelvin Scale of Color Temperature

Light Source	Approximate Color Temperature in Kelvin	Color Cast Seen
Candle light	1900K	Very red
Sunrise/sunset	2000 – 3000K	Red orange
Household incandescent bulbs	2500 – 2900K	Orange yellow
Photographic tungsten bulbs	3200K	Yellow
Early morning/early evening	3500K	Yellow pink
Halogen lights	3200 – 3500K	Yellow – yellow pink (cover the same range as the two previous)
Fluorescent lights	3200 – 7500K	Green
Mid-afternoon sunlight	5000 – 5400K	Yellow white
Average noon daylight	5500K	White
Electronic flash	5500K	Blue white
Overcast sky light	6000 – 7500K	Gray
Shade	6500 – 8000K	Medium blue
Clear blue sky	10,000 – 16,000K	Very blue

The lower the number on the Kelvin scale, the more red and orange the color is, while the higher the number, the more blue there is. By knowing what the color of the light is, you can set the camera to accurately capture the scene by using the proper white balance.

White balance

The white balance setting on your camera tells the sensor what type of light the photo is being taken under, and renders the scene as accurately as possible. Setting the white balance before you take the photo will help to make sure that your photograph turns out the way you want it to. There are ways to adjust the white balance in post-processing using the camera's software or any of the photo editing programs. This is easier if you shoot using the RAW file type (which I whole heartedly recommend), but it is now possible to adjust the white balance of other image file types as well.

Every camera manufacturer, and in some cases each different camera model, can have slightly different settings for each of the white balance presets.

▶ **Auto white balance.** Most cameras have an Auto white balance setting (see Figure 2.4), which tries to set the correct white balance based on the information reaching the sensor. This setting is usually good for many situations, but as

with all automatic settings it does have a few drawbacks.

The first is that because the camera sets the white balance for every shot, there can be slight differences even if the subject and location are the same. If you need a series of photographs to look the same, then you need to pick one of the other settings.

The second drawback is that the camera, no matter how smart it might seem, doesn't actually know what you are shooting. The Auto white balance is just a guess and can never be as accurate as when you set it yourself.

2.4 The White Balance menu on the Nikon D2X

▶ **Daylight.** The daylight setting tells the camera that the light reaching the sensor is in the 5000 to 5500K range. This is the color of the sun's light at noon where there are no clouds. While this is an accurate representation of the light, it can look a little cold, especially when shooting people. A better choice for shooting people is the cloudy setting.

▶ **Cloudy.** This setting tells the camera that the light is slightly colder, so it compensates by adding a little more red/orange to the scene and makes people look just a little healthier.

▶ **Flash.** This setting is used to match the color of the light produced from the camera's flash. It is a little bluer than daylight and is very close to the cloudy setting.

▶ **Shade.** The light in deep shade is very blue or cold. When you set the white balance to shade, the camera adds more red to balance out the color.

▶ **Tungsten or Incandescent.** Incandescent lights fall to the warmer side of the Kelvin scale, so when using this white balance, the camera adds blue to the scene. You will notice that photographs of people taken indoors seem to be warmer than those taken outdoors

▶ **Fluorescent.** Fluorescent lighting is really tough on photographers. It can change depending on the gas used in the tubes and the cycle of electricity used to power the tubes. Because the lights work on a cycle, the shutter speed can also affect the color of the light. This setting tries to match a fluorescent bulb's lighting but can give you mixed results, depending on the actual bulbs.

2.5 Shot under the incandescent bulbs of a wine bistro, this is the same image processed using two custom white balances. As you can see, the top image is much closer to what you think of as normal. Taken at ISO 100, f/4, and 1/60 second.

▶ **Kelvin.** Many cameras, espe-
cially the semiprofessional and
professional models, allow you
to enter the actual Kelvin tem-
perature of the light. This allows
you to fine-tune the white bal-
ance and set the exact tempera-
ture you want.

▶ **Custom.** Some cameras allow
you to take a photo of a white
surface, and then let the camera
adjust the white balance and use
that as a setting under those
lights (see Figure 2.5). This is great when shooting under mixed lighting where
none of the presets is exactly what you want.

RAW and JPEG file types

When it comes to digital photography, there are two main file types: RAW and
JPEG.

RAW files are those created in the camera with all the information from the sen-
sor. Nothing is changed, and nothing is added or removed. This is as close to a
film negative as an image file can be. The advantages to this are that because the
file has all the information from the sensor, it has a wider tonal range and expo-
sure latitude. The down side is that the files are really big, take up more space on
the memory card, are slower to download, and need to be processed (*developed*
in film terms) before they can be used. Each camera manufacturer has a propri-
etary form of RAW file, making it necessary for the computer and software man-
ufacturers to keep updating their programs to read these types of files.
Sometimes that update is not available when the camera is first sold.

continued

continued

JPEG files are compressed image files that follow the standard set by the Joint Photographic Experts Group back in 1992. This means that the file can be used directly from the camera without any processing, because all the image processing has been done in the camera. It can be e-mailed, viewed on a computer, printed, and even used in a digital frame. When you save your files using the JPEG file format, any adjustments you make in the camera are written directly into the file. When you open a JPEG file in a photo editing software program, make changes, and resave the file, you lose a little information. Every time you do this, image quality suffers just a little.

Exposure Basics

When photographers talk about the exposure of an image, they are talking about capturing the proper amount of light so that the dark areas are dark and the light areas are light. A correctly exposed photograph will have detail in both the darkest and lightest parts of the image (see Figure 2.6). If the image is overexposed it will be too light, and if it is underexposed it will be too dark.

2.6 I shot this in the afternoon with a clear blue sky. I needed to make sure that the sky was bright and the shadows in the building were still dark. Taken at ISO 160, f/8, and 1/13 second.

Photographers measure the light and determine the correct exposure setting for any scene. Your camera has a built-in light meter that can determine what to set the camera at to achieve proper exposure.

There are three variables you can control that, used together, allow you to determine the exposure. These are the shutter speed, the aperture, and the ISO. As the photographer, it is up to you to set these three variables so that the correct amount of light is captured by the camera's sensor.

Stop

The basic measurement of exposure is called a *stop*. This is how photographers describe the change from one shutter speed to the next, from one aperture to the next, and from one ISO to the next, where the change either doubles or halves the amount of light that reaches the sensor.

Let's look at some examples:

▶ **Shutter speed.** Changing the shutter speed from 1 second to 2 seconds leaves the shutter open for twice as long, which lets in twice as much light. Changing the shutter speed from 1 second to 1/2 second reduces the amount of light by half.

▶ **Aperture.** When you change the size of the opening in the lens from f/5.6 to f/4, the opening lets in twice as much light, while changing it to f/8 lets in half as much light.

▶ **ISO.** When the ISO is changed from 400 to 200, it is half as sensitive to the light, but when it is changed from 400 to 800, it is twice as sensitive.

Stop Progressions

The following table illustrates the progression of f-stops from the smallest apertures (deepest depths of field) to the largest apertures (shallowest depths of field), by full stops and also by one-third stops:

Full f-stops		One-third f-stops					
1	5.6	1	1.8	3.2	5.6	10	18
1.4	8	1.1	2	3.5	6.3	11	20
2	11	1.2	2.2	4	7.1	13	22
2.8	16	1.4	2.5	4.5	8	14	
4	22	1.6	2.8	5	9	16	

All these changes are 1-stop changes. Many cameras allow you to change these settings in 1/3 or 1/2 increments, but keep in mind that a stop is just a way of describing the change. You might hear a photographer say that he is going to stop up or stop down; don't be intimidated — it is just a way of saying that they are going to let in more light or less light.

Shutter speed

The shutter speed is the amount of time the shutter is open when you press the shutter release button, allowing light to reach the camera's sensor. The shorter the length of time the shutter is open, the less light is able to reach the sensor, while the longer the shutter is left open, the more light is able to reach the sensor. The shutter in your camera acts like a blind in front of a window. When the blind is closed, no light can enter the room, but when the blind is opened, the light streams through the window, illuminating the room.

One of the biggest complaints from beginning photographers is that the images they take don't look really sharp. This is usually because the shutter was left open too long and while it was open, either the subject or the camera moved. This movement, even if it is very slight, can cause the image to look blurry. The longer the shutter is open, the more likely this is to happen. The faster the subject is moving, the faster the shutter needs to open and close to capture a sharp image. For example, you would need a faster shutter speed to capture your dog running on the beach (see Figure 2.7) than you would a landscape that doesn't move at all (see Figure 2.8).

If there is plenty of available light, then using a fast shutter speed is easy, but when there is less light and you need to use a fast shutter speed, you will have to select the right aperture.

Aperture

The aperture is the opening in the lens that allows the light that is travelling through the lens to reach the shutter. The bigger the opening, the more light is allowed through the aperture. If all that happened when you changed the aperture was that the amount of light reaching the sensor changed, then selecting the aperture would be easy. But when you change the aperture, you also change the depth of field.

The *depth of field* is one of the least understood parts of photography and many people find it complicated, frustrating, and tend to ignore it; however, the depth of field is really important to composition and will come up again and again throughout this book. When you control the depth of field, you can control what is in focus and what is out of focus in your image.

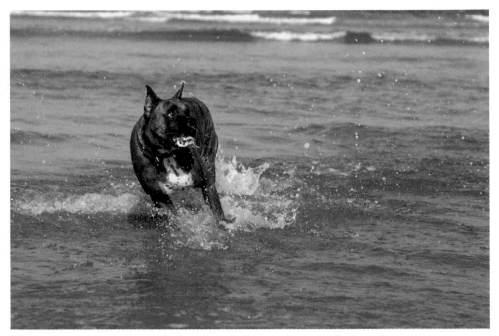

2.7 My dog loves to run on the beach and she makes a great subject for action photographs. Capturing her as she ran through the surf required a very fast shutter speed. Taken at ISO 200, f/3.3, and 1/2500 second.

2.8 Capturing the sunset required a slower shutter speed since there was less light. Taken at ISO 100, f/19, and 1/2 second.

When you focus your camera on a specific point in your scene, there is an area in front of and behind that point that is in acceptable focus. This area is the depth of field and you can control it to suit your needs (see Figure 2.9).

This is what causes the background to blur, making the subject pop on those great sports photos, and also what causes the entire scene to remain in focus when you take landscape images.

The basics are as follows: The smaller the aperture or opening in the lens, the less light is let through, the greater the depth of field is, and the more of your scene is in acceptable focus. The larger the aperture or opening in the lens, the more light is let through, and the shallower the depth of field is.

The aperture is described using *f-numbers* or *f-stops*. These numbers are actually describing the size of the opening and can seem a little back-

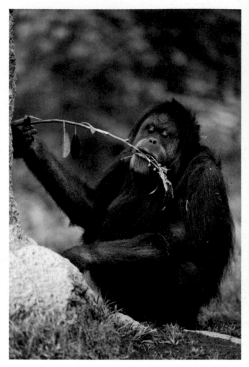

2.9 I used a shallow depth of field when shooting this orangutan to make the background blur out of focus. This made the subject stand out and is a technique I use often. Taken at ISO 500, f/2.8, and 1/500 second.

ward to begin with. If you don't know how the numbers are calculated, an f-stop of f/2.8 would seem much smaller than an f-stop of f/9, when in reality it is the exact opposite. This is because the f-stop is a fraction. It is actually 1/2.8 and 1/9, and 1/2.8 is larger than 1/9.

 The smaller the number under the f/, the larger the opening.

ISO

Both the shutter speed and the aperture control the amount of light reaching the camera's sensor; the ISO changes how the sensor deals with the light that reaches it (see Figure 2.10).

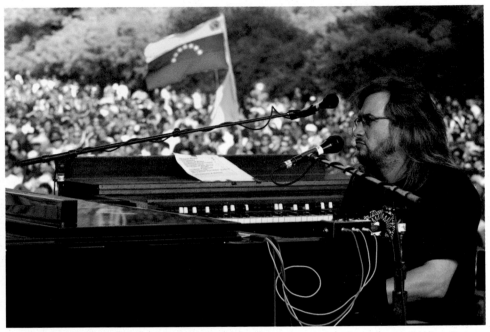

2.10 Keyboardist Jeff Chimenti photographed during a bright afternoon in Golden Gate Park. Taken at ISO 200, f/6.7, and 1/180 second.

The ISO is a standard method of describing the light sensitivity of a digital camera's sensor. The ISO (International Organization for Standards) number is a standard rating that is based on the sensitivity of film used in photography.

For digital photography, camera manufacturers worked out a way to amplify the information or signal produced when the light hits the sensor. The more the signal is amplified, the less light is needed. With ISO, the bigger the number, the more the signal is amplified, and the less light is needed to reach the sensor.

The downside is that as you raise the ISO, effectively increasing the sensitivity of the sensor to light, more digital noise is introduced to the image (see Figure 2.11). As the signal is amplified, the noise increases so that at very high ISOs, it is more visible and can be very distracting.

Camera manufacturers have made great gains in reducing the noise when shooting at high ISOs. Newer cameras are able to produce images at much higher ISOs with lower noise than ever before.

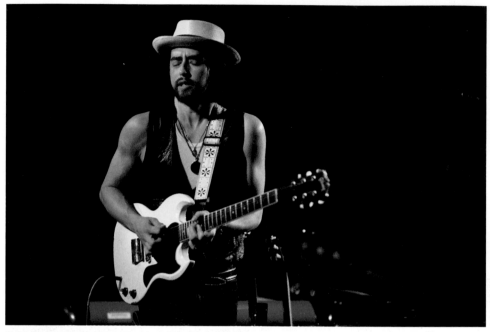

2.11 Guitarist Jackie Greene photographed in a very dark club. You can see the digital noise in the dark areas of the photo compared to Figure 2.10. Taken at ISO 3200, f/2.8, and 1/250 second.

Equivalent exposures

Because there are many different ways to get the same amount of light through the lens and onto the sensor, there are multiple combinations of shutter speed, aperture, and ISO that will all result in proper exposure. These are called *equivalent exposures* and are an important part of photography.

For example, if you use a short shutter speed and a wide aperture, you can get the same exposure with a longer shutter speed and narrower aperture.

The easiest way to explain equivalent exposures is to use an example. Take my hiking boots that I can never seem to put away. They tend to sit next to the back door and at times can be a tripping hazard. I got down to their height and took the three images you see in Figure 2.12. The exposure in all three images is the same, that is the boots are exposed the same, but the actual settings are different.

In the first shot, I used a very high ISO and shutter speed with a wide aperture to make sure that the wind wouldn't move anything while I shot. Using the wide aperture makes the background really out of focus.

Then I realized that the wind had died down so in the second exposure, I could use a slower shutter speed and a lower ISO. This reduced the digital noise in the photograph. I decreased the ISO by a full stop and decreased the shutter speed by a full stop.

By the time I took the third shot, the wind was gone completely. I could further reduce the shutter speed, but this time I also changed the aperture to let through less light. The smaller aperture increased the depth of field, so I decreased the shutter speed by a full stop and increased the aperture by a full stop.

The three exposures represented in Figure 2.12 are *equivalent*, that is they all end up with the same amount of light recorded by the sensor. The last two exposures are equivalent and let in the same amount of light, but the depth of field is different because we changed the aperture.

This chapter just covers the basics of light and exposure. For a more detailed explanation and examples, I recommend getting my *Exposure Digital Field Guide*, also published by Wiley.

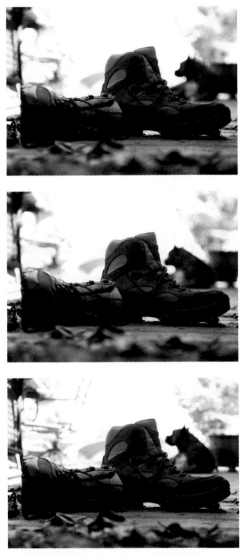

2.12 These three images might look the same, but they were all taken at very different exposure settings. From top to bottom, the settings are respectively: ISO 800, f/3.2, and 1/800 second; ISO 400, f/3.2, and 1/400 second; and ISO 400, f/5.6, and 1/200 second. While the ISO, shutter speed, and aperture all change, the shoes are exposed the same way each time.

The Rule of Thirds

By the time you finish reading this book, I hope that you will be sick of hearing about the Rule of Thirds; I also hope that it will be engrained as a way to start framing each and every shot you take. I am not saying that it is the only way to compose a photo or even the best way in every situation, but it is a great way to start looking at your compositions. One factor that works against this technique is that camera manufacturers put most of the focus points in their cameras in the middle of the frame. This tends to make people place their main subject directly in the middle of the frame. I hope that this chapter will make you look at the scenes in front of you in a new, controlled, and off-centered way.

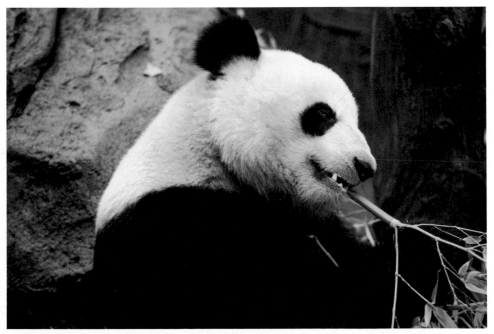

Giant pandas make great photo subjects with their unique coloring and docile behavior. When photographing this panda, I made sure that the eye of the panda was on one of the intersecting points that make up the Rule of Thirds. As a bonus, the bamboo that the panda is eating creates a leading line into the image. Taken at ISO 500, f/2.8, and 1/250 second.

What It Is

The Rule of Thirds is a method of dividing the scene into thirds with imaginary horizontal and vertical lines. Then you place one of the four spots where the lines intersect over the main subject of your image (see Figure 3.1). This technique seems really basic and simple but it works well. You can apply it to landscapes, portraits, horizontal images, vertical images, and everything in between.

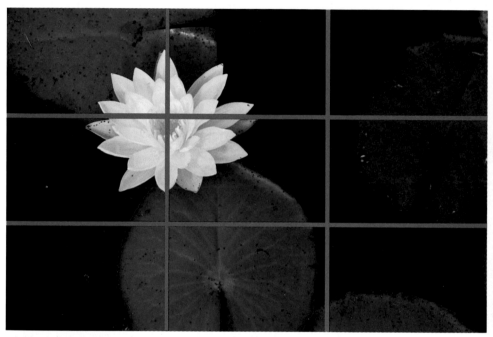

3.1 As you can see, I placed the subject of the image where the lines of the grid intersect. The idea is to keep the grid in mind when composing your images. Taken at ISO 200, f/4, and 1/4000 second.

Although this rule is really simple, it makes a huge difference in composition. If you study the history of the Rule of Thirds, you will learn concepts such as *the golden mean* and the *golden ratio*, even the *golden rectangle*. These all explain why certain compositions are pleasing to the eye. Let's look at some examples.

3.2 This flower was originally centered in the image. By zooming in a little and moving off to the right, the composition improves and feels more balanced. Taken at ISO 100, f/10, and 1/200 second.

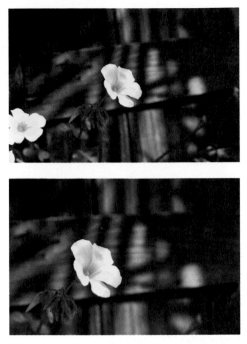

I saw the flower shown in Figure 3.2 and liked the way it looked against the backdrop of the wooden fence. The problem was that when the flower was in the center of the frame, the image was frankly a little boring.

All I did was move very slightly to the right and zoom in slightly to isolate the flower. The stem of the flower works as a leading line into the image and helps to create a more balanced composition.

When shooting a portrait, the best way to use the Rule of Thirds is to place one of the points directly on the subject's eyes (see Figure 3.3). Because the eye is the most important part of a portrait, it should be the one element in your image that gets the most attention.

There are times when it feels like there is too much space above the subject; in these situations, just take a few extra photographs so that you can see the difference.

Walk into any bookstore and take a look at the magazine rack; you will see a lot of great examples of portraits, most taken using the Rule of Thirds. Many times the name of the magazine has plenty of space to appear above the portrait.

3.3 When photographing Tim, I first placed him in the middle of the frame, then I moved so that his eyes were one-third of the way down into the frame and his right eye was directly on the intersecting point. Taken at ISO 200, f/5.6, and 1/200 second.

It is not always as simple as looking at the scene and just picking a random line or point to place your subject on. There can be other factors that influence your decision and help you make up your mind. For example, when photographing the tiger in Figure 3.4, I placed her on the right vertical because I wanted to eliminate the brighter area that was on the tiger's left.

Pay attention to the surroundings when you place a subject using the Rule of Thirds; it will not help if you align your main subject correctly but in doing so you introduce a conflicting element.

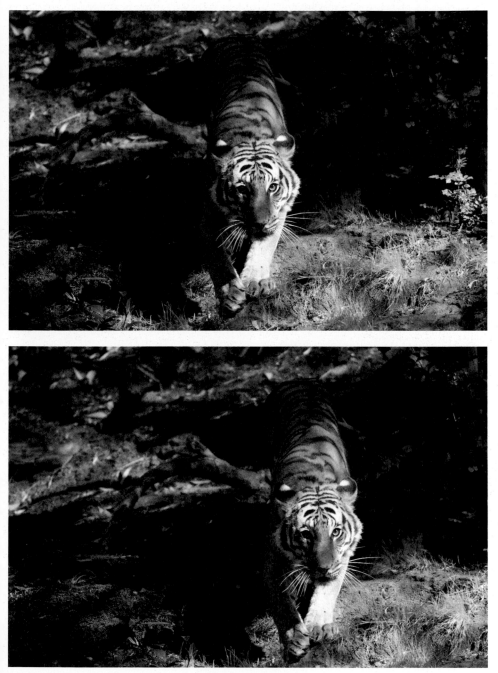

3.4 One of my favorite subjects is animals, and none are more beautiful to shoot than the big cats. With the tiger in the middle of the frame, there just seemed to be something lacking and my eye kept being pulled to the brighter area on the right. Recomposed with the tiger placed one-third in from the right, the image seems more balanced. Taken at ISO 400, f/2.8, and 1/1000 second.

When to Use

The short answer as to when to use the Rule of Thirds is always! Well, not really, but it is a great place to start with every shot. If you don't believe me, take two photos, one with the subject directly in the middle and one using the Rule of Thirds. After a while, you will find that you take the one using the Rule of Thirds first and start to see the world through your camera viewfinder a little differently (see Figure 3.5).

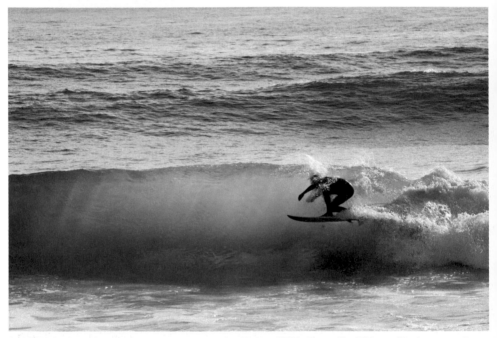

3.5 When shooting action, you can use the Rule of Thirds easily. This surfer is not only placed on one of the points, but the composition also allows space in front of him to move, and by placing that action on the lower horizontal, you make the action seem closer to the viewer. Taken at ISO 100, f/9, and 1/320 second.

There are times when it is best to use the actual lines instead of the points of intersection. This really comes into play with the horizon line.

The horizon line

The placement of the horizon line in your image is really important. Even if you cannot actually see a true horizon, you know where it should be. For example, check out the horizon in Figure 3.9; the horizon is hidden by trees, but you can imagine where it is. Here are a few tips for dealing with the horizon line and how it relates to the Rule of Thirds:

▶ **Keep the horizon straight.** Unless you have a good reason for tilting the horizon, make sure that it is straight (see Figure 3.6). A slightly tilted horizon just looks sloppy and can be very distracting. When you see a tilted horizon line, your brain wants to straighten it because it seems to be wrong.

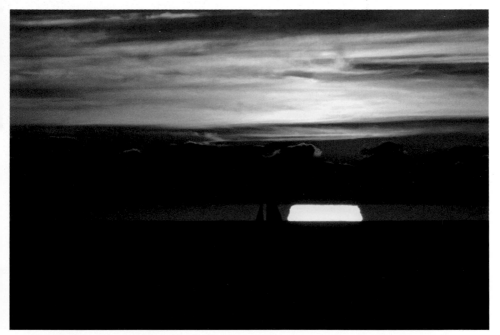

3.6 The horizon line and the cloudbank lines are both straight, which is important in this image. Had either line been tilted, the image would have seemed unbalanced and wrong. Following the Rule of Thirds, the horizon line is one-third of the way in from the bottom of the image, to show more of the dramatic sky. The glowing sun is placed on one of the four intersecting points. Taken at ISO 400, f/17, and 1/400 second.

3.7 I placed the horizon line toward the bottom of the image, but I placed the subject, the Celtic cross, on the bottom third. The empty space in the sky helps to draw the eye back to the cross. Taken at ISO 125, f/10, and 1/400 second.

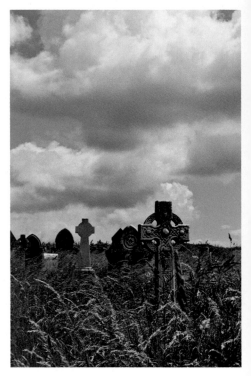

▶ **Place the horizon one-third in from the bottom.** When you place the horizon on the bottom horizontal, the top two-thirds of the frame becomes the subject of the image (see Figure 3.7). You will see this arrangement often, especially when it comes to photographing landscapes.

Whichever part of the image has more space dedicated to it will be the subject of your image. The exception to this is when you want something on the horizon to stand out. Filling the area above it with a clear sky can make the object stand out.

▶ **Place the horizon one-third in from the top.** This makes the ground or foreground more interesting than the sky, giving the bottom area more weight in your image than the top area or sky (see Figure 3.8).

I cover foreground, middle ground, and background in Chapter 8.

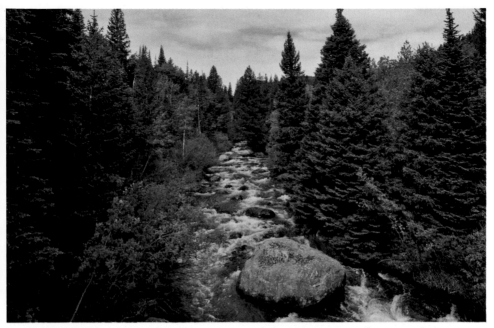

3.8 By placing the horizon line toward the top of the image, I focused the attention on the rocks in the river. Taken at ISO 200, f/9, and 1/250 second.

Verticals

It is really easy to compose using the vertical lines created by the Rule of Thirds when there is an obvious vertical element in your image.

For example, look at Figure 3.9, where I placed the statue on the right vertical line.

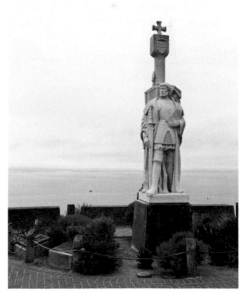

3.9 When photographing the statue of Juan Rodriguez Cabrillo at the Cabrillo monument in San Diego, I started by having the statue in the middle of the frame, but as I moved to the left I found the composition more pleasing with the statue on the right vertical. Taken at ISO 200, f/10, and 1/400 second.

When Not to Use

There are times when you want to break the Rule of Thirds. This could mean that you either place the subject in the very center or push it way off to the side.

Not every photo you take is going to be able to use the Rule of Thirds and that is fine. Composition is a personal choice after all, and this book is simply trying to help you make those choices. Every photographic situation is unique, and while the Rule of Thirds can help, you always have the choice to ignore it.

When it came to the bear in Figure 3.10, I started by placing the bear on the left verti-cal, but there was too much background in the image, including fencing and other zoo patrons. So I started to zoom in, which pushed the bear's face into the middle of the screen, but because the size and weight of the bear was still off to the left and the bear looked like he had a place to move, I took the photo with this composition.

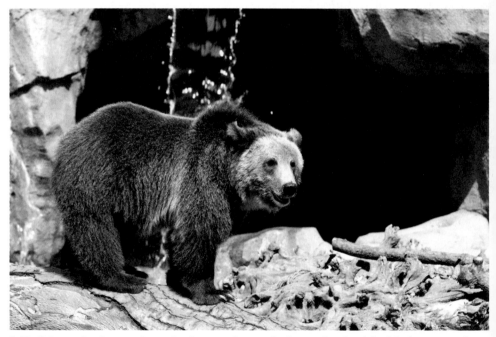

3.10 A bear checks out the onlookers at the zoo before going back inside for a morning nap. Taken at ISO 100, f/4.5, and 1/250 second.

The same holds true for portraits. For example, in Figure 3.11, I wanted a lot of empty space in the frame with the model all the way off to the left. I started with Nicole on the left vertical but I moved her as far over to the left as possible while still keeping her in the frame.

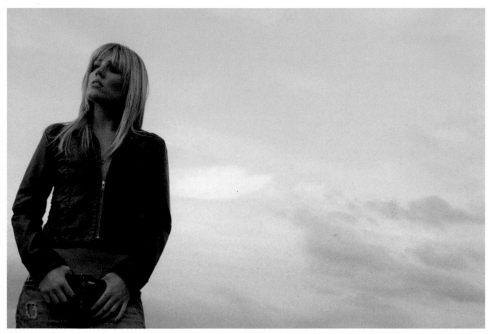

3.11 I wanted to leave as much space as possible on the right side of Nicole, so I pushed her right up against the left edge of the frame. I also had her look off to the left, which created more tension in the image. Taken at ISO 200, f/10, and 1/20 second.

One other time not to use the Rule of Thirds is when taking images using a fisheye lens. Theses lenses have a tremendous amount of distortion, especially towards the edge of the lens, and anything that is placed just one-third into the frame from any direction is going to be distorted (see Figure 3.12). This is especially true when taking photographs of people.

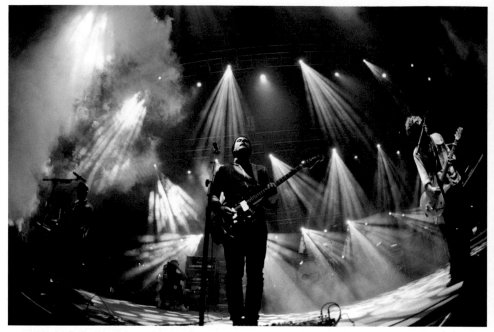

3.12 As you can see from this concert shot that while the effect is a lot of fun, the musicians at the edges of the frame are really distorted. Taken at ISO 1600, f/2.8, and 1/160 of a second with a 16mm fisheye lens.

Leading Lines

There are lines everywhere, both subtle and obvious, in both nature and man-made environments. Your eyes pick up on them even if you're not aware of it. By using these leading lines in your images, you can control where and how the viewer's eye travels. Unlike the Rule of Thirds, which you can use easily in just about every situation, composing an image using leading lines usually means a close study of the surrounding scene before pressing the Shutter Release button. This chapter will look at what leading lines are, how they work, where to use them, when to use them, and when not to use them.

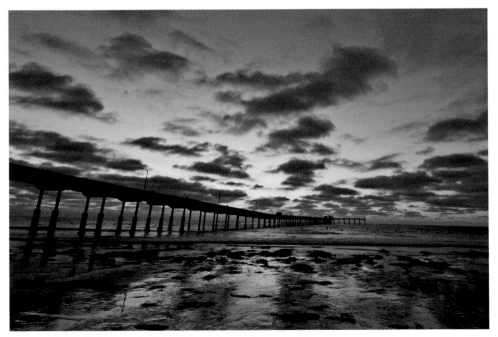

One of my favorite spots to photograph is the Ocean Beach pier in San Diego. I picked this image because it contains multiple lines, from the pier heading out to sea, to the way the clouds are lined up in the sky, and even the way the reflections in the foreground seem to point out to the horizon line. Taken at ISO 100, f/16, and 0.8 second.

What Are Leading Lines?

There are many different types of lines that you can use to draw a viewer's eye into and around an image. Many times these lines start on the edge of the frame and lead inward, which leads the eye from the edge into the image. This works especially well when it comes to diagonals.

Diagonals

These can be the strongest lines, leading the viewer from the outside edge, especially close to the corners of the image, toward the main subject. These can be really obvious, such as the neck of the giraffe in Figure 4.1, or less obvious, such as the branches coming in from the top-right corner of the same image. When you look at the photo, you can't help but be drawn to the face of the young giraffe.

For Figure 4.2, I was watching the interaction between the spectator and the horse at a local park. Focusing on the hand, I realized that the ropes and chain created lines leading to the nose. When the hand was placed on the nose, everything fell into place. Even without the hand, the composition would still be strong with the existing leading lines.

Straight lines

Straight lines in your image run either horizontal or vertical, as in Figure 4.3.

4.1 I used the line of the giraffe's neck to draw the eye up from the bottom-left corner, while at the same time I used the direction of the branches to draw the eye inwards from the top-right corner. Taken at ISO 100, f/3.2, and 1/250 second.

CROSS REF A horizon line is one type of horizontal line, and you can find an example of this in Chapter 3. Also, check out Chapter 9 for more information about shooting from below.

4.2 This image has three different diagonals, all meeting at the same point. Between the red rope from the top left, the chains from the bottom left, and the hand from the bottom right, the eye is immediately drawn to the nose of the horse. Taken at ISO 200, f/4.5, and 1/160 second.

When you have lines that are standing straight up, such as a tall tree or the telephone pole in Figure 4.4, it denotes a feeling of power and strength, especially when photographed from below.

The lines coming in from the edges support the feeling of strength and power and lead the eye straight to the main subject.

4.3 I really liked this candid shot of a local painter. It makes a great example of the combination of diagonal lines and straight lines. Taken at ISO 100, f/9, and 1/160 second.

4.4 This entire image is made up of vertical, horizontal, and diagonal lines. Taken at ISO 320, f/22, and 1/250 second with −1 exposure compensation.

When photographing people, there are many opportunities to use straight lines. For example, arms, legs, and body can all be used in your composition. However, you need to resist the temptation to pose your subjects in unnatural ways just to create a usable line.

Look at Figure 4.5: There are two different sets of lines in the same image, but they are both doing the same thing. There is the edge to the pool on both sides of the model; these straight lines run in from the edge toward the model. Another set of lines created by the model's legs draw the eye up toward her face.

4.5 I photographed Mia on the edge of the pool and used her pose to help draw the eye into the frame. This was lit by two strobes placed camera left, one to light the background was gelled blue and other was used to light the model. Taken at ISO 100, f/5, and 1/200 second.

4.6 The curved lines in this image are made from the shape of the rocks. See how the line leads in from the bottom right, curves towards the center of the image, and then ends in the pool of water. Taken at ISO 200, f/3.3, and 1/250 second.

Curving lines

Not all lines in images are straight; sometimes they curve and this can be a really good thing. Curving lines can add a feeling of motion and help keep the viewer's eye inside the photo. Because these lines move around inside the frame (see Figure 4.6), your eyes do the same.

Most of the time, lines in nature are curved. The more gentle the curve in the line, the more calming the image is (see Figure 4.7), while the more the line zigs and zags, the more energy it seems to have.

Curved lines are also present when you photograph people. Many times the curved line is the shape of the person's face or body. Look to see how the curve of a hip or the positioning of a shoulder can change the flow in an image, as in Figure 4.8.

4.7 The roots all curve and snake as the main subject of this image. Taken at ISO 200, f/7.1, and 1/25 second.

4.8 This image is a great example of people and lines; there are the curved lines created by the dancer's body, as well as the lines of the wings she is dancing with. Taken at ISO 200, f/4, and 1/640 second.

This implied line can control the viewer's gaze as easily as if it were an actual physical line in the image. For example, in Figure 4.9, Dhanie is looking off to the right, and so the viewer wants to look off to the right to see what she is looking at.

Consider that the classic definition of a woman's figure is an hourglass, which consists of just two basic curves. Men too have curving lines (of course these usually are much more subtle than a woman's), but photographs tend to show men standing straight up, denoting power.

When to Use

As with the Rule of Thirds, the best time to use leading lines is whenever you can. What is different is that many times there are obvious lines in the image, and so it is up to the photographer to either find some lines or create some implied lines. If you have the subject of your image looking in a certain direction, then the viewer's eye almost always looks to see what the subject is looking at.

4.9 I posed Dhanie off to the side of the light, and then she turned and looked toward the light. Taken at ISO 200, f/4, and 1/125 second.

There are times when your subject actually contains lines itself. These sometimes can conflict, drawing the eye away from the main subject, luckily that isn't the case, with the zebra in Figure 4.10.

I tried to use the lines created by the shape of the neck to draw the viewer's eye up into the image, while the lines on the neck keep the viewer's eye in the image. What is interesting about this image is that with all the straight lines visible, the notch in the ear in the upper-right corner really stands out.

I could have zoomed in closer to the hawk in Figure 4.11, but I wanted to give the image some perspective and I liked the starkness of the branches the bird had chosen as a vantage point.

The idea is that the branches lead the eye into the frame because they are the only things that touch the edge,

4.10 There are many different types of lines in this image, from the line of the zebra's neck to the lines on the zebra's face. Taken at ISO 640, f/5.6, and 1/800 second.

but you need to be careful because it is just as easy to guide the eye out of the image.

When you look at the hawk, does your eye stay with the bird or does it travel down and out of the image?

Remember that the viewer of your image needs to have something to look at; the main subject needs to be compelling or it won't matter how the lines are used. The image will still be boring.

4.11 Branches make excellent lines in an image, drawing the eye in. Taken at ISO 200, f/9, and 1/640 second.

What to Look For

As the photographer, it is your job to see and use the lines in the best way possible. This is easier to do when shooting a static subject, such as a landscape or portrait, because you can take your time, as opposed to a moving subject such as when shooting sports or wildlife.

Many times I look out over a scene and close my eyes, then slowly open them and see where my eyes end up. Once I understand where the natural focus point is, I look to see why my eye was drawn to that point and use those same lines to compose my scene.

In Figure 4.12, my eyes kept being drawn back to the hands and how they were so tightly gripped around the balloon strings. I could have just focused on the hands and captured the grip, but I wanted to make sure that the viewer's eyes went where I wanted them to go, right to the clutching hands.

The multicolored strings draw the eyes from the top-left corner to the hands, and just for good measure, I made sure that the angle I used would show the same strings leaving his hand and going off to the left. This helps to bring the eye into the image as it travels around the outside of the frame.

Once you start looking for the lines in an image, you will find them every-where. Still looking at Figure 4.12, there are other lines that draw the viewer's attention to the hands in the image. There are the two stripes of color (one dark blue, the other white) on the right side that both point upward to the hands. The sleeve of the jacket also creates lines that point to the hands.

4.12 Check out the lines created by the balloon strings as they are clutched in the birthday boy's hand. Taken at ISO 200, f/4.5, and 1/640 second.

In Figure 4.13, I had seen that the spotlights at this concert venue were placed on either side of the crowd at the back of the venue. I went all the way to the back row and waited until both lights were on at the same time before tak-ing the photo. The twin beams of solid white draw the eye in not only because of the placement and direction, but also because of the symmetry and color.

Symmetry and color are covered in Chapters 5 and 6, respectively.

Consider this last section a little bit of a warning. Sometimes it is easy to get carried away with the idea of lines in an image, and you can actually harm your compositions by plac-ing elements that distract instead of help. I repeatedly talk about filling the frame; make sure that items in the background don't distract from the main subject of your image.

In Figure 4.14, I believed that by waiting until the jaguar was in this position, the branches in the background would help to lead the eye to the big cat; instead, what has happened is that the branches look like they are poking the subject in the eye — not the image I was looking for. I should have paid more attention to the overall com-position than just trying to force a leading line situation.

4.13 I waited until the two spotlights were both on and aimed at the stage before pressing the Shutter Release button, creating matching diagonals that draw the eye towards the bright stage. Taken at ISO 400, f/2.8, and 0.8 second.

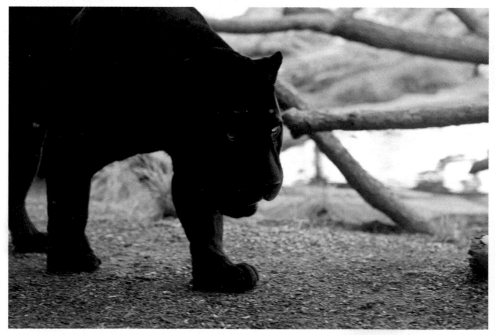

4.14 The sticks off to the right help to bring the eye into the image, but are they too distracting? Taken at ISO 800, f/4.5, and 1/160 second.

Symmetry and Balance

Not every rule can apply to every situation, and there are times when an evenly balanced image with good symmetry works really well. So when do you choose symmetry and balance over tension and the Rule of Thirds, and how can you use it to improve your compositions? What design elements should you look for and what shapes work best? In addition to these points, I'll also talk about reflections and how they can add balance to your images, especially when shooting landscape scenes.

I centered the vents in the frame, as they were centered in the wall of the building. The symmetry of the building strengthens the composition. Taken at ISO 800, f/13, and 1/60 second.

What Symmetry and Balance Mean

To understand how and when to use symmetry and balance effectively in your images, you first need to know what *symmetry* and *balance* mean.

When you place the main subject of your image in the exact middle of the frame, the image seems to be symmetrical; it is balanced with the same amount of space on each side (see Figure 5.1).

The same holds true if there are two objects placed an equal distance from the center of the frame. These two objects seem to balance each other out as if the center of the frame is a pivot point and the two objects are on a balance beam (see Figure 5.2).

The symmetrical composition has the same elements on both sides of the image — either left and right or top and bottom — and can also be divided on the diagonal.

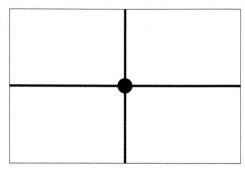

5.1 If you look at the grid produced when you have a vertical and horizontal line bisecting the image, you see that any subject placed alone in the center can create a symmetrical and balanced composition, as is the case with the flower shown here. Taken at ISO 800, f/13, and 1/60 second.

Opposites

The opposite of a symmetrical composition is an *asymmetrical composition,* which occurs when there is an imbalance because the same elements are not on both sides of the dividing line.

When an image has symmetrical composition, it also has symmetrical balance. This is the opposite of the *dynamic balance* produced when you put the subject on one of the intersection points created by using the Rule of Thirds, as shown in Chapter 3. Symmetrical balance is based on the center point of the image.

When photographing people, there are times when a symmetrical composition works well. I set up the image of Dhanie in Figure 5.2 to take advantage of the symmetry in the composition. She was posed carefully so that her arms both came up to the same spot and were held in the same way. Her gaze is directed upward, and the camera was set up directly in front of her.

Even with all the preparations, I still needed to edit the final image in postproduction to create the look I wanted. I took parts of the image from the left side and matched it to the right side of the image so that the two halves were perfectly symmetrical. This involved quite a lot of Photoshop work to line up the two sides to have it look natural.

5.2 I shot this image in the studio and set it up so that each side of the image was exactly the same. I lit the model with the same lights placed in the same position on either side. I edited certain elements in postproduction to make sure that the composition was as symmetrical as possible. Taken at ISO 100, f/9, and 1/320 second.

When it comes to shooting buildings and other static objects, try centering the composition right in the middle of your frame. This is easy because every camera has a focus point right in the center.

When I wanted a different view of my favorite pier in Figure 5.3, I opted to go under the pier and use a symmetrical composition to show the sturdiness of the structure. I focused on the exact center of the image, which was the tiny speck of light seen at

the end of the pier. The symmetry is enhanced by the repeating columns that are the same distance from the center point, and the triangle created by the bottom of the pier helps to draw the eye in as it goes overhead out to the vanishing point.

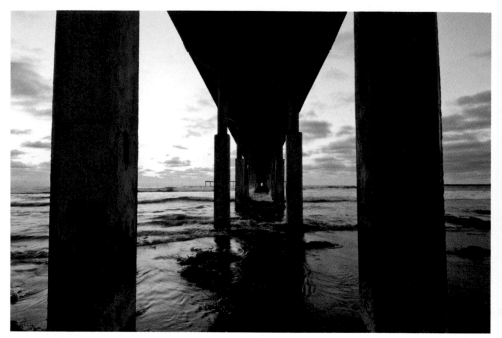

5.3 A very different view of the Ocean Beach pier. Taken at ISO 100, f/16, and 1.5 seconds.

One thing to notice is that even though I am not using the Rule of Thirds in the traditional sense, the pillars that are farthest away from the center are roughly one-third of the way in from each edge of the frame.

> **TIP** When it comes to creating images that have symmetrical composition, the symmetry needs to be precise because an image with just a slight symmetrical composition can look sloppy and wrong.

When to Use

Your brain likes to see order, but things that are considered orderly don't always hold your attention. So in what circumstances would you use an orderly, symmetrical composition so that it won't be perceived as boring?

Remember that composition, while it has guidelines, is a subjective choice. If you like the way a certain image looks and it seems to break the rules, then that's just fine. Many of the images in this chapter break other rules of composition, but I still like them.

There are two specific situations where I tend to create symmetrically balanced images: when I am shooting scenes that have reflections, and when I am shooting nature scenes.

Reflections

When you shoot reflections, you usually want to break one of the main rules of composition by placing the horizon line in the center of the image. This allows you to balance the image by having the scene evenly visible on both sides of the dividing line.

The most common use of this technique is the classic reflection shot of mountains and clouds cleanly reflecting back in a pristine lake as in Figure 5.4. I know the image is a cliché, but it works really well. The key to the image is the symmetrical composition.

5.4 This is not a pristine lake but it is the closest I have ever come. Photographed on the way to a wedding outside of Boulder in Colorado. Taken at ISO 125, f/8, and 1/320 second.

As the sun came up, there was a brief moment when the reflection of the sky and mountains looked great in the lake. I set the shot up to get a mirror image of the scene. This works best if the top and bottom of the image seem to perfectly reflect each other. The most important part of the composition is to make sure that the space above the centerline is the same as the space below it.

Nature

There is a lot of symmetry in nature — in flowers, leaves, feathers, and even our features. Sometimes, all you have to do is look close enough and you can see the patterns that are there.

There is more than one pattern going on in the leaf in Figure 5.5. One pattern consists of the small lines coming off the main vein and giving the image some flow and motion, while the other is the pattern of different colors as the leaf changes between light and dark green.

Both of these patterns are symmetrical in their own way, and I made sure to place the main stem of the leaf in the exact middle of the frame so that each of the patterns could have space to develop.

When photographing the symmetrical pattern, I wanted to make it the subject of the image, so I made sure that the pattern was not interrupted and didn't end.

5.5 I photographed this leaf to show its symmetrical pattern. Taken at ISO 800, f/20, and 1/13 second.

 For more information on photographing patterns, see Chapter 14.

I knew I wanted to show the symmetry of the peacock feather in Figure 5.6, but I also wanted to do something different than the typical straight up-and-down or side-to-side composition. By shooting at a 45-degree angle, I was still able to show the symmetry but I added a little more for the eye to examine.

5.6 I composed the peacock feather to show the symmetry in the design. Taken at ISO 800, f/16, and 1/250 second.

There is nothing wrong with using parts of each composition rule, but you need to understand why you are doing what you are doing. In this case, the coloring was slightly uneven so I needed to balance the image in a different way. Do you see the touch of green on the upper-right and the lower-left corners? These pieces of color help to emphasize the symmetry of the image.

What to Look For

It is not always clear exactly what to look for when creating a balanced and symmetrical composition. Some things I look for are strong design elements that will help to anchor the composition of my image, as well as repeating lines, which can help to add a sense of symmetry.

One thing to always keep in mind is that there can be unexpected opportunities for symmetrical compositions. The more you practice the more you will be able to see these opportunities when they present themselves.

Strong design elements

When shooting a symmetrical composition, it helps if there is a strong design element that will immediately be evident in the image.

The shot of New York City in Figure 5.7 works because of the symmetrical composition created by the two buildings on either side and how they relate to the skyscraper in the center of the image.

Even though the buildings on the sides are not exactly the same, they are close enough to work as a balanced composition. The building in the center holds the entire composition together and could stand by itself because it is architecturally symmetrical.

There are times when the subject of your image just seems to work better in the center, as is the case in Figure 5.8, which shows the cross at the veterans' memorial on Mount Soledad.

The whole structure is built with the cross as its center point, and that's where I felt it belonged in the image.

5.7 Shot in New York City, this image of the skyscraper is balanced by the buildings on either side. Taken at ISO 200, f/5.6, and 1/125 second.

I also worked to get the stairs and the stair rails as balanced as possible, to maintain the symmetry of the image. There is a sense of power and stability in the image because of this, and the placement and angle make you look up to the cross, adding to that feeling of majesty and power.

5.8 The cross at the veterans' memorial in La Jolla, California. Taken at ISO 400, f/13, and 1/640 second.

Repeating lines

Let's talk about the repeating lines of symmetry that you can use to create pleasing compositions. For the image of the daisy in Figure 5.9, I used the symmetry in the petals, the middle part of the flower, and the center. Each of the three sections of the flower has been bisected right through the middle, creating three concentric semicircles.

This repeating pattern, along with the placement of the flower at the bottom edge of the frame, creates an interesting composition that is both pleasing to the eye and symmetrically balanced.

5.9 This half-flower shows the use of both a symmetrical composition and the flower's shape. Taken at ISO 800, f/8, and 1/200 second.

Unexpected opportunities

Figure 5.10 was shot in the studio, and while it was not set up to be a symmetrical composition to begin with, I noticed how the chains were hanging and decided to create a symmetrical composition. I took a few extra photographs with the symmetrical composition to see how they compared to what I was originally trying.

I recommend that you take two photographs of each scene, one using a symmetrical composition and one using an asymmetrical composition, to see the difference. This is the only way that you will be able to see for yourself which composition works best in each circumstance.

 Try using the Rule of Thirds, **CROSS REF** described in Chapter 3, to compose a shot and then compare it to your symmetrical composition.

5.10 Dhanie photographed in the studio. Taken at ISO 100, f/2.5, and 1/200 second.

The key here is to notice when elements in your image are already in a symmetrical pattern and to use them. It won't work all the time — nothing ever does — but as you keep looking and photographing, these different compositional "rules" will begin to seem more obvious.

Color

When you understand how color works in an image, you can use it to draw the viewer's eye in and focus their attention on specific elements. Colors often evoke meaning to people, and you can bring this significance out in your images by picking the right color or color combinations.

This chapter will help you to understand how color makes a photo look cool or warm, and which color combinations can make people feel great about the image. You will also learn when you should use color and what to look for when composing your image, including the use of complementary and clashing colors.

These hammocks were for sale but when photographed hanging on top of each other, they become a mix of lines and colors. Taken at ISO 200, f/4, and 1/60 second.

What Color Means

Painters and artists have always been using colors to evoke feelings in the viewer and to enhance the subject of their work; photographers, on the other hand, have been limited because photography is usually about capturing the world in a realistic way.

Early in my photography development, I concentrated on accurately recording the world as I saw it through the viewfinder; I didn't spend much time worrying about the colors and how they affected the feel of the photograph until I realized that some images just worked better and had a better feel to them than others. That is because certain colors have meanings that can add emotional resonance to your images.

I'm sure that at some point when using a computer or reading your camera manual you have come across the acronym *RGB*. This stands for Red, Green, and Blue, which are the primary colors (also called hues) used in every TV screen, computer monitor, and camera screen. When these colors are all added together, the result is white.

But individually, these three colors each carry certain connotations:

- ▶ **Red.** Red is the universal color for danger (see Figure 6.1). It is used in streetlights to tell people to stop, in warning lights and caution signs, and as the color of the brake lights on the back of a car.

 When you see red, your eyes are drawn to it immediately. In your images, using a little red can go a long way. Red also means warmth and energy; the redder an image is, the warmer it feels.

- ▶ **Green.** Green is the color of plants, trees, and grass, as you can see with Figure 6.2. It is the opposite of red in Western culture, because it is used to indicate that everything is working

6.1 Nothing grabs your attention quite like a red warning sign. Taken at ISO 200, f/5.6, and 1/400 second.

well. Green in your images will not usually stop anyone's eye as there is little that is alarming or arresting about it.

Green also has a growing connotation as being environmentally friendly. Think of recycling and keeping the planet green. It imparts a good feeling.

 When shooting leaves, grass, and other foliage, a polarizing filter can often make the colors pop because it can reduce the light reflecting off the smooth surfaces.

6.2 Green means spring and plants coming back after winter. This image captures the whole spring feel, from the vibrant green to the single red flower and a bee gathering pollen. Notice how the red of the flower and the green of the plants seem to go so well together? That's because they are complementary colors. Taken at ISO 200, f/5.6, and 1/1000 second.

▶ **Blue.** Blue is the color of the sky and water. When seen from space, the earth is just a blue, spinning ball. When you see blue, it has a calming effect and can convey a feeling of peace and quiet, such as you may feel from Figure 6.3.

And while blue is not the direct opposite of red on the color wheel, it does have the opposite effect on the color temperature of an image in that the more blue there is in an image, the colder it feels.

6.3 Photographed out the window of the small commuter plane, all the different soothing blues of the Tahitian waters are easily seen. Taken at ISO 100, f/5.6, 1/250 second.

Try photographing colors just to see how they interplay with each other. Look for primary colors and see what was placed around them and how your eye is drawn to the colors. Also pay attention to how the different colors make you feel; being aware of your own emotions when viewing certain colors will help you to create that same feeling in the people who view your images.

How to Use Color

People make use of color all the time even if they don't know it; for example, the choice to photograph or print in black and white is a decision about color. So you need to think more about what colors you can add or remove from the frame to make a better composition.

Black and white

In Figure 6.4, you see the same image in both color and black and white. I took the image because I really liked the colors and the vibrant look of the sunflowers. When the image is converted to black and white, you can see the form and pattern but the impact and the intent of the original image are lost.

6.4 These sunflowers were in a bucket at a local farmer's market; the colors were vibrant under the white awning, which acted like a giant softbox. Taken at ISO 200, f/3.5, and 1/90 second.

Color combinations

Certain color combinations have built-in meanings that could change, depending on your location. For example, in the United States, the red, white, and blue combination evokes an image of the American flag and can elicit a very strong emotional response. It is one of the reasons why Superman and Wonder Woman are dressed the way they are. Wonder Woman even went so far as to have the white stars against a blue background as part of her costume.

For Figure 6.5, I could have used any color of lipstick, but it wouldn't have had the same impact. I carefully chose the colors and the placement so that the blue and white were in the background, but the red was in the foreground. They work together to tie the whole image together.

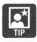 A viewer's eye always goes to the brightest area or color of a scene.

6.5 Dhanie was shot in the studio against a backdrop of a flag. You can see how the blue and white in the flag and the red in her shirt and lipstick complete the look. Taken at ISO 100, f/5.6, and 1/250 second.

Bold and bright

There are times when the colors of a scene dictate the whole look of the image; sometimes this is when there are very few colors and the scene looks monochromatic, and other times the sheer amount of color becomes the focus of the image, as in Figure 6.6.

Both styles can work, but if you are going to have a busy scene with bold, bright colors, then you need to know that it can overwhelm any subtle subjects.

6.6 These Mexican blankets were hanging in a shop wall and the sheer number of colors and patterns made for an interesting photo. Taken at ISO 200, f/6.7, and 1/180 second.

Understanding White Balance

I want to briefly talk about white balance here, and reiterate that the color of the light can play a huge role in your images; at times, it is better to leave the warmer or cooler colorcast, depending on the mood you want to achieve.

For more information on white balance, see Chapter 2.

The two images in Figure 6.7 show the same photo, with the only difference being the white balance of the image.

The first shot was taken using the daylight white balance setting, causing the photo to have a slightly warm colorcast, which is right because it was taken close to sunset.

With the second image, the white balance was set to fluorescent, giving the image a decidedly blue cast. Adjusting the white balance in postproduction can be used to change the image color after you have taken it, but be careful that you don't introduce a color that negatively impacts your image.

 For more information on white balance, see Chapter 2.

What to Look For

Color is everywhere, but to use it in your composition effectively, you need to understand how the different colors work with each other and how at times they work against each other. You can use color to create a mood, evoke an emotional response, and lead the viewer around your image.

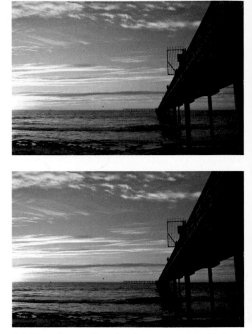

6.7 The Ocean Beach pier at sunset. Taken at ISO 200, f/3.5, and 1/640 second.

The first thing I look for in my images is the brightest color in the scene because your eyes are drawn to the brightest area of an image and after that, they are drawn to the brightest color, especially red or white (see Figure 6.8).

Because your eyes are drawn to those areas first, if they are not part of the subject, then they will be distracting for the viewer.

When you want to use colors in your composition, or even as your composition, think about the following color uses:

▶ **Complementary colors.** Two colors are complementary when they are opposite from each other on the color wheel; when used together, they balance out an image. Some of the most commonly used complementary color combinations are blue and orange, red and green, and yellow and violet.

Now, this doesn't mean that you need to have equal amounts of each color in the image; even a little dab of a complementary color can cause both colors to seem more intense.

6.8 There are at least three different blues in this image, but it is the white lettering that the viewer's eye is drawn to. Taken at ISO 100, f/9, and 1/50 second.

▶ **Single color.** You can use a single color in the image or a single overwhelming color that overshadows everything else (see Figure 6.9). This allows you to convey a feeling or mood.

Note that this is not the same as when the whole image has the same colorcast.

▶ **Stand-out colors.** Having one color different from the rest of the colors in the image draw's the viewer's attention to the subject you want.

The human eye cannot focus on two colors at the same time because each color is a slightly different wavelength. So when two colors that are farther apart on the wavelength spectrum are right next to each other, the brain translates the signal from the optic nerve as color vibrance, which produces a feeling of discord. This is why certain colors don't seem to go well together.

6.9 Fall colors are easy to identify and to photograph, especially when the scene has some fill light from a flash. These leaves were photographed in the fall in Northern California. Taken at ISO 200, f/2.8, and 1/250 second.

▶ **Color repetition.** Using the same color repeatedly in your image can add cohesiveness to the composition. This can be as simple as matching the color of an element in the background to something in the foreground.

▶ **Color frames.** You can frame your main subject by a color as opposed to an actual object. This could just be the change in wall color or the way the clouds are lined up in the sky. Framing a subject properly draws attention to the subject and not away from it, and so one of the things to watch out for is using a brighter color on the frame than the subject. Because you tend to be drawn to brighter objects, a bright frame can draw your eye away from the main subject.

▶ **Colorcast.** Color can set a mood, with reds and oranges being warm and inviting (as in Figure 6.10), while blues are cold and uninviting. You can control the whole mood just by controlling the main color.

 Color wheels come in a variety of sizes and specialties, I have one from The Color Wheel Company http://www.colorwheelco.com.

6.10 The color at sunset adds a warm glow to the mountain range. Taken at ISO 100, f/3.3, and 1/35 second.

Event Photography

Event photography covers a wide range of different situations, from concerts to birthday parties and just about everything in between. It is very difficult to be ready for all the different situations that can arise at an event, but this chapter deals with some things that hold true for all events. For example, you will learn how to make the subject stand out from the rest of the scene, and what to look for in the surroundings and the background. You will also read about the gear involved in shooting events, as taking the right lenses can really increase your chances of getting the best shot in every situation. Researching the event you are shooting will also really improve your odds of successfully photographing it.

Shooting at an air show yields a great set of images; look for the aircraft on the ground, not just in the air. I used the rule of thirds here by placing the aircraft one-third of the way up from the bottom of the frame. Taken at ISO 200, f/5.6, and 1/1000 second.

Composition Considerations

There are many different ways to compose images, but here I discuss some of the ones that you will find particularly useful when shooting events.

Fill the frame

Many times events are crowded places where there are performers, spectators, vendors, and just a lot of people. The real question becomes how to make sure your images make the main subject of your photograph stand out. The most effective way to do this is to fill the frame with the subject as in Figure 7.1.

I'm going to sneak two extra composition tips in here, both of which you will see repeated throughout this book. The first is that when photographing people, you should keep the focus on the eyes. The second is to utilize the rule of thirds, which states that you should put the most important part of the image at the intersection points of an imaginary grid that divides the scene into thirds both horizontally and vertically.

If you look at all the images in this chapter, you will see that they follow the rule of thirds and when it comes to the images of people, their eyes are always in focus.

7.1 Nothing is quite like the joy of a birthday cupcake. Even when filling the frame, I made sure that the focus was on the eyes and that the eyes were placed one-third of the way in from the top of the frame. Taken at ISO 250, f/2.2, and 1/400 of a second.

The rule of thirds and the rule about focusing on the eyes also apply when it comes to shooting portraits, as you see in Chapter 9.

7.2 Blowing out birthday candles is much more dramatic when you do it in a darkened room and use the candles to light the scene. I made sure I was in position and ready to take the shot when the birthday boy started to blow. Taken at ISO 1000, f/5, and 1/100 of second.

Figure 7.2 was a real challenge for me, as I wanted to capture that moment where the candles were blown out on the cake but I also wanted it to be timeless and not have any of the background in the image. I made sure that I was sitting directly across from the birthday boy and filled the frame with the cake and the subject.

I also had to make sure that I had picked the best focal point, because as the subject went to blow out the candles, he leaned in toward me and the camera needed to quickly refocus.

Watch the surroundings and background

I shoot a lot of concerts, which is both huge fun and quite difficult. One of the hard parts is paying attention to the surroundings and the background while still capturing the action on stage (see Figure 7.3).

Watching the background is not just important in concert photography but in all kinds of event photography. Notice the rest of the images in this chapter; in each one, I carefully looked at and dealt with the background. One of the easiest ways to fix a bad background is to move your position so that the background changes. This could be side to side but it could also mean crouching down or trying to get a higher viewpoint.

Another way to pick the background is to use an aperture that provides a very shallow depth of field, which throws the background out of focus, making your subject stay the center of attention. You do this by shooting in Aperture priority mode and setting the aperture as wide open as the lens allows.

7.3 These two images were taken moments apart at the exact same settings, but they are worlds apart when it comes to the composition. Both have the main subject, guitarist Michael Paget from Bullet for My Valentine, in the same part of the frame but the background is vastly different. The second image was taken as he walked toward the drummer and suddenly the background was filled with amplifiers, not road crew. Taken at ISO 640, f/2.8, and 1/400 second.

Pick the right lens

You can shoot events with any lens, but you will get better results if you know what it is you are shooting and use the best lens for each situation. I choose my lenses based on what I want to capture, the area I will be shooting from, and the available light. I also take into consideration how long I will be shooting and how the final images will be used.

What I want to capture

If the event is a concert or press conference, or some other public event where I need to get in close and fill the frame, I always take the 70-200mm f/2.8 lens. This lens works really well in most circumstances as it allows you to get in close and can be used in relativity low light as it has a maximum aperture of f/2.8 (see Figure 7.4). On the downside, this lens is big, heavy, and expensive, and it takes a commitment to want to carry it around all day.

7.4 When shooting a press conference for the TV show *24*, I needed to use a long lens with a wide aperture so that I could fill the frame with Katee Sackhoff and get a good exposure shooting in the darkened room without using a flash. I used the Nikon 70-200mm f/2.8 for this shot since it gave me the zoom and the wide aperture. Taken at ISO 800, f/4.5, and 1/160 second.

When I am shooting an event that takes place outdoors during the day, I generally pack a smaller zoom, something like the 18-200mm lens. While it doesn't have the same low-light capability, it allows you to get in just as close and it weighs and costs a lot less.

If I plan on shooting a birthday party or family gathering, then I use the 24-70mm lens as it is great for shooting in close and can go wide enough to get those all-important family group shots.

If I am working where I think I will need a huge range of focal lengths and low-light capability, then I carry both the 24-70mm and the 70-200mm lens. This is my basic concert shooting kit.

The area I am shooting from

If the event has strict rules about where I can and can't shoot from, then I make sure I take the lenses that will give me the best shots from those spots. Usually this is a longer lens, as the designated photo spot is rarely close to the action. For example, when shooting a concert recently, I was informed that all the photos would be shot from the soundboard at the back of the room so I made sure to take an extra-long 300mm lens for the job.

Available light

Knowing the amount of light that will be present also helps you determine which lenses to bring. If there is plenty of light, then any lens can work, but in those situations where there is little light, you need to use lenses with a wide maximum aperture. These are the f/2.8 lens or even wider. I have been known to add an 85mm f/1.4

lens to my camera bag if I know there is going to be low light or if the shoot is going to go into the evening.

Those extra stops of light at the widest aperture can sometimes mean the difference between a nice, sharp image and one that is blurry because the shutter speed was too low for the situation.

Tell a story

Event photography is a great time to practice telling a story with your images. While it is possible to tell a story with one image as in Figure 7.5, I'm talking more about using a series of images to let the viewer participate in the event. One of the best ways to do this is to start with an overall view, move in for a medium view, and then zoom in on one of the details.

When shooting at a local air show, I wanted to be able to do more than just capture a jet flying overhead. I wanted to be able to show more of the story, including the jets getting ready for launch with the ground crew (see Figure 7.5) and the jets flying overhead. Instead of trying to just get the newest jet, I worked on getting more than one type of aircraft into the shot (see Figure 7.6).

7.5 When shooting an air show, it helps to shoot the planes not only as they are flying overhead but also on the ground as they prepare for their moment in the spotlight. Taken at ISO 400, f/5.6, and 1/1250 second.

7.6 It was an air show, and no air show story would be complete without a shot of the planes in flight. Taken at ISO 400, f/5.6, and 1/4000 of a second.

I was also able to take some close-ups of the aircrafts as they were sitting on the tarmac giving yet another view of the same event (see Figure 7.7). Each of these shots might be able to stand alone, but as a series they tell a better story.

Telling a Story without Moving

Even when shooting a concert and not being able to physically change my position, I can tell the same type of story by using a variety of focal lengths. Wide-angle stage shots can set the scene, while a shot of the lead singer, guitar player, or even drummer will identify the lead character followed by a hand on the guitar or a close-up of the singer's face showing the emotion as he sings out to the crowd.

7.7 For the final shot at the air show, I wanted to focus in on one of the planes that were on display. I framed the image in tight to have the front of the aircraft stand out. Taken at ISO 200, f/10, and 1/400.

Photographing Fireworks

Many special events have fireworks displays, and photographing them can create great images (see Figure 7.8).

The secret to taking good fireworks photos is to use a slow enough shutter speed that the individual lights can move while the shutter is open, thus creating trails. Because fireworks displays are made of light, they are usually shown at night to be seen clearly against a dark background.

Your first step is to find a vantage point where you can see the fireworks with no obstruction. Using a tripod, set your camera up as follows:

1. **Set the camera on the tripod.** You need to make sure that the camera isn't going to move during the exposure.

2. **Compose the scene as best you can.** Because you can't see the fireworks until they go off, you need to compose where you think they will be and be ready to adjust the framing when the fireworks actually go off.

3. **Set the ISO.** The lower the ISO, the lower the noise, and because you can and want to use longer shutter speeds, the lowest ISO works best.

4. **Set the focus.** You need to set the focus mode on your camera to Manual and set the focus to infinity. You don't want the camera trying to focus when the fireworks are going off.

5. **Set exposure mode.** You need to set the exposure mode to manual so that you can set the shutter speed and aperture.

6. **Set the aperture.** Set the aperture to f/9, f/11, or f/16. These apertures are available on every lens and will give you a good depth of field for the images of the fireworks.

7. **Set the shutter speed.** I start with a 2-second exposure and increase or decrease the shutter speed, depending on the results.

7.8 This fireworks display during the Fourth of July celebration was photographed in the portrait orientation to get the lights from the pier where the fireworks were launched from. Taken at ISO 200, f/16, and 5 seconds.

8. **Take the photo.** The best bet is to watch the fireworks and trigger the shutter release as you see the trail from the fireworks go skywards.

9. **Check the LCD.** Check the image on the back of the camera using the LCD. If the image is too bright, then use a faster shutter speed; if the image is too dark, then use a slower shutter speed, this also allows you to see if you need to adjust the zoom or positioning of the camera. Are you too low, or maybe too high. Check to see if the tops or bottoms of the light trails are being cut off and adjust accordingly.

10. **Check the composition.** Make sure that you are getting all of the fireworks in the scene and haven't aimed either too low or too high.

Remember that the grand fireworks finale will be much brighter than the rest, so you need to increase the shutter speed to allow less light to reach the sensor.

Shooting Events

There are great event photo opportunities all the time. Some events are just made for photographers with photo opportunities everywhere. Other times you have to wait to be able to get the shots you want. Knowing when things are going to happen makes this waiting a lot more productive (see Figure 7.9).

Knowledge is power

All events follow a schedule (see Figure 7.10). If you know what the schedule is, then you can be ready to capture all the best moments. If the event is a parade, then knowing where and when it starts and ends and where the judges' tables are (if any) will allow you to set up to get the best shots.

If you know that the event is going to take place in the evening, then you will know to pack those lenses that have wide apertures and are better for use in low light, or make sure you pack a flash or two.

7.9 Many times there are great photo opportunities at events such as comic conventions. David Tennant was discussing the wildly popular *Dr. Who* TV show and his role as the tenth Doctor. Waiting till he turned toward where I was sitting and using a long lens both helped achieve this photograph. Taken at ISO 1250, f/4, and 1/250.

 Some events do not allow you to use a flash, so be prepared for the worst.

You may need to find out if you are allowed to photograph the event, especially a concert. Many times there are restrictions placed on who can and can't shoot certain events and what types of cameras are allowed inside the venue (see Figure 7.11). It is very disappointing to go to a show with camera in hand only to be turned away at the door.

7.10 All-day music festivals often post a time schedule of what is going to happen when. Sometimes, this will be a glossy, well-produced schedule, while at other times it will be more casual. At the Green Apple Music Festival, the schedule was written up by the soundman on a handy piece of cardboard and posted up for the public. Taken at ISO 100, f/7.1, and 1/250.

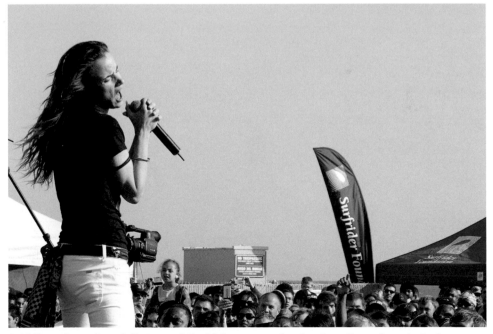

7.11 Knowing when Juliette and the Licks were going to play allowed me to be in position to get this shot. Having found out that a photo pass was needed to shoot with a dSLR, I made sure that I had applied for credentials before arriving at the festival. Taken at ISO 200, f/8, and 1/320 second.

Pack properly

Once you know what you are shooting and what lenses you plan on taking, the next step is to pack your gear. This might seem obvious but when you have a lot to photograph and little time to do it, you need to make sure you have packed your bag properly. When shooting concerts, I need to be able to find and change my lenses in the dark, and the longer it takes me to do that, the greater the chance that I will miss a shot.

Some events call for more gear than others and that is especially true when you are shooting events for the first time. When it came to photographing the Cinco de Mayo festival (see Figure 7.12) for the first time I packed a huge variety of lens, cameras, and flashes, not knowing what to expect. After returning from the festival, I saw which gear I used and which gear I didn't. This made it much easier to pack for the next time I was shooting an event of this type. Since the event took place during the day and was over by the time the sun started to set, I could use the smaller, lighter lenses and not have to carry all my low light prime lenses, which made for a smaller, lighter camera bag.

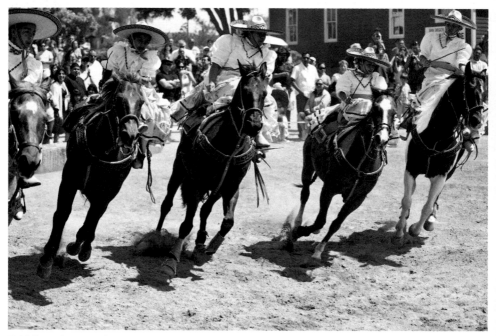

7.12 I made sure that I packed a 24-270mm lens that would allow me to get a wide angle on the horse demonstration at a local Cinco de Mayo celebration. Taken at ISO 200, f/4, and 1/1000 second.

There is a wide range of camera bags on the market, and not every situation calls for the same bag. I try to use the smallest bag possible for the job but I would rather take a bigger bag with a few extra items in it (see Figure 7.13) than need something while shooting and have left it at home.

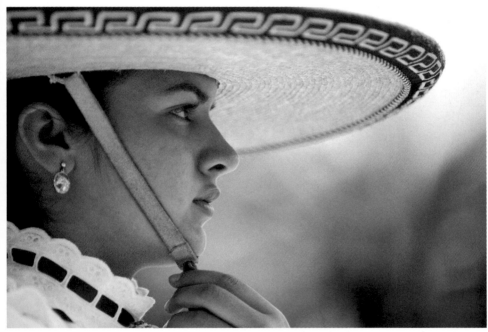

7.13 I wanted to be able to zoom in close on the faces of the participants, so I packed a 70-200mm lens, allowing me to get close without intruding as this young rider gets ready to perform. Taken at ISO 200, f/2.8, and 1/1250 second.

One of the newer types of bags on the market is a *dedicated lens bag*. These are not meant to carry your camera, but just some extra lenses and other small gear. These have one thing going for them that traditional camera bags don't: They don't carry your camera, so you are more likely to actually shoot photographs than simply carry your camera in a bag.

 I make sure that I pack my camera bag the same way every time. This makes it easier to find the right lens, battery, or memory card, especially in the middle of a job.

Composition Tips

Events can be tough, fast-moving, photographic challenges. Just keep the following in mind and the shoot should go well:

- ▶ **Fill the frame.** There is no better way to make your subject clear to the viewer than to fill the frame with the subject.

- ▶ **Focus on the eyes.** When shooting people, make sure you focus on their eyes. Out-of-focus eyes can ruin a good image.

- ▶ **Watch the background.** Try to minimize distractions in the background. If you can't move and your subject can't move, then use a shallow depth of field to make the background blurry.

- ▶ **Practice without a flash.** This is key when shooting live music events, as most bands, venues, and promoters do not allow flash photography, even if you have credentials to shoot the show.

- ▶ **Know your gear and where it is packed.** Many events are fast-paced and you need to be able to find and use your gear quickly. You need to be able to change settings, lenses, and memory cards without fumbling around. Knowing where you put the extra batteries and memory cards in your bag can save you precious minutes.

- ▶ **Pay attention to your surroundings.** If you are given special access to shoot an event, make sure you don't get in the way of the people running the event. That would be a sure-fire way of not getting permission the next time.

- ▶ **Arrive early and do your homework.** Find out if any special displays or presentations are at the event. If you are shooting a parade, find out where the judges, if any, are going to be and try to set up close to them. Each float tries to impress the crowd at that location.

- ▶ **Plan for the changing light.** When shooting outdoor events, the light will change as the day progresses. Knowing how long the event will last and what time the sun starts to go down will allow you to plan ahead and capture the shots you need.

- ▶ **Change angles.** Try to move around and shoot from a variety of positions and angles. For example, shooting from low angles is great for parades; it makes the whole event seem larger than life.

Landscape Photography

You can photograph landscapes in any environment, from the mountains to the deserts and any place in between. When shooting landscapes, there is usually plenty of time to set up the shot; after all, you do not have to worry about the subject moving. In landscape photography, there is no reason not to have everything composed exactly the way you want it. Landscape photography is about patience and waiting for the light to be just right. The positioning of each element in the landscape, using the rule of thirds, using leading lines to control the viewer's eye, and even changing your viewpoint are all covered here.

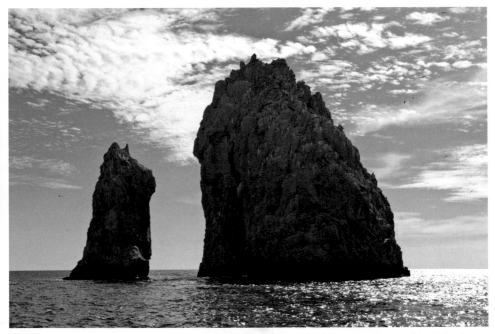

This image was photographed from the deck of a boat in Cabo San Lucas. I had the boat moved so that I could capture the light striking the rocks in the way I chose, and the clouds would act as leading lines into the image from the top left. Taken at ISO 200, f/11, and 1/500 second.

Composition Considerations

There are times when you can get away with sloppy composition; for example, when shooting your kids playing in the yard, the subject can make a poorly composed image a favorite. However, when it comes to shooting landscapes, the composition is the most important thing.

Rule of thirds

The rule of thirds works wonders for landscape photographs by organizing the elements in your scene and helping to create a balanced composition. The rule of thirds works by dividing the scene into thirds both vertically and horizontally with imaginary lines. If you have a single object as your focal point for the scene, then it works best if you place the object at the intersection of two of the lines as in Figure 8.1.

8.1 Before I took this photograph in Colorado, I needed to make a decision on where to put the line between the trees and the mountains. Because I wanted the image to show more trees than mountain, I composed the photo with the break one-third of the way in from the top of the image. Taken at ISO 125, f/7.6, and 1/125 second.

This is a compositional rule that you will see over and over in this book and in all kinds of photography. When it comes to landscapes there is one other way to use the rule of thirds: Place the horizon line of your image one-third of the way in from the top or the bottom but not in the very middle.

When you place the subject in the middle of your image, you tend to have a very boring image with neither the land nor the sky being dominant, and they actually fight for the viewer's attention.

If you want the sky to be the focus of the image, then the horizon needs to be one-third of the way up from the bottom of the frame with two-thirds of the frame filled with the sky. When the ground is the subject of the image, place the horizon one-third of the way down from the top and fill the bottom two-thirds with the land.

When composing a landscape, the natural tendency is to put the horizon line in the center of the image. Instead, take a few seconds to decide what you want to focus on, and then either angle the camera up to get more sky and move the horizon down, or angle the camera down and incorporate less sky.

If you are not sure which way is better, try both; actually, try all three (including the horizon in the center of the photo) and look at the results later. This also works with vertical compositions.

Don't be fooled into thinking that because you are shooting landscapes you have to shoot in landscape orientation; portrait orientation works as well (see Figure 8.2).

8.2 When I took this photograph in Sedona, Arizona, I placed the peak of the formation at the intersection of the lines one-third in from the right and one-third in from the top. I also noticed that the lines created by the formation start at the bottom corners and lead the eye up into the image. This is also a good example that all landscapes don't have to be in landscape orientation. Taken at ISO 100, f/8.5, and 1/320 second.

Foreground and background

To keep your landscape images from looking flat, add elements in the foreground that give the scene depth. This could be a flower, a rock, or any element that gives your eye something to look at in the foreground of your image. When you use a wide-angle lens, the distance between the foreground elements and those in the middle ground and background will seem to be really far apart due to the optical properties of wide-angle lenses.

When you place items in the foreground and have a subject in the background, there can be a problem with the middle ground of your images seeming to be very empty and having a lack of any interest. A great trick in dealing with this problem is to shoot from a lower angle, which naturally compresses the middle ground (see Figure 8.3).

© Jeremy Pollack / jeremypollack.net

8.3 This image shows great compositional use of the dead tree in the foreground with the mountain range in the background. Also, because of the angle, the middle ground is hidden. Taken at ISO 400, f/16, and 1/125 second.

When you have subjects that are in both the foreground and background, it is important to control the depth of field. You want to use a depth of field that is deep enough to get everything in focus, which usually means an f-stop of f/16 or smaller. When you

use these f-stops, very little light is allowed through the lens, meaning you need to use a longer shutter speed or a higher ISO, or both. When using a longer shutter speed, you need to make sure the camera does not move during the exposure. For this, you can use a tripod. You might see that statement a lot in this chapter, because to shoot landscapes like the professionals, you need a tripod.

Leading lines and S curves

You can use lines in an image to move the viewer's eye to where you want it to go; it is a little like a magic trick that gives you control of how your image is viewed. Fortunately, there are lines everywhere, both natural and man-made, and you can use both types in your images.

Straight lines help to lead your eye into the image, but you want the viewer to look at the image, and then spend some time examining all the details that you have captured. While the straight lines lead them in, a more gentle curved line, especially one shaped like an "S," works best to keep their attention within the image.

There are three different sets of leading lines in Figure 8.4. The way they all combine leads our eye into the image and then to the curve.

© Jeremy Pollack / jeremypollack.net

8.4 Another great image photographed by Jeremy Pollack. Taken at ISO 200, f/5.6, and 1/60 second.

The first set is the actual path that starts in the lower left and travels towards the top right, but this line is not straight; it begins to twist and turn towards the end, starting to make a gentle "S" curve.

The second set of leading lines is created by the fallen leaves on the ground and the slight wall on the right. The pattern formed here helps to draw the eye towards that curve in the path.

The third set of lines is created by the tree branches. The darker branch comes in from the top right and leads your eye into the image, then the line follows the branches and tree trunks down toward the path.

Frames

In addition to portrait photography, frames can also work really well when you are shooting landscapes. You can use anything as a frame: a window, a door, or even a tree branch that overhangs the scene. The frame will help to lead the viewer's eye to your main subject, as in Figure 8.5.

Figure 8.5 shows one compositional trick that needs to be used sparingly because the frame can be more distracting than helpful. If the frame is brighter than the scene, then the eye will go toward the frame and not the subject. The same thing can also happen if the frame is in sharper focus than the subject.

Look for frames that enhance a scene and not detract from it. If you can't make up your mind, shoot the scene both ways and look at the results later.

8.5 Using the natural cliffs to frame the scene helps to draw attention to the far cliffs. Taken at ISO 100, f/8, and 1/125 second.

Viewpoint

Shooting everything from the same height can be quite boring after a while. When you change the viewpoint, you change the relationship between the viewer and the scene. Looking down at a scene from a higher angle opens the whole scene up (see Figure 8.6), while using a low angle makes items in the foreground that much more important to the whole scene.

The viewpoint can also change how the light interacts with the scene. Things that were hidden are suddenly lit while other items that may have been in full sun are now streaked with shadows. This can be particularly true when it comes to shooting well-known subjects such as in Figure 8.7.

8.6 I wanted to make sure I got the whole sweep of the bay in my image so I stood on a low wall and looked slightly down on the scene. Taken at ISO 200, f/11, and 1/250 second.

8.7 Photographing the Cliffs of Moher in Ireland was a real challenge. I needed to practically lie on the ground to get a view where I could expose for the cliffs and block out the sun. Taken at ISO 125, f/11, and 1/250 second.

97

Panorama Photography

Panoramic images have recently become more popular. This is partly because it is now easier to capture great panoramic views than ever before, and also because software such as Adobe Photoshop CS5 and Adobe Photoshop Lightroom makes it simple to stitch together multiple exposures into a single panoramic image. These panoramic images have an exceptionally wide view and are used in all types of photography, but especially in landscapes for the way they portray wide-open spaces.

There are two ways to create panoramic images: the first is to crop a single image (see Figure 8.8), and the second is to stitch together a series of images into a single photograph. It is easier to just crop a single image in Photoshop or just about any photo-editing software.

However, you lose information from the image, you are limited in how big it can be blown up. Most importantly, you are limited as to how wide the image can be by the widest lens you have. When you take a series of images and stitch them together, the final image can be much wider than the widest-angle lens you have, but it does take a little more work.

8.8 This image was a great candidate for cropping using software because I wanted the birds in the scene. Because they were moving, there was a good chance the position of the birds would have moved had I tried to stitch a panorama together using several photos. The composition still uses the rule of thirds with the bridge placed one-third of the way up from the bottom of the frame. Taken at ISO 100, f/6.3, and 1/180 second, and then cropped in Photoshop CS5.

The key to shooting good panoramic photographs is to set up the shot correctly before making the first exposure. Although you can shoot a panoramic image without using a tripod, stitching the images together later is much easier if you take them all from the same level.

To make it easier to stitch your images together in postproduction, it's best to do the following:

1. **Set your camera in the tripod in portrait orientation.** This means that you will need more frames to cover the whole scene, but it also means that you have more information to work with later as well as some area that you can crop if needed.

2. **Use a white balance to match the scene, but not auto white balance.** Auto white balance allows the camera to make small adjustments to the white balance with every shot and can cause problems if there are any adjustments between images that you need to stitch together.

3. **Take a meter reading of the main subject of your panorama.** Set the metering mode to spot metering, and the exposure mode to program auto, and then aim the camera at the subject of your image.

4. **Use the camera's built-in meter to get an exposure reading by pressing the Shutter Release button halfway down.** Make a note of the exposure settings that the camera picks for the scene; you will be using them in the next step.

5. **Using manual mode, input the setting from step 4.** This ensures that the exposure is the same for all the frames used in the panorama.

6. **Use manual focus.** Pick the most important spot and focus on it using manual focus so that the focus is the same for all the images used in the panorama.

7. **Take a series of images.** Start on one side and slowly move towards the other, making sure that each frame overlaps the one next to it by 25 percent, giving the software enough information to help it stitch the images together.

This is a tip I got from photographer and author Scott Kelby: When you are about to take the first frame of the panorama, hold one finger in front of the camera and take a photo; when you are done with the last photo in the sequence, hold two fingers in front of the camera and take a shot; this will let you find all the images that belong in the same panorama easily when in an editing program.

Once you have a series of images, it is pretty easy to stitch them together into a panorama using software (see Figure 8.9). In addition to Adobe Photoshop and Photoshop Elements, it is even possible that the software that was bundled with your camera can do this; just check the user's manual.

8.9 A regular panorama stitched together using 8 images taken in the Anzo Borrego desert using Photoshop CS5. Taken at ISO 200, f/8.0, and 1/800 second.

Shooting Landscapes

Landscape photographers are usually up and out the door before the rest of us are even contemplating getting out of bed in the morning. They go out into the wilderness, set up tripods, and patiently watch the light as it moves across the landscape till they finally press the Shutter Release button. This is the type of photography where patience rules and preparation is key. You have to be in the right place at the right time, waiting for the right light just to get a single great image (see Figure 8.10).

The golden hour

A magical time for photographers occurs twice a day. The first is that precious time right before the sun comes over the horizon, and it lasts for about an hour. The second time is that hour right before the sun sets (see Figure 8.11).

These two hours of the day produce a light that is beautiful for photographers. It is softer and has a much warmer look. Just about everything looks better when photographed under this type of light.

The light during the golden hour is warmer in color because, with the sun near the horizon, the light has to travel through more of the atmosphere. The atmosphere reduces the light's intensity and makes the sun appear redder.

Today, it is pretty easy to find out the sunrise and sunset times for just about anywhere in the world using the Internet. The Web site www.timeanddate.com has a very handy sunrise and sunset calculator that gives you an accurate date and time for both the sunrise and sunset for just about any location. If you are planning to shoot landscapes, then I suggest doing it during those two hours of the day.

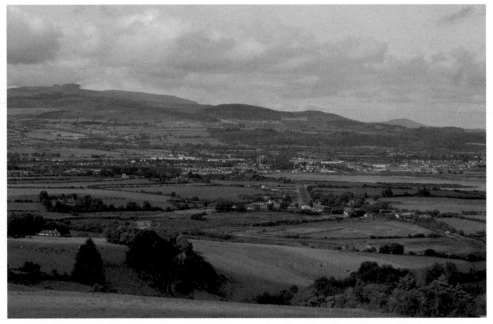

8.10 I shot this Irish landscape in the early morning hours. I would have liked to return to this spot when the light was better, but that is one of the risks you take when it comes to relying on natural light. Taken at ISO 125, f/8.5, and 1/320 second.

8.11 The sun had barely dropped behind the mountains when this was taken. Taken at ISO 200, f/4, and 1/250 second.

101

The duration of the golden hour can change drastically depending where in the world you are. North of the polar circle in summer it can last for several hours. Near the equator, you'd be lucky to get even a few shots off during the golden hour; it lasts only for a few minutes.

Be patient and watch the light

Photography is about capturing a moment in time. Because landscape doesn't move, what makes one moment better or worse than the next? I have already mentioned that the light during the first hour and the last hour is the best light, but when during this time should you press that Shutter Release button?

Watching the light as it moves across the landscape will give you your answer. As the light moves, it reveals parts of the landscape as it hides other parts (see Figure 8.12), and it is this play of the light that you need to study.

8.12 I waited until the shadows were long enough to give definition to the rocks but still short enough to show off the red color. Taken at ISO 100, f/7.1, and 1/180 second.

As you practice, you can take an image every few minutes. Watch how the morning light changes and how as the sun rises in the sky the shadows start to get shorter and shorter; when shooting in the evening, watch as the sun sets and the shadows get longer and longer.

These shadows define the shape of the landscape, so it pays to be ready and then be patient, only pressing that Shutter Release button when the scene is exactly as you want it. If it doesn't work out the first time, the landscape will be there tomorrow. Because the light is never exactly the same twice, you will have another unique opportunity to capture the scene.

Use a tripod

One of the most important pieces of equipment that you can have as a landscape photographer is a good tripod. When you are shooting landscapes, most of the time you will be using small apertures so that you are getting a very wide depth of field. This means that the whole image will be in focus from the foreground to the background.

When you use an aperture that gets you this very wide depth of field, it usually means that you need to use a slower shutter speed to get a proper exposure. The problem with using slower shutter speeds is that it becomes very difficult to handhold a camera absolutely steady while the shutter is open, and any movement, no matter how slight, can cause your image to be slightly blurry.

A good tripod locks your camera into place and allows you to use much longer shutter speeds than you ever could when holding the camera. There are many different types of tripods available, and it really is a matter of personal choice and budget when picking the right one. Just keep in mind that if you are going to get serious about landscape photography, a tripod is a must.

Some things to consider when purchasing a tripod are:

▶ **Size.** Tripods come in all sizes, with some small enough to fit in a backpack. If you are planning on hiking into the wilderness, then you want to get a tripod that is big enough to hold your gear but small enough to be portable.

▶ **Weight.** This goes hand in hand with size. You want to buy a tripod that is light enough to carry the distances that you travel with your gear. I carry a tripod in my car that is fine for carrying a mile or two, but I wouldn't want to hike with it all day; it's just too heavy.

▶ **Height.** If you are tall, make sure that the tripod can extend to a height that is comfortable for you to use and still stable enough to hold your camera gear rock solid.

▶ **Materials.** Tripods are made out of a huge variety of materials, from metal to wood, as well as a variety of different fibers. Each of the materials comes with its own set of strengths and weaknesses for the weight, stability, and cost.

▶ **Stability.** This is the most important factor when picking your tripod because if the tripod doesn't hold your camera gear steady, then it is no good to you. When looking for a tripod, take the camera and lenses that you plan on using with you or make sure that the store you are visiting allows you to test the stability with a loaner camera that is the same weight as yours. If you are planning on using a motor drive or a really big lens, make sure you take that into account.

It is important to note that the *tripod head*, the part that actually holds and adjusts the camera, can be purchased separately from the tripod legs. Look at the different types of heads and determine which is the one that matches your style of shooting. The most common types of tripod heads are:

▶ **Ball head.** The ball head is basically a ball that can move in any direction, with a locking mechanism that will lock the ball exactly where you want it locked. The bigger the camera-and-lens combination, the bigger the ball you need to support the weight.

▶ **Three-way pan head.** This is a more traditional tripod head, with separate controls for each of the three axes (see Figure 8.13). You can usually adjust the horizontal and the vertical, and switch between landscape and portrait orientation, with each of the adjustments having its own controls.

▶ **Smooth panning head.** This is generally used more for video than still photography, but with many of the top-selling dSLRs now shooting video, it might be the tripod you want — that is, if you do more video shooting than still shooting.

 Many times it is a good idea to weigh the tripod down to add to its stability. A couple of small sandbags do a great job.

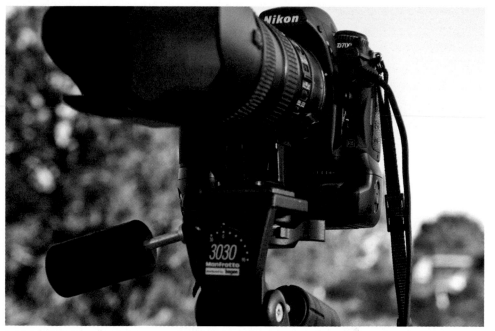

8.13 My Nikon D700 is locked into a Manfrotto 3030 tripod head, which is a three-pan head that allows me to finely tune the position of the camera. This head also features a quick-release plate which allows me to remove the camera from the tripod easily. I can photograph handheld and then quickly reattach the camera to the tripod. The tripod stand Manfrotto 055MF3 has carbon fiber for the legs and an aluminum and nylon polymer center column.

Composition Tips

As you can see, there is more to landscape photography than just setting your camera on a tripod and aiming it out in the distance. I hope that these tips will help you when shooting landscapes.

▶ **Pick your subject.** Make sure that the main subject of your photo isn't competing with other distracting elements in the image.

▶ **Pick your focal length.** Remember that telephoto focal lengths cause elements in the background to appear closer to elements in the foreground, while wide-angle focal lengths cause elements in the background to appear much farther away than elements in the foreground.

▶ **Add a person.** When you include a person in your landscape images, you add a sense of scale and perspective. It can be difficult to determine the true size of a landscape without a recognizable object to give a point of reference.

▶ **Look around before shooting.** The best image may not be the first one you see. Take a moment to look around before setting up your photograph.

▶ **Follow the rule of thirds.** Place the important elements at the intersection of the rule-of-thirds lines and make sure any horizon line is one-third in from either the top or bottom but not dead center in the frame.

▶ **Look for the leading lines.** Lines lead your viewer's eyes into the image and to your main subject. Use them to control where and what the viewer looks at.

▶ **Check for distractions.** When shooting landscapes, check not only the background but the foreground as well. Any feature that draws the viewer's eye away from what you want to be the focal point needs to be removed from the composition.

▶ **Watch the light.** As the sun moves across the sky, the light changes constantly. Watch where the shadows fall and how different areas are lit over time. The same landscape photo taken at dawn will look very different even one hour later.

▶ **Use a tripod.** This is the most important thing you can do for your landscape. Nothing in this chapter is as important as using a tripod. It is the only way to get the slow shutter releases needed with very deep depth of field and a tack-sharp image.

Portrait Photography

The basic goal of portrait photography is to capture the likeness of the person being photographed in the most flattering way. To get a great portrait of someone, a piece of their personality needs to come through. It is up to you as the photographer to get the subject to pose in the best way and to make sure that you understand the basic concepts of portrait photography.

This chapter covers the importance of focusing on the eyes and where in the frame to place the eyes, choosing the best focal length for portraits, filling the frame, and framing the subject. It also covers shooting indoors and outdoors, working with groups and with children, and common posing and troubleshooting tips.

You can take portraits on location as well as in a studio setting. This was shot on a local beach around sunset, which produced a great golden, natural light. Taken at ISO 200, f/5, and 1/30 second.

Composition Considerations

There are many different types of portraits and each has its own set of compositional challenges. It makes a difference if you are photographing a corporate executive in a studio or a family outdoors, a candid shot of a child playing or the tender embrace of a newly engaged couple. With that said, there are a few things that are key for all portraits.

Focus on the eyes

It has been said that the eyes are the window to the soul. Now, I can't speak to that, but I do know that the eyes are the key to a good portrait (see Figure 9.1). Take the most beautiful model, in the best studio, and if the eyes are out of focus, then the whole photograph is ruined.

There is more to the eyes than just making sure the focus is sharp. For example, you should consider what the eyes should be doing, and what the subject should be looking at.

9.1 When shooting Mia in the studio, I made sure that her eyes were in focus. Taken at ISO 100, f/4.5, and 1/250 second.

▶ **Looking right at the camera.** This is one of the most powerful ways to portray a subject's eyes. It shows openness and honesty and can help a viewer connect with the subject. The look should be natural and not as if the subject were just staring blankly ahead (see Figure 9.2).

▶ **Looking off-camera.** Having the subject look slightly off to one side of the frame can be a very effective way of engaging the viewer. They don't know what the subject is looking at, which creates interest and mystery. Have the model look straight ahead, then turn her head so she is looking off to one side; this creates a natural-looking pose. When shooting these types of images, make sure the model is actually focused on something and not just looking out into space; it will show in the image.

▶ **Eyes closed or looking down.**
Even if the eyes are closed, you should still focus on the eyes, as people are drawn to that part of the face naturally.

When the eyes are closed or looking down, the scene can take on a very intimate feel; however, be careful not to shoot someone with their eyes half open, as that just looks bad.

▶ **Whites under the iris.** A photography technique that makes the eyes look larger and brighter is to shoot them when the subject is looking upward so that that there is a little white under the iris.

Have the model tilt their head down slightly and then look up slightly just enough for the white in the eyes to show.

9.2 Even when you can't see the rest of the face, you can get a lot of communication from the eyes. Taken at ISO 200, f/6.3, and 1/250 second.

Picking the right lens

You will often hear that the 50mm is the best lens for portraits, or that the 85mm lens is the best. The truth is that many focal lengths work, but you should know why you are picking one lens over another.

Focal length is very important when it comes to shooting portraits because of the compression or expansion that can happen to a scene when you use longer focal lengths or shorter focal lengths, respectively. The best way to demonstrate this is with a photograph or two.

Figure 9.3 shows two images of Mia that were taken at the same time in the same location with the same light. The only difference between the two shots is the focal length of the lens used and where I stood when I took them. If you overlay the two images, you will see that her eyes are in the exact same spot in both images but they look completely different.

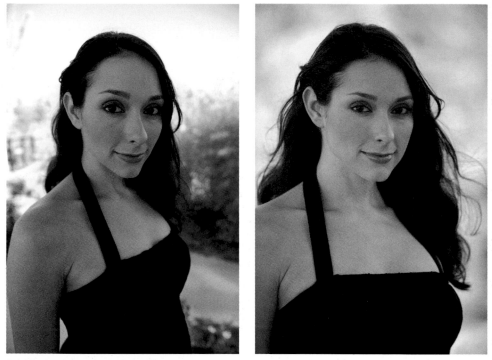

9.3 Both of these photographs of Mia were taken at ISO 200, f/5.6, and 1/500 second. The image on the right was shot with a 24mm focal length, creating compression, and the image on the left was shot with a 200mm focal length, creating a fuller look.

To have Mia take up the same amount of the frame in the two images in Figure 9.3 meant that I had to move in really close when using the 24mm lens and move back quite far when using the 200mm lens. So when shooting with the wider-angle 24mm lens, the features on Mia's face start to seem distorted, with those parts that are closer to the lens (such as her nose) appearing to come toward the camera, and those parts that are farther away (such as her shoulders and ears) appearing to recede from the lens. The whole effect makes her face appear angular and is not very flattering.

When you look at the same pose taken with the 200mm lens, the whole face seems more natural and fuller. An added bonus is that the background is also much more pleasing to the eye.

For more on how the focal length affects the background, see Chapter 1.

When it comes to buying lenses for portraiture, you can start with three particular zoom lenses, so that you can cover a huge range of focal lengths. These lenses are:

► 14-24mm

► 24-70mm

► 70-200mm

With this assortment of lenses, you go from the super-wide 14mm all the way to the 200mm. This collection of lenses is actually great for just about all photography. The only downside is that good lenses in these focal lengths can cost over $2,000 a piece. I use my 70-200mm more than any other lens, and many of the photos in this book were taken with it.

There are other lenses that cost less that will do a great job, but that lower price usually means that you are giving up something. Most of the time, a cheaper cost sacrifices the maximum aperture of f/2.8. It pays to shop around, but remember a good lens that is taken care of will last a lot longer than your camera.

Fill the frame

When it comes to portraits, work on filling the frame with your subject. This is much easier when you use a long lens and stand farther back, as it compresses the background, making less of it visible in your photo. The background elements that are visible should be nicely out of focus (see Figure 9.4).

When you fill the frame with your subject, pay careful attention to where you are cropping them. You want to make sure you are not cutting your subjects off at the joints. What this means in practical terms is that you don't want to cut off anyone at the ankle, knee, elbow, or wrist. It is better to zoom out a little or move the arm or leg than to cut off the offending limb.

9.4 I photographed this little beauty in her backyard. I zoomed in on her face and filled the frame so that you couldn't see any of the distracting background elements. Taken at ISO 125, f/5.6, and 1/125 second.

Frame the subject

Not every background is bad and not every shot needs to be cropped in tight. There are times when you can use the environment to help draw attention to your subjects. One great way to do this is to use elements in the scene to frame your subjects. Look at doors, windows, and other architectural elements that you can use to draw attention to and keep the focus on your subjects (see Figure 9.5).

The doors that frame the couple in Figure 9.5 have a dual purpose: First, they help to add some interest and texture to the background, and the shape leads the viewer's eye back to the subject, which is the couple.

The second purpose of the background is more sentimental. The couple was going to get married at the winery, and these engagement photos have a visual element to remind them of that time.

9.5 I used the artwork on the door of a winery to frame this couple. Taken at ISO 200, f/3.5, and 1/125 second.

> Try to keep the background frame simple so as not to overpower the rest of the composition. You want to make sure that the framing of your subject helps the composition and doesn't hurt it.

Look around and see what you can use to frame your subjects. Remember that the frame doesn't just have to be behind them; you can shoot through windows and archways and get a framing effect. Make sure that you keep the focus on the portrait subject and don't get too caught up in the framing.

Change your angle

If you stand in the same place and your subject stays in the same place, all your photographs will look the same. It is really important to change your angle from time to time and see what it does to your image. Changing angles and height is crucial when

photographing kids, as they live at a different height from adults. To capture their world, you have to get to their height (see Figure 9.6). (More on photographing children a little later in this chapter.)

The best starting point is to be at the same eye level as your subject. If you are shorter, then you might need a little step stool, or if you are tall like me, then you will learn how to crouch a lot.

9.6 I got down low when shooting Cameron and his new soccer ball. By being down at his height, I captured the world as he sees it. Taken at ISO 200, f/5.6, and 1/1250 second.

Changing the angle can change how your subject appears to the viewer. Shooting from a low angle up toward someone can make that person appear taller and more powerful. This is a very common practice for the cover of magazines when showing the CEO of a company. Try to drop down a little bit the next time you are shooting a portrait and use a slightly upward angle; see if the subject doesn't look slightly more imposing.

It is also possible to shoot down at someone. While this might not seem like a good idea after reading how shooting up creates height and power, shooting downward also has some benefits. People typically look better when being shot from above; their faces can appear slimmer but their eyes stay the same size. This causes the eyes to seem larger, always an attractive look.

When shooting portraits, move around and see what you can accomplish just by changing the angle.

Watch the background

A background can make or break a photo. When you are composing a portrait, the person is the most important thing in the image and not the tree in the background. Of course, there are times when the tree (or any other background element) is important, but if you are shooting portraits, the person is always the most important element in the image (see Figure 9.7).

9.7 I waited patiently until no people were walking in the background so that I could keep the composition nice and simple. There are no distracting elements in the background that pull your eye away from the subject. Taken at ISO 200, f/2.8, and 1/2000 second.

There are times when you will take portraits where the surroundings are important, and you will want to make them part of the photograph. However, these environmental images are still portraits. When looking though the viewfinder, you need to let your eye travel around the frame. If there is something in the background that catches your eye, then you need to recompose the scene.

Often when photographing portraits, there is a tendency to move the lights in nice and close, as this gives the most pleasing light. Pay attention to the edges of the frame, especially on the sides where the lights are set up, and make sure that they are not in the frame.

Rule of thirds

The rule of thirds is one of the fundamentals of composition, and it works great when taking portraits. With the rule of thirds, you divide the scene into thirds both vertically and horizontally; you place the main subject at one of the four points where those imaginary lines intersect.

In the first image in Figure 9.8, I placed the model in the center of the frame but still had her eyes one-third into the frame from the top. The photo is fine, but when I moved over to the right just a little, her left eye was now on the intersection of one-third in from the top and one-third in from the right, creating a stronger image. This adjustment had the secondary advantage of cleaning up the background.

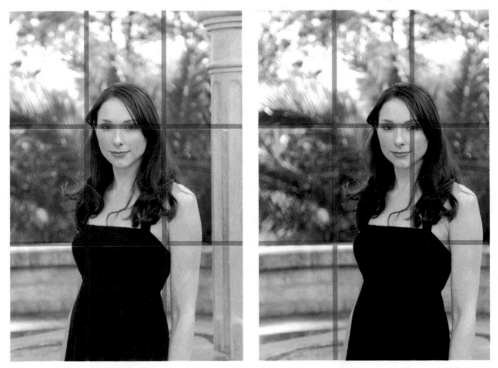

9.8 These two photographs were taken at the same place and the same time with just a slight change in the composition. While there is nothing wrong with the first image, the second is more pleasing just due to the slight change in placement of the model. Taken at ISO 200, f/2.8, and 1/200 second.

If you look at the images in this chapter, you will see that most of them place the most important element on one of the intersections.

Working with People

Portraits are photographs of people, and to get great portraits you need to be able to work with people. I have talked about the eyes, the lenses, and even the background. Now it is time to consider the people, your subjects, and how to pose them to get the best results. The more you practice, the easier it becomes to get good poses and the easier it becomes to see what works and what doesn't work.

Posing tips

Here are a few posing tips to get the best results possible. Not every tip will work for every situation; just pick and choose those that work for you.

▶ **Eyes.** Control the direction of your subject's eyes. People tend to want to look at the camera and shift their focus towards it, even if that isn't the look you are going for. The very last thing I do is check the eyes before I press the Shutter Release button, which allows me to check their direction and to make sure the focus is on the eyes.

▶ **Head.** Everybody's head leans to one side or the other when they are relaxed. You want to make sure that your subject doesn't get too comfortable and start to lean to one side or the other. Leaning the head a little forward can cause the face to seem thinner, and because the chin is lower, the eyes seem slightly bigger. If the subject's head is leaning forward too much, the pose seems to be submissive, which can give the wrong idea.

▶ **Body.** When the body is turned slightly towards the camera, the distance between the shoulders seems to be narrower, which creates a slimmer-looking subject. When the model is square to the camera, the subject seems wider and more aggressive.

▶ **Legs.** Standing comfortably is difficult; it might seem easy when you see it in photos, but it does take practice. When you stand up straight, your knees tend to lock out, but when you relax one of your legs, the knees bend slightly. When you put your weight on one foot, the hip on that side pushes out. Have the subject shift weight from one leg to the other and see how it changes the composition.

▶ **Feet.** The feet are the base of the pose and need to be positioned correctly, even if they are not going to be in the image. If you place the back foot at a right angle to the camera and have the front foot face the camera, then the body

naturally turns at a slight angle to camera, making for a slimmer look. If the feet are placed square to the camera, the pose becomes more powerful and aggressive.

▶ **Hands.** Hands have the ability to make or break a portrait. Hands are covered in the problem section later in this chapter.

▶ **Sitting.** When your subject is sitting in a chair, make sure the chair is angled slightly and have your model sit forward on the chair while making sure their posture is still good. Watch out for people slouching, as it is much harder to get away with bad posture when sitting.

▶ **Standing.** Let your model relax between shots. Tell her to take a couple of deep breaths and then return to the pose. This makes it easier to get the shots you need.

Children

Although children can be a challenge, they are fun to photograph and the results are really rewarding (see Figure 9.9). One of the biggest challenges when shooting children is that they don't always follow directions, and they can be difficult to compose in a photograph.

9.9 When photographing Abigail at the beach I made sure that I was at eye level and not looking down at her. Taken at ISO 320, f/8, and 1/250 second.

The single most important thing to remember when shooting children is to be ready for the shot, as you rarely get a second chance. What this means is that you need to be constantly composing the photograph through the viewfinder as the child moves, and you must be ready to press that Shutter Release button the moment you see something that you like. There will not be much time to stop and recompose, so here is what I do:

1. **Get down to the level of the child, as it adds some perspective from their height.** I will even lie on the ground if necessary. This not only lets you see the world from their level, but also makes you more approachable and less scary.

2. **Set the camera for high-speed advance.** Kids move so fast that you want to be able to take multiple photos when you see something you like.

3. **Use a long lens and stay back from the subject so as not to be too intrusive.** I find the 70-200mm lens perfect for this.

4. **Press the Shutter Release button halfway down and lock the focus on the child's face, preferably the eyes.**

5. **Place the child in the frame according to the rule of thirds.**

6. **Patiently wait until you have the expression or look that you want.**

7. **Press the Shutter Release button and take a series of photos.**

Every child is different; some like to sit quietly and read books or play with building blocks, while others run around pretending to be their favorite superhero. Knowing the child and their personality will make it easier to get that great shot. If you are shooting a child in the studio, then the same approach works there; have some toys for them to play with so that they are kept engaged.

Often the best shots of children are the ones with the simplest composition. Keep the background and foreground clear of clutter, fill the frame with the child, and focus on the eyes. Then press that Shutter Release button quickly and often. One thing that kids tend to do is make funny faces when the camera is pointed at them, so you might just have to wait it out.

Groups

Getting one subject to pose comfortably can be a challenge; getting a group to pose comfortably can be a bigger challenge; and getting everyone in the group composed in the same frame can be a huge challenge. Some of the most common group portrait problems include different people looking in different directions, people blinking, and people being hidden behind someone else. You can fix most of these problems by following these simple tips:

▶ **Be in control.** As the photographer shooting a group, you need to have the attention of all the people in the group and keep their attention focused on you. This keeps everybody looking in the right direction when it is time to press that Shutter Release button. Be firm and commanding but make sure you are not overbearing; a group full of scowling faces doesn't make for a great portrait.

▶ **See all the faces.** When building a group, make sure that you can see everyone's face and ask if they can see yours. If you can't and they can't, then somebody will be hidden in the final photo.

▶ **Shoot in burst mode.** Forget just taking one shot; take a series of quick shots, as that can reduce the number of people caught blinking. Usually people blink the first time you press the Shutter Release button; by taking a couple of shots after that happens, you can usually catch everyone with their eyes open.

When it comes to composing groups, there are some little things that can make all the difference. There are two great ways to place people in your image: The first is to stagger the heads so that people in the second row are not directly behind the people in the first row (see Figure 9.10), and if you have a third and forth row you just keep staggering the heads. This is really effective for situations such as class photographs or team portraits.

9.10 During this family portrait session, I had the family take a break and have a seat against the cliff. I took this photograph after some rearranging to make sure the light was reaching all the family members. Taken at ISO 320, f/6.3, and 1/160 second.

Another way to arrange people is to gather them around a center point instead of in a straight line. This works great for bigger family photos and small groups, especially for wedding portraits where you can place the bride and groom in the middle and have the rest of the group gather around them.

Shooting Portraits

Shooting portraits can take place just about anywhere, indoors or outdoors. Even in the best environment, there are always ways to make your images better. For example, you can use a makeup artist and pick the right clothes.

There are also some common problems that can occur when shooting portraits, and those are covered in this section, along with a very brief overview of lights and light-modifying tools (see Figure 9.11).

Indoors

When shooting portraits indoors, especially in a studio, you have total control over the camera settings and the light, making it much easier to produce a great portrait (see Figure 9.12).

It isn't that difficult to build a small home studio, with a portable backdrop and a couple of lights from companies such as Westcott for under $1,000.

9.11 Shooting in the studio under controlled lighting, I was able to compose the image exactly how I wanted it. Taken at ISO 100, f/4.5, and 1/250 second.

When shooting on location indoors and not in a studio, it becomes a little more difficult to control the lighting and the composition. You can always diffuse the light coming in from an open door or window with a diffuser or even a sheet, but you have to pay very close attention to the background. Watch out for reflective surfaces, as they can cause unwanted elements to show up in your images and can also cause the light to bounce into areas where you don't want it.

9.12 Photographed in a studio, this image was taken against a plain white background. Taken at ISO 100, f/7.1, and 1/250 second.

Shooting indoors can make your lens choices difficult, as you might not have the space to use the focal length you want. This is when you either have to pick a different lens or change the location.

Outdoors

Shooting outdoors gives you much more space to work in, but other problems can arise. For example, it is tougher to control the light and the surroundings.

Just because you are shooting outdoors doesn't mean that you have given up control over the lights; you can actually use the available light and produce great portraits (see Figure 9.13).

Photographers consider early evening and early morning to be the *golden hour*, and this light is great for photographing people. Just check out the photo on the first page of this chapter to see an example that uses this light.

The golden hour is discussed in greater detail in Chapter 8.

When working outdoors, pick your focal length carefully because items in the far background will seem much closer when using a longer focal length and items in the foreground will seem much closer when using a wider focal length.

9.13 I needed much more space than what was available in the studio for this photo of Tim. By shooting it outside, I was able to stand farther back and use a longer lens to get the whole scene in the frame. I also used a few small flashes to light Tim. Taken at ISO 200, f/3.2, and 1/3 second.

Makeup and clothes

Makeup and clothing are important parts of a portrait session, and both can make dramatic changes to your images.

If you can afford it, use a makeup artist for your important photos (see Figure 9.14). They understand how to hide blemishes, and a good makeup artist will be able to reduce certain features by accentuating others.

Clothing choices are important, and not just for determining the mood of the portrait. Wearing a suit or a pair of jeans and t-shirt will produce vastly different images. Here are some clothing tips for better portraits:

- ▶ **Vertical lines are better than horizontal lines.** Vertical lines can help to make people seem taller and, hence, thinner, while horizontal lines can have the exact opposite effect, making people seem wider.

▶ **Avoid logos.** Logos can distract the viewer by competing for their attention with the main subject of the portrait, usually the face of the subject.

▶ **Make sure that the tops have sleeves.** Sleeveless tops might look great in real life, but they can have a distracting effect by making the person's arms look heavier than they really are.

Hands, glasses, and other problems

Not every shoot goes well and not every model is a professional. Problems can arise, ranging from where to place the model's hands, and dealing with reflections on glasses, to subjects who might weigh a few pounds extra or who are just not comfortable in front of the camera. Here are some solutions to help you solve these problems.

9.14 Applying makeup between photographs. Shot at 1/200 second at f/8.0 using ISO 200.

▶ **Tense subjects.** When your subject is tense, you will not get a great photograph, so you need to get your subject to relax. Play around a little, have them stretch, breathe deeply, and generally take a few seconds to relax in front of the camera. Just break the tension and have fun; the subject will loosen up if you are calm and relaxed (see Figure 9.15).

▶ **Hand problems.** What to do with your subject's hands can really be a problem. Keep in mind that the side of the hand looks slimmer than the front or the back. Be careful not to have the hands too far forward in the frame as their position can detract from the rest of the image by drawing attention to themselves. When in doubt, leave them out.

▶ **Glasses.** Glasses can cause unwanted reflections in your images. Just move the arm of the glasses a little higher up than the person normally wears them; this causes the reflective surface of the glasses to be angled downward slightly and reflections will not show up in the image. Just don't change the angle too much or it will not look very natural.

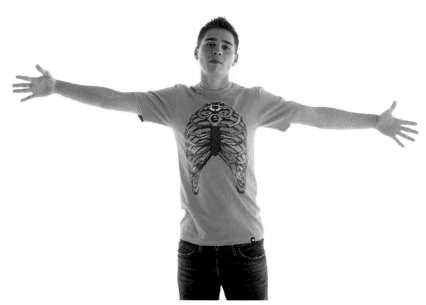

9.15 Shooting a first-time model for a clothing company, I had the model start to play around, and he finally started to relax. Taken at ISO 200, f/10, and 1/250 second.

▶ **Dealing with baldness.** People with thinning hair or who are completely bald can cause unwanted reflections from lights that are overhead or are aimed at the head. Try to diffuse the light that is striking the problem spot or adjust the angle of the light. A professional makeup artist may be able to reduce shininess on the skin.

▶ **Weight issues.** To reduce the double-chin problem, shoot the subject from a higher angle, which deemphasizes the area under the chin. It also helps to light the scene from a higher angle, causing a shadow to fall under the jaw and help hide the double chins.

Portrait lights

A chapter about portraits wouldn't be complete without a discussion of lights. There are two different kinds of lights used today in most portrait photography: studio lights and small flashes. Each can do the job but they have very different strengths and weaknesses.

Studio lights

Studio lights come in two different types: strobes that are triggered by the camera for every shot and continuous lights that are always on.

Studio strobes

Studio strobes fire a short burst of light every time they are triggered. They are very similar to the flash that is attached to your camera, just much bigger and more powerful. You usually need a device that fires the studio strobes when you press the Shutter Release button. This can be a sync cord, which syncs your camera to the flash, or it can be a remote trigger such as a pocket wizard. Using any of these methods limits the shutter speed on your camera to 1/250 second or less, but the very short burst of light will freeze any action.

Continuous lights

As their name implies, these are lights that stay on all the time. Continuous lights are easier to work with because what you see is exactly what you get. You don't need to trigger them in any way.

When it comes to composing your subjects, continuous lights are easier than strobes, as you can see where the light will fall. These lights work well in the studio, but when used outside or on location they need a constant power supply. This means you need access to a power outlet or a battery pack.

Small flashes

These are the small flash units that traditionally are placed in the hot shoe of your camera. Their size, portability, flexibility, and power, as well as the range of accessories available, make them a perfect candidate for portrait lights especially for on location shoots where you don't have the space or power requirement for the big studio lights. The small flashes can also be used off-camera, which adds to their flexibility, and you can also use small flashes in conjunction with bigger studio lights.

There are a lot of resources available for photographers who want to learn to photograph with small flash units. One that I recommend is the Strobist Web site, created and run by David Hobby (http://strobist.blogspot.com).

Light modifiers

Light-shaping tools all change the light in some way, from reducing its intensity to changing its direction, shape, and color (see Figure 9.16). There are two main light modifiers — diffusers and reflectors — and they do exactly what it sounds like they do; diffusers diffuse the light and reflectors reflect the light.

9.16 You can see my assistant (the model's mom) helping by holding a diffuser to reduce the power of the sun. Taken at ISO 100, f/5.6, and 1/160 second.

Diffusers

A *diffuser* is a light modifier that is placed between the subject and the light source, and it can reduce the intensity of the light, create a larger light source, and even change the color of the light. When used to shoot people, a diffuser can create a softer, more flattering light with softer-edged shadows.

When shooting portraits outdoors, a diffuser that is placed between the small, bright sun and your subject can create a larger, softer light source. The tough part is getting the diffuser between the sun and the subject, and this is where a good light stand or an assistant comes in very handy.

> **CAUTION** Be careful that you don't get the diffuser in the scene when composing your photo. Watch the background and especially the top of the frame for the edge of the diffuser as it shades your subject.

You can use any piece of semi-opaque material as a diffuser, from a simple bed sheet to a professionally created diffuser from a camera-lighting equipment company.

Some of the more common diffusers seen in photo studios are *umbrellas* and *soft-boxes*. These are used to modify studio light and smaller flash units. They work in the same way as the larger light diffusers by creating a larger, softer light from a small, bright light.

▶ **Umbrellas.** Umbrellas used in photography look just like the ones that keep the rain off your head in bad weather but they are made specifically for photography. You can use them in two different ways: The first is by shooting the light through the umbrella, which works well if the umbrella is made of a semi-opaque mate-rial. The second way is when the light is reflected from the umbrella back at the subject. This works well when the umbrella has a reflective inner surface.

▶ **Softbox.** A softbox is a special piece of photography equipment that you place over the light source, turning a small studio light into a bigger, softer light source. Softboxes come in a variety of sizes and shapes, from small squares to very large octagons, and are easier to control than umbrellas. Most portraits that are taken in a studio use softboxes at some point.

Reflectors

Reflectors work by reflecting light onto the subject. When it comes to shooting por-traits, reflectors are often used to add a little more light to the side opposite the main light. This could mean a little *fill light* on the left side if the main light is on the right, or even a little *up light* to fill in the face if the main light is overhead. Reflectors come in many sizes and colors:

▶ **Size.** The bigger the reflector, the bigger the light it produces. Using a 9-inch reflector produces a much smaller light than using a 36-inch reflector. Some reflectors can also be bent and angled to change the amount of light produced, but a smaller reflector can never produce as much light as a bigger reflector of the same type and color.

▶ **Color.** Reflectors come in a variety of colors, and the color does change the light. Here are some of the most common colors and what they do:

• **Silver.** Because silver is highly reflective, it reflects the greatest amount of light and doesn't change the color much; if anything, the silver reflective side makes the light seem a little cool (blue) but this works really well when matched to studio lights and does not cause a difference in color.

• **Gold.** Gold surfaces do not reflect as much light as silver, but they are close. What gold reflectors do is add warmth to the light by introducing a golden glow that resembles the light at sunset. This also adds a little warmth to whomever you are shooting and makes the person seem healthier.

- **White.** Plain white surfaces reflect less light than the silver and gold surfaces. This light is softer and less intense than that from both silver and gold and can work in most environments. Because the surface is white, it reflects back whatever color the main light source is, which is especially important if you want to use colored or gel lights when shooting.

- **Mixed surfaces.** Often you will see surfaces that are a mix of silver and gold with white. These surfaces are just diffused versions of the solid color.

Because you can use the reflectors to reflect light back at the subject, you would normally have an assistant hold them, attach them to a light stand, or even lean them up against a nearby surface.

Composition Tips

Portrait photography can be scary when you first start out. Having to photograph people who expect to look good in the final product can be a little daunting. Here are a few tips that will help you with your portrait photography:

- ▶ **Focus on the eyes.** The key to any good portrait is to focus on the eyes, so make sure that the eyes are in focus.

- ▶ **Get them comfortable.** Many people are not comfortable in front of the camera, and it will show in their images. They will have clenched jaws or fake smiles and generally will look uncomfortable. Try to get your subjects to relax and be comfortable around the camera; it will pay off in the resulting images.

- ▶ **Watch your angle.** Try not to stay at one angle when shooting different people, but instead, move around a little to make sure that the angle you are using is best for the subject. When photographing children, try to match their height; it will make the photo more inviting.

- ▶ **Have a plan.** Portrait shoots can go by very quickly, so make sure you have a plan of what you want to do. A great idea is to have it written down in a list form, to ensure that you get all the poses you want.

- ▶ **Pick your lens carefully.** There are a lot of differences between using a wide-angle and telephoto lens. Pick the lens carefully based on whom you are photographing, where you are photographing, and what type of image you want.

- ▶ **Watch the background.** It is very easy to forget about the background when shooting portraits, as your attention is on the main subject. Be careful not to fall into this trap and pay careful attention to the background.

▶ **Be calm.** Things will probably go wrong at some point, but it will be the way you handle it that the subject will remember. Try to remain calm; it will go a long way toward keeping the subject calm.

▶ **Professional makeup works wonders.** If you can have a professional make-up artist on a shoot, it will make a world of difference.

▶ **Clothes make the man or woman.** The choice of clothes can make a big difference in the outcome of the photos. Make sure that you go over the clothing choices with your portrait subjects before the shoot starts.

▶ **Be on the same page.** It is important for you, the photographer, and the model to be working toward the same outcome. Often it is best to meet beforehand, if possible, and go over what each party expects from the shoot.

▶ **Shoot, then shoot again.** In the days of film, photographers used to worry about every frame of film they shot. However, with digital media, the costs are a lot lower, and while it can be overwhelming to have to sort through that many images, it is still better to take more images than less, especially when you are starting out.

▶ **Share the images when shooting.** With digital cameras, it is really easy to give instant feedback to the model about what is and what isn't working and even better, you can show them what is being captured. Many times they don't see what it is you are doing or how the setting and lighting will be flattering to them, so share the images right from the back of the camera with them; it will really help to build a rapport between you and the model.

Sports and Action Photography

Sports and action are all about capturing that defining moment: when the football player catches the ball, or the bat connects with the ball for that home run. To really capture the action and make it stand out, you need to compose the image correctly. It is important to be thinking about your composition all the time because the action moves so fast there is not a lot of time to recompose. Filling the frame with action, using a shallow depth of field, and utilizing leading lines can all lead to better sports and action photographs.

Kids' soccer games are commonly photographed subjects for parents. For this shot, I set the focus on the ball and waited for the kids to come into the frame. Taken at ISO 200, f/2.8, 1/2000 second.

Composition Considerations

When shooting sports and action photographs, you can use a variety of composition guidelines to help you get the best shot possible. Many times, I use the rule of thirds as a basic guide for how I compose my shots, and I rarely ever leave the focus point in the center of my frame but move it off to one side or the other. Filling the frame and using a shallow depth of field are both techniques that also work well because they isolate the main subject.

Fill the frame

One thing that gives your sports or action composition a lot of impact is filling the frame with your subject. Pay attention to the face of the athlete, as that is where the emotion is, and with the emotion comes the impact for the viewer.

To fill the frame, you need two things: a long lens that allows you to get in close to the action and a good angle (see Figure 10.1).

The right lens for the job

Check out the photographers on the sidelines of any professional sports game, and you will see a lot of really big lenses. These long lenses allow those photographers to get in really close to the action and fill the frame with the subject from a long way off (see Figure 10.2).

Using a long lens takes some practice to get right. Because sports and action photography happens pretty fast, the amount of time the subject is in the

10.1 Getting this shot took timing and a zoom lens. I was focused in close on the football player and hit the shutter release the minute I saw movement in the frame. This is how I was able to catch the ball in mid air. Taken at ISO 200, f/5.6, and 1/1000 second.

frame is fleeting to say the least. That means that your timing needs to be spot on to capture the moment.

10.2 I obviously was not allowed to stand in front of the runners as they came down the track, so I needed to use a long lens to fill the frame with the runners. I used a 300mm lens on a cropped sensor camera, giving me an effective focal length of 450mm. Taken at ISO 200, f/6, and 1/320 second.

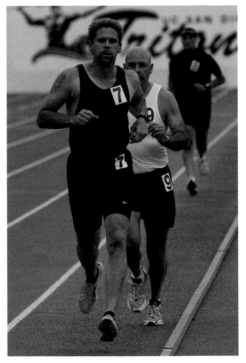

 In Chapter 1, I talk about focal lengths and how the longer the focal length is, the smaller the amount of the scene in front of the camera it records.

Many of the lenses that pro-sports photographers use are telephoto *prime lenses* (lenses that have only a single focal length) that cost a whole lot of money. When it comes to shooting sports on a budget, a good telephoto zoom lens will work just great.

The advantage of these lenses when starting out is that you can slowly shoot from a wider angle to telephoto, as you get more confident in your shooting (see Figure 10.3). It is also possible to crop a wider image so that the subject fills the frame in post-processing.

For more on cropping, see Appendix A.

The right angle/position

Being positioned correctly lets you capture and fill the frame in the way you want to. I try to make sure that the angle gives me a view of the athlete's face. As I mentioned previously, the face is the easiest place to see the athlete's emotion during the activity. If possible, watch for awhile to see how the action unfolds and where the best angle is.

The skateboarders in Figures 10.4 and 10.5 are perfect examples of this. In Figure 10.4, I made sure I was at the bottom of the skate ramp to get the whole flying-through-the-air look, but I was on the wrong side of the ramp. By changing my location and angle, I was able to capture the skateboarder's face in Figure 10.5.

10.3 This young little-league catcher was set to catch the ball as it was thrown toward him. I made sure that there were no other elements in the frame to distract from the player. If you overlay a rule-of-thirds grid, the glove is at one point of intersection while the body follows the left vertical line. This was shot with a 200mm lens on a cropped sensor and then further cropped in postproduction. Taken at ISO 100, f/2.8, and 1/750 second.

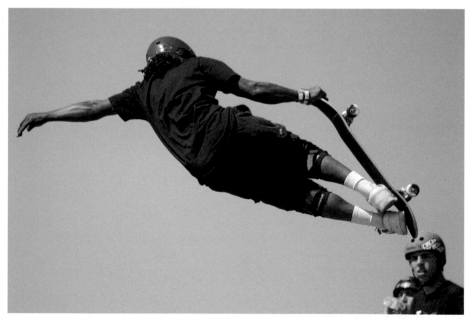

10.4 This image of a skateboarder was taken at the same skate park as the one in Figure 10.5, just minutes apart. Taken at ISO 100, f/2.8, and 1/1250 second.

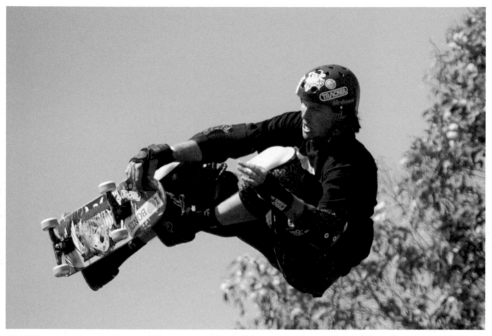

10.5 A quick change in position reveals a better angle than Figure 10.4. Taken at ISO 160, f/6.3, and 1/500 second.

Another consideration when choosing the best angle for your shots is to look at the background and make sure that nothing is going to distract from your main subject (see Figure 10.6).

Nothing turns a great photo mediocre faster than a bad background. Because your subjects are most likely moving (it is action photography, after all), chances are that you will need to imagine your subjects against the background and actually compose the image in your mind's eye before the action takes place.

Shallow depth of field

Look at any sports magazine cover and you'll see great action shots of football players snatching the ball out of the air, or basketball players shooting that three-point shot, and in all cases, the background seems to fade out of focus, making the subject pop right off the page.

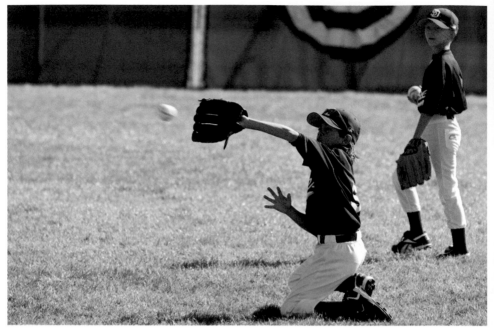

10.6 This was taken at a slight downward angle so that the fence in the background is minimized. The player helped by sliding to his knees as he made the catch. Taken from the stands using a 300mm lens at ISO 100, f/4, and 1/350 second.

Now, while this works great for those pro sports photographers, it can also work really well for kids' sports (see Figure 10.7). Using a shallow depth of field as part of your composition can make the little league game or kids' soccer match look like a big league game.

Although this book is about composition, and talking about depth of field is more about the exposure settings, this is one of those times that it just can't be helped. On the plus side, this is pretty easy to comprehend.

When it comes to shooting sports, you need to use a fast shutter speed to capture the fast-moving action. As you decrease the amount of time the shutter is open (faster shutter speeds), you need to have a larger opening (aperture) in the lens so that the same amount of light reaches the sensor.

As you use larger and larger openings (apertures), the depth of field is reduced. This is what creates that great blurred background.

> **CAUTION** When using a shallow depth of field, make sure your focus is on the proper spot; if not, the subject will be blurry.

To make sure that you are using the widest possible aperture, giving you a shallow depth of field, do the following:

1. **Set your camera to Aperture Priority mode.** This is usually marked with an A on Nikon cameras and an Av on Canon cameras.

2. **Set the f-stop to the smallest number possible.** This depends on the lens attached to your camera and can range greatly from lens to lens.

3. **If the shutter speed is too low, then increase the ISO.** Remember that shooting fast-moving action requires a fast shutter speed, and while using the widest aperture automatically uses the fastest shutter speed, when shooting indoors or in low light, you might need to boost the ISO.

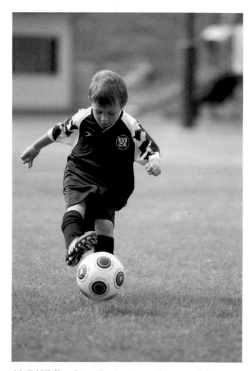

10.7 While shooting my nephew at his soccer practice at a local high school field, I had to deal with some very distracting elements in the background. I used a large aperture to blur the background and make the little soccer star the center of attention. On a side note, if you overlay a rule-of-thirds grid over the image, the intersecting points fall on the kicking foot. Taken at ISO 200, f/2.8, and 1/2000 second.

This compositional concept works best when used in conjunction with one of the other compositional techniques. For example, my soccer ball-kicking nephew in figure 10.7 was not only shot using a shallow depth of field, but he was also placed according to the rule of thirds. Because he was moving from the left to the right, I also took advantage of the *space to move* concept that I discuss shortly.

Leading lines

Leading lines in your sports and action photographs let you guide the viewer's eye to the main part of the action. The idea of leading lines as a compositional tool is usually associated with landscape photography, but it can also be used very effectively when shooting sports and action (see Figure 10.8).

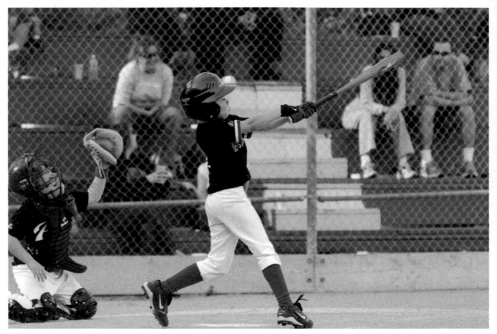

10.8 Notice that the bat, the legs of the batter, and the arm of the catcher all help pull the eye to the batter, the main subject. Taken at ISO 200, f/3, and 1/500 second.

Many times the lines work best if they are on a diagonal and come from the corners of the image. One way to use these lines is to slightly change the orientation of the camera. If you look at the images in this chapter, there are many examples of leading lines. Some are subtle, like the foam in the water in Figure 10.12, while others are really obvious, like the white line that the football is on in figure 10.13.

Pay attention to the details in the scene and use any leading lines you see. These little things can turn a good photograph into a great photograph.

Space to move

One of the key techniques when composing for sports and action is to leave some space in front of the action so that your subject has somewhere to go. This is also true for wildlife and animal photography, which I will discuss in Chapter 13. The general idea is to have the subject in the first two-thirds of the frame, leaving the final third free so that the subject has a place to go, and the story has a way to continue (see Figure 10.9).

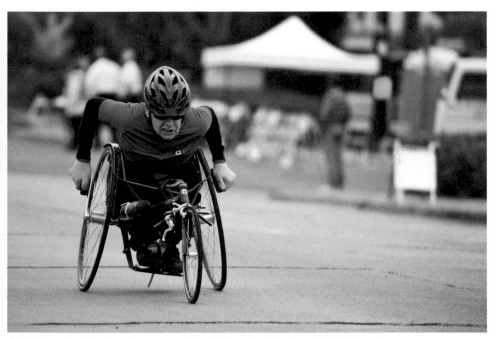

10.9 The wheelchair racer competing during the Rock and Roll Marathon was photographed as he came into the frame, leaving an area in front of the racer and not crowding him. Note the emotion on the racer's face as he pushes himself up the hill. Taken at ISO 400, f/3.2, and 1/500 second.

Pay attention to the way the athletes are moving and plan ahead. In practical terms, this means:

1. **Shoot in landscape orientation.** This gives you more space to work with and lets the action travel from side to side.

2. **Move the focus point off center.** Because the main subject will not be in the middle of the frame but closer to one of the edges, you should move the focus point to one of the sides.

3. **Track the movement through the viewfinder.** By keeping your eye to the viewfinder, you can compose the image through the lens and be sure it comes out the way you see it.

4. **Shoot in burst mode.** If you shoot multiple images as the action crosses in front of your lens, you will be more likely to get the best shot possible.

If you look at Figure 10.9, you can see that the racer was traveling from left to right in the frame. I made sure the focus point was on the left and that there was space remaining to the right of the frame.

Shooting Sports and Action Photographs

There is a thrill to photographing sports and action. This type of photography is fast paced and exciting, and when you get it right, you can produce very striking images. You don't have to be a professional to shoot sports; there are a great many opportunities for this type of photography. Most children play team sports, some all through junior high and high school. It is also possible to shoot some professional sports from the stands.

Shooting sports and action photographs is all about the timing. Every sport has predictable moments and movements, and you need to be waiting for them.

Know the sport

It is very important to understand the sport you are shooting. As with all types of photography, knowledge is power, but when it comes to capturing sports and action, it is imperative. Knowing how the action progresses and more

10.10 Knowing how basketball is played made it relatively easy to capture this shot at the local court. I watched as the player made a break for the net and shot as the ball left his hand. Taken at ISO 125, f/8.5, and 1/320 second.

importantly where the action will take place allows you to capture the sport with confidence (see Figure 10.10).

Certain sports are easier to shoot and follow than others, especially those where you follow a ball. Soccer, basketball, rugby, football, and even baseball all have a set pattern to how the ball moves and how the players react.

Even sports like surfing and boxing have set patterns that can be determined and followed. Some sports, like ice hockey, move so fast that it is difficult to see the puck with the naked eye and almost impossible to follow it when moving at high speed. In these cases, it is imperative that you understand where the puck will end up and understand the ebb and flow of the game so you can be ready to capture the action.

If you try to follow the action, then you will always be slightly behind the action; instead, try to plan ahead and have the action catch up to you. The best way to shoot a new sport is to watch it for a while (see Figure 10.11).

10.11 I watched the motocross performers fly through the air and at the height of the jump, they would do their tricks. From a compositional point of view, I used the lines in the hills and the lines of the performer to draw attention to the trick, and there is space in front of the bike for the performer to travel into so that the shot does not feel cramped. I could have used a shallow aperture, but I didn't feel it necessary because the hills in the background were very far away and don't compete for attention. Taken at ISO 320, f/9, and 1/320 second.

Shooting outdoors

The best time and place to shoot sports is outdoors under direct sunlight or slightly overcast skies. This allows you to use a high shutter speed and low ISO, and not have to worry about having enough light.

The downside is that backgrounds can have a lot of distractions, especially when it comes to shooting at a local sports park. Cars, fences, buildings, and other spectators make it difficult to make the subject of your photos stand out.

Remember that composition is all about what to include in your image and what to keep out. Take the surfer in Figure 10.12: I made sure that I didn't include the other surfers waiting to catch a wave or the family standing on the beach. Neither of those elements would have enhanced the image, so I made sure not to include them.

Not all outdoor sports take place during the day; sometimes, the action takes place in the evening or at night. There are times when the action starts in bright daylight and ends up under the lights.

Shooting sports in low light is one of the toughest types of photography you can try (see Figure 10.13). With the lack of really bright lights, it is best to try to shoot when the action is a little bit slower and you can use a slower shutter speed. This actually makes composing the image easier, as you can take a little more time to set the shot up.

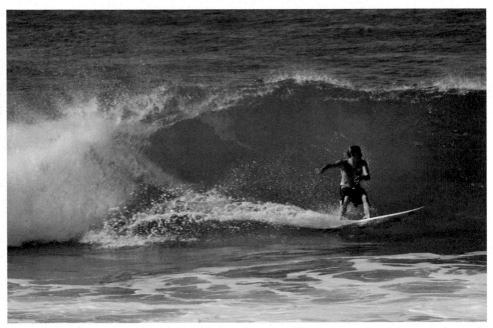

10.12 This surfer is doing a bottom turn on a pretty nice wave on Hawaii's North Shore. There was plenty of sun and because the waves were breaking close to the shore, I didn't even need a very long lens. Taken at ISO 125, f/8.5, and 1/320 second.

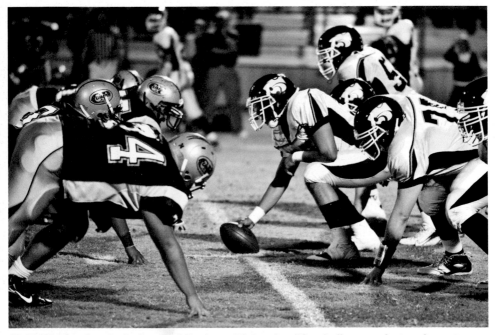

10.13 Waiting for the ball to be hiked at a high-school football game shot under not-so-bright lights. Taken at ISO 2500, f/2.8, and 1/320 second.

Shooting indoors

Shooting sports indoors is much like shooting sports outdoors at night. The lights in most gyms are usually lower than those outside and to make matters worse, unless you are shooting in a professional venue, the backgrounds are usually plain and boring or filled with distracting elements that detract from your image.

Getting in really tight on your subject can help to minimize the distractions from the background (see Figure 10.14). The problem with this is that to do it well, you need a lens that allows you to get in close. Unless you want to spend a lot of money on some very *fast glass* (pro-photographer slang for lenses that have very wide maximum apertures), you will need to actually get as close as possible to the action. If it is impossible to get close enough, there is always the option to crop the image using software in postproduction.

10.14 Getting in close was easy in the small gym. I was able to shoot using a 50mm lens at ISO 400, f/1.8, and 1/60 second.

 You can find more information on cropping in Appendix A.

Composition Tips

Fast moving by nature, sports and action photography can challenge even the best photographers. Don't be discouraged if your images don't come out the way you want the first time. Shooting sports and action takes practice, a lot of practice. These tips will help you get better sports and action shots:

▶ **Fill the frame.** To give sports and action photographs the impact they deserve, fill the frame with the action. Get in as close as you can and use a long focal length; it puts the viewer right in the middle of the action.

▶ **Know your aperture.** Using a wide aperture creates a shallow depth of field. This will make your subject stand out from the background and will give your photos that pro-sports look.

▶ **Focus on the face/capture the emotion.** Shots with emotional impact grab viewers' attention and draw them into the scene. The easiest way to capture emotion is to focus on the faces of the athletes. It is there that you will see the thrill of victory and the agony of defeat.

▶ **Leave space for the action.** While this seems to go against the fill-the-frame concept, at times it is important to leave space on one side of the frame so that the subject has space to move. It makes your composition look less cramped.

▶ **Watch for leading lines.** Many times I look for leading lines in the background or foreground to lead the viewer's eye to the main subject of the photo. When shooting sports, look for lines in the form of the athlete and the lines of the uniform. This is particularly useful when players are reaching and leaping for a ball or another person.

▶ **Shoot vertical.** Some sports and actions look better when shot in portrait orientation, or vertically. A basketball player shooting at a basket or dunking the ball, or a football player leaping for a catch are both examples of this type of shot. Covers of sports magazines offer great examples of sports images shot in portrait orientation.

▶ **Shoot horizontal.** Some sports tend to look better with a wide composition. When the action is moving across your view, as in surfing, use a landscape, or horizontal, orientation to capture the action.

▶ **Use your focus tracking.** One of the best features of the newer digital cameras is their great autofocus capability. Set your camera autofocus to track moving subjects so you don't have to adjust the focus while working on the composition.

▶ **Look for different angles.** It is important to change your angles when shooting sports. One technique to try is kneeling down and shooting the action from field height. This can be very effective, especially when shooting kids. At other times, go into the stands and shoot down at the game.

These different angles can radically change the composition of your shot. Look to see what works for you, but keep in mind that the same perspective all the time can be boring. Have fun and change it up sometimes.

Travel Photography

I, along with everyone, love to go on vacation, travel to new and exciting places, and then share my photographs when I return. Travel photography is one way that you can share your adventures with family and friends.

To take great travel photographs, you need to combine a variety of different types of photography into one. From photographing the local architecture and famous landmarks to capturing the people and customs, good travel photographs can transport you to just about any place on the planet. There are some things to keep in mind when photographing your travels, from keeping the composition simple to using leading lines when photographing the buildings, people, and culture of the places you visit.

The Golden Gate Bridge photographed from the northwest side with the city of San Francisco in the background. I zoomed all the way in to isolate part of the bridge but it is still recognizable as the famous California landmark. Taken at ISO 200, f/9.5, and 1/350 second.

Composition Considerations

Travel photography is a combination of landscape photography, architecture photography, and people photography with some still-life images thrown into the mix. I am not going to rewrite the whole landscape chapter here, so keep in mind that when a travel landscape situation comes up, you can refer to Chapter 8. Following are some of the guidelines to use when shooting your travel images, starting with the basics.

Keep it simple

This is one of the basic composition rules and can be one of the hardest to follow. When I look out at a scene, I usually have one element, the main subject, which stands out to me.

My goal is to compose the scene so that that element that stood out when I took the photograph stands out to the viewer. Because the camera just records everything it sees through the lens, it is up to you to make sure that you only record the things you want to (see Figure 11.1).

11.1 There is no doubt what the subject of this image is, but if you could see the whole area you would have seen doors and windows and a trashcan. I moved around and zoomed in until I was left with just the wall and window box. Taken at ISO 125, f/5.6, and 1/125 second.

There are a few methods for making certain you only capture the desired elements. First, remove as much of the clutter and distracting elements from the scene as possible. It is important to not only look at the main subject but the background as well.

Take a few moments to check the background of your image for unwanted elements. If there are distracting elements, move to get a different angle, or change the focal length or the aperture to minimize the distractions. Taking a few extra seconds before pushing that Shutter Release button can make all the difference in how you evaluate a scene (see Figure 11.2).

11.2 I waited until the pedestrian was where I wanted him to be before I pressed the Shutter Release button. Waiting until the composition speaks to you and not just rushing the image makes all the difference. Taken at ISO 100, f/6.3, and 1/50 second.

Another way to make sure that your main subject stands out is to ensure that it fills the frame. When this happens, there is less space in the background for distracting elements.

Shooting landmarks

Many cities have famous landmarks, from the Golden Gate Bridge in San Francisco to Big Ben in London, and no trip to these cities would be complete without photographing these landmarks.

Of course, everyone shoots the same landmark from the same angle, resulting in the same photos. Look for angles and vantage points that might better reflect your take on the landmark. You need to look for a location that gives you a good view of your subject — not blocked by other buildings — and then wait until the scene is clear of distracting elements.

 The time of day determines where the shadows fall. The side that is in shadows early in the day could be brightly lit by the end of the day. So if you can, come back at different times.

Figures 11.3 and 11.4 are of the same New York City landmark, the Empire State Building, but taken at two very different angles to create two different points of view. Is either one better than the other? I do like one more than the other, but each has its good and bad points, and both were composed in a similar fashion, using the rule of thirds.

If you look at where the building is placed in the frame you will see that the location is the same.

Figure 11.3 was shot from the top of Rockefeller Center while Figure 11.4 was shot from street level with the Empire State Building framed by other buildings.

11.3 The Empire State Building as seen from the top of the Rockefeller Center. Taken at ISO 100, f/8, and 1/320 second.

11.4 The Empire State Building from the ground, the view seen by thousands of people every day as they walk past. Taken at ISO 100, f/8, and 1/200 second.

Leading lines

Leading lines are objects in your photograph that help lead the viewer's eye into your image. These can be anything and range from the obvious to the subtle. They tend to work best when coming in from one or all of the corners.

The viewer looks along the lines into the image. So when you are out photographing on your travels, look for lines that lead to the subject (see Figure 11.5).

11.5 Walking across the Brooklyn Bridge, I couldn't help but notice the pattern of the support cables holding the bridge up. The leading lines made for a great composition, showing how they can draw your eye into the image. Taken at ISO 100, f/6.3, and 1/320 second.

151

There are times when the lines are really obvious, as with those created by the cables on the Brooklyn Bridge. There are at least thirteen different lines leading to the center of Figure 11.5.

Here, the lines actually become part of the subject of the image. I made sure that I was in the center of the bridge so that the lines all started at equal points in the frame and all met at the same point in the middle. I did place the big support cables at the top third of the image, creating a nice balance in the image. There is that rule of thirds again; it seems to show up just about everywhere.

When composing the photograph in Figure 11.6, I lined up the grass walkway with the bottom edges of the frame.

11.6 Shot in Dublin, Ireland, the White House is framed by trees, and the grass entrance way creates natural lines leading to the building. Taken at ISO 200, f/8, and 1/250 second.

This allowed me to use the lines to direct the viewer's attention to the building. This works really well with all parallel lines as they go off into the distance; roads, train tracks, and other parallel lines can all be used to give this effect.

Pick the right focal length

When it comes to photographing your travels, it would be nice to have a huge range of focal lengths available for every situation, but the truth is that unless you are on assignment from a travel magazine or Web site, it is unlikely that you will want to carry around a huge camera bag while on vacation. I know that when I travel, I would like to have all my cameras and lenses with me, but then it isn't a vacation.

Fortunately, the technological advances that lens manufacturers have made in the quality of their zoom lenses can really help with this dilemma.

One of the most useful lenses available for travel is the 18-200mm, which is available for just about every dSLR on the market. These lenses are lightweight and compact and can cover a wide range of focal lengths without you having to change lenses. They allow you to go from a relatively wide angle to a telephoto with a quick turn of the lens (see Figure 11.7).

When it comes to picking the right focal length, there is no right answer; it all depends on the situation. The advantage to using a zoom lens is that you can experiment with different focal lengths quickly.

Shoot wide to get the whole scene, and then start to zoom in to pick out the details that are important to telling the story of your travels (see Figure 11.8).

11.7 The Golden Gate Bridge spans from the city of San Francisco to Marin. I shot this using a wide-angle lens to get the whole bridge in the shot. Including the grass gives the image a feeling of depth. Taken at ISO 200, f/5.6, and 1/200 second.

11.8 The details above the side door to Westminster Abbey were captured by zooming all the way in over the heads of the people who were visiting the London landmark. I used the 200mm focal length on my 18-200mm lens to isolate the subject, as I was not allowed any closer that day. Taken at ISO 125, f/9, and 1/30 second.

Frame your images

One very simple yet powerful compositional guideline is to look for items that frame other items in your images. This can be a window, a doorway, or an arch, but it usually needs to be in the foreground and needs to frame the subject of your photograph (see Figure 11.9). These types of shots are best when photographed using a wide-angle lens. The wide-angle focal lengths cause the distance between the foreground and background to seem greater. Having something in the foreground of the shot helps to create a sense of depth in the image.

For more on focal lengths, see Chapter 1.

When shooting through frames, you usually want to make sure that the frame and the subject are both in acceptable focus; otherwise, the frame just looks like a blur around the subject. To do this, you need to use a deep depth of field, and while this is easily done on all lenses, it can cause problems because it lets in comparatively less light.

11.9 This archway over a street in Ireland helps to frame the street behind it. Taken at ISO 125, f/6.3, and 1/180 second.

To compensate for the lesser amount of light, use a slower shutter speed or increase the ISO, or both, until you get a good exposure and both the foreground and background are in focus (see Figure 11.10).

When using the slower shutter speed, make sure that you keep your camera steady and use a tripod or monopod if necessary. If you don't have a tripod or monopod with you — and many times I don't when traveling on vacation — look for any solid surface that you can rest your camera on to keep it steady. I have found the roof of a car to be really useful in these situations.

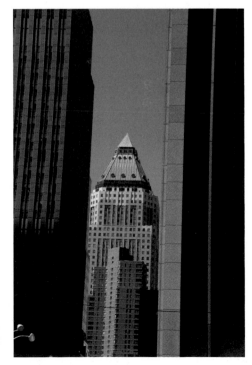

11.10 I used the buildings in the foreground to frame those in the background while walking around New York City. Taken at ISO 100, f/8, and 1/250 second.

Shooting Travel Photographs

I've talked about how to compose strong travel images but not much about what to shoot. Every trip is different and not all that is written here will apply to every trip, but there are some things that you can count on in just about every travel situation, such as buildings and people.

Photograph the buildings

Nothing says travel quite like the unique architectural styles of various cultures and even generations.

The buildings don't have to be vastly different from what you're used to, like the adobe buildings of the Pueblo Indians of the southwest United States or the castles that dot the European landscape; it could just be the proliferation of sky-scrapers, like in New York City (see Figure 11.11).

When it comes to photographing build-ings, there are some things to watch out for:

▶ **Keystoning.** Try not to aim up at a building because that can cause an optical distortion called *keystoning*, or converging verti-cals where the building seems to lean backwards.

There are two simple ways to fix this: You can move farther away from the building and by doing so change the angle that you are using to photograph the build-ing; or you can fix the problem in postproduction by using lens-correction software, like the lens correction tools available in Photoshop CS5 and Lightroom 3, for example.

11.11 As the building rises above me, it seems to lean back and away. You can make this work for you if you frame the image properly. Everything in this image leads the eye up the building and towards the brightly lit top floors. Taken at ISO 100, f/8, and 1/125 second.

While it is always better to try to fix the problem in the camera, sometimes it just isn't possible to move back far enough.

▶ **Reflections.** Most modern buildings are made from highly reflective materials like steel and glass. These buildings reflect whatever is around them, from the clouds above to the cars below. Pay attention to the details in the windows and on other reflective surfaces when composing your photograph so that the reflections work for you and not against you.

▶ **Permission.** The world is not as open and trusting as it once was, and there are lots of rules in place about what you can and cannot photograph. These rules change from time to time and the best way to find out if photography is allowed is to ask.

Many government buildings and airports, for example, cannot be photographed unless with special permission. Check the laws that are applicable in your destination country. Things are not the same everywhere and it is always better to be safe than sorry. A quick Internet search can really help.

Photograph the people

May of us grew up reading *National Geographic* magazines and studying the images of people from distant lands. Taking photos of people while on your travels is a key ingredient to a complete travel photography portfolio. I cover people portraits in Chapter 9, so in this section I cover some of the situations that are unique to photographing people on your travels.

Asking strangers

One of the hardest things for me to do is to ask a stranger for permission to take their photograph. From what friends and colleagues have told me, this is not limited to just me; most people have a tough time doing this.

Here are some things that might help you when asking for permission to take photographs of people you don't know:

▶ **Have a business card.** Be prepared to share who you are; there is no better way than to have a card stating who you are with your contact information on it. Offer to send them a copy of the image and give them a way to contact you.

▶ **Explain who you are.** You might be a plumber or an office worker or an executive, but in this case you are a photographer taking travel photos. Let the people know who you are; it makes a good connection and makes it easier to have them say yes.

▶ **Explain why you want to photograph them.** You might be on assignment for a magazine, but chances are you are just on vacation. Let your subject know this; they will be more likely to allow you to shoot if they understand why you want the photos.

▶ **Be polite.** This should go without saying at all times. Being polite always gets better results than the alternative.

▶ **Walk away.** Never push or force anyone to do anything. If the person says no and doesn't want their photo taken, then just walk away. There will be another opportunity just around the corner.

TIP If you plan on using the images for commercial use, you will have to get a model release for any people that are recognizable in your images. If the images are for editorial usage, then usually a model release is not required.

To tip or not to tip

I have been asked for a dollar in more languages than I can remember. Many times, it is because they see the camera and assume that you can and will pay for their image. I will pay to take someone's photo, usually a dollar or two, only if they ask and I wanted to take their photo in the first place.

Now I am not suggesting that you pay everyone who asks for money to have his or her photo taken. It is a personal decision that you will need to make, and that is dependent on where you are shooting, whom you are shooting, and what the local customs are.

Keep in mind that your camera gear is probably worth more than some people make in a year or two. I carry some loose single bills in a separate pocket for situations like this and will not pull out a large wallet or wad of cash; I do not want to start a tipping frenzy or be followed around by a group of people with their hands out. One solution is to look for photo opportunities at local markets and places of business. This allows you to "tip" by purchasing something from them and then asking if you can take a photo.

One place where you can take photos without having to tip or even ask permission is at shows, dinners, or cultural events where photography is allowed. Because you are

paying to view the event and photography is allowed, it is a great time to get those photos without having to worry about tipping. There might even be a photo opportunity set up for you.

 Keep in mind that in some places in the world, offering money will just insult the people that you are trying to get closer to.

Posed or candid

I really like candid shots but they are more difficult to get great compositions with. It is easier when you can position your subjects and take your time, knowing that they are not going to suddenly move. With that being said, it is easier to shoot candids because you don't have to approach the subjects and interact with them.

When shooting candids, remember the following:

▶ **Use a long lens.** A long lens lets you get in close without being a part of the scene. This can be very useful when shooting candids and you want to be an observer, not a participant.

▶ **Use a wide angle.** There are times when you want to be part of the scene, and that will take getting in close with a wide angle lens.

▶ **Be discreet.** If you want to capture a candid, it helps when the subject doesn't know that you are interested in the shot (see Figure 11.12). Try not to be too obvious about your actions.

▶ **Focus on the eyes.** As with all people, photographs focus on the eyes of the subject even if the subject is part of a candid photograph.

11.12 The bagpiper was warming up before taking to the streets in a parade. Taken at ISO 200, f/8, and 1/40 second.

▶ **Ask Permission afterwards.** After taking a candid shot I will then ask permission to use the photograph if it is possible. I am prepared to show them the image on the camera, and I will delete it if they want it gone.

When shooting posed shots, keep the following in mind:

▶ **Don't be afraid to ask.** They might say no, they might want a tip, but they will never say yes if you never ask.

▶ **Look at the background.** If you are going to take the time to set up a shot and get a local to pose for you, do a quick check of the background. No point in wasting all that energy to have something distracting in the background.

▶ **Add a little fill flash.** When shooting portraits, remember that a fill flash can really add something to your images by opening up the shadows on their face.

▶ **Focus on the eyes.** I know this is a tip that you see in the candid section above, but it is true here and with all photos of people, so remember: Focus on the eyes.

Photograph the action

Nothing can give your travel photos a pop quite like capturing some great action photographs. When you want to capture the action, you need to watch the shutter speed and make sure that you use the best one for the situation. You need to use a shutter speed fast enough to freeze the action, which usually means 1/250 second or higher, sometimes much higher.

The faster the activity, the faster the shutter speed needs to be. The downside to this is that if the shutter speed is set really high, then you need a lot of light or a very wide aperture to get a good exposure.

Use a longer lens to really get close to the action — not only people action but also animal and wildlife action. Longer focal lengths, like 200mm, can help isolate the action and because these lenses compress the information, they can also lead to better backgrounds in your images.

Speaking of backgrounds, there are times when the movement in your images will be in the background and the objects in the foreground will be still. These are great times to use a slower shutter speed and let the objects that are moving blur to show the movement (see Figure 11.13). When you use a slower shutter speed, make sure that the camera is held very steady or is on a tripod so that there is no camera movement.

 For more on sports and action photography, see Chapter 10.

Composition Tips

There is a lot to take care of when on vacation: making sure you have the right reservations, the right money, and all the necessary travel documents. The following tips will make it easier to get the shots you want while traveling.

▶ **Keep it simple.** Make sure that the elements in your scene are those that you want to be there. Keep the clutter in the frame to a minimum and your main subject will stand out. Take a second when composing to pause and check the background.

▶ **Practice at home.** I tend to think of vacation destinations as other places, far-away lands with

11.13 Capturing the fire dancer meant using a shutter speed fast enough to freeze the dancer, but slow enough for the fire to leave a trail. Taken at ISO 400, f/4, and 1/15 second.

exotic people, but there are people out there who think that it would be great to come and visit your hometown. So look around where you live and try to think like a tourist. It doesn't cost anything to practice and you get to try out different shots as many times as you like.

▶ **Plan ahead.** It is often best to shoot early in the morning or late in the afternoon because that is when the light is usually best. By planning out your itinerary with this in mind, you can maximize your time and shoot as much as possible in the best light possible.

▶ **Do the research.** Use the Internet and travel books to see what is happening where you are traveling. There are hundreds if not thousands of local events happening all the time, and one just might be where you are going. Better to know about it beforehand than to be surprised to find out about it a little too late.

▶ **Be a tourist.** There are many different types of tours available for just about everyone. There are even tours specifically designed for photographers. These are a great idea, especially in a place where the language might be different or where you have never been before. Even for those places that you think you know really well, a guided tour can show you things that you didn't know existed.

▶ **Ask the locals.** There are times when asking the locals where and when to photograph will really pay off. A friend and fellow photographer was in Agra, India, and wanted to shoot the Taj Mahal. There were already groups of photographers setting up by the front entrance so she asked a local gardener for the best place to shoot. She was shown a unique angle where she was able to shoot all by herself and get the shots she wanted. If she hadn't asked a local, then it wouldn't have happened.

▶ **Take another photograph.** There is a good chance that you won't be on vacation in the same spot at the same time ever again. Take as many shots as you can and then take a few more. Digital memory cards are getting bigger and bigger and the prices keep dropping, giving you an amazing amount of storage in a very small space. Don't worry about editing out the bad ones when shooting; wait till later when you have some time.

▶ **Check out the postcard racks.** When I travel to different cities, I look at the postcard racks to get inspiration. These are the shots that show the location in the best light and can give me ideas of where and what to shoot. The nice part about postcard racks is that they are everywhere that tourists go so they are easily found.

▶ **Protect yourself and your gear.** Traveling to strange places can mean that you are out of your comfort zone. Photographers make easy targets, especially when traveling in a foreign place. Use common sense and pay attention to your surroundings. Ask at your hotel about places to avoid and places that are safe.

Wedding Photography

As a photographer, you will at some point likely be asked to photograph a wedding. Do not take this request lightly; the wedding images are very important to the bride and groom. Photographing a wedding is a combination of portrait photography, event photography, and good planning. Things tend to move along at a pretty fast pace and there is only one chance to capture those special moments. When shooting a wedding, you can take advantage of a variety of different compositional rules, from using different focal lengths to using the rule of thirds.

I loved the balanced composition created by the white dress on one side and the dark tuxedo on the other. I used a long focal length and still had to slightly crop the image in postproduction. Taken at ISO 100, f/2.8, and 1/250 second.

Composition Considerations

The best thing about photographing weddings is that they offer you many opportunities to shoot a wide variety of photos. The worst thing about photographing weddings is that they offer you many opportunities to shoot a wide variety of photos. To be successful when shooting weddings, you need to pay attention to a variety of composition considerations, from using different focal lengths to using leading lines.

Using the rule of thirds

I have talked about the rule of thirds a lot in this book, simply because it is one of the best ways to create a good composition or at least is a good starting point for creating a great composition. Following this rule when shooting weddings can produce great images, especially when it comes to portraits.

> **TIP** The rule of thirds: Divide the scene into one-third sections both horizontally and vertically with imaginary lines, and then place the important part of the image at one of the four points at which the lines intersect.

At times it is easy to see how the rule of thirds comes into play; at other times it is a little more subtle. If you look at Figures 12.1 and 12.2, you can see how the rule-of-thirds composition comes into play.

In Figure 12.1, you see the wedding couple has been placed on the left vertical line with their heads at the top intersecting point. It is really easy to see how the rule of thirds is used in this image.

In Figure 12.2, the couple is placed in the center of the frame but the composition really works with the wedding party placed on the bottom line. This placement creates a nicely balanced image.

© Kenny Kim

12.1 The couple was posed one-third of the way into the frame, utilizing the rule of thirds perfectly. Taken at ISO 1600, f/4.5, and 1/50 second.

© Kenny Kim

12.2 The wedding party was placed one-third up from the bottom of the frame, leaving enough space above them for the inclusion of the hanging lights, creating a strong, balanced composition. Taken at ISO 1600, f/3.5, and 1/80 second.

12.3 Nicole and Glenn share a first kiss as husband and wife. Putting them anywhere but in the center of the image would have diminished the composition of the shot. Taken at ISO 800, f/4, and 1/320 second.

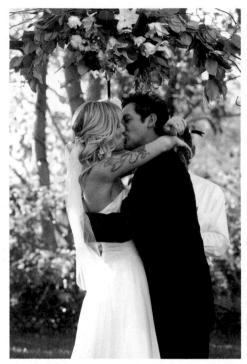

Centering the subjects

I like to center the bride and groom in the middle of the frame, especially during the ceremony (see Figures 12.3 and 12.4).

I know this seems to contradict the rule of thirds, but you have to remember that not all rules work all the time. You can use whatever you think works at the time.

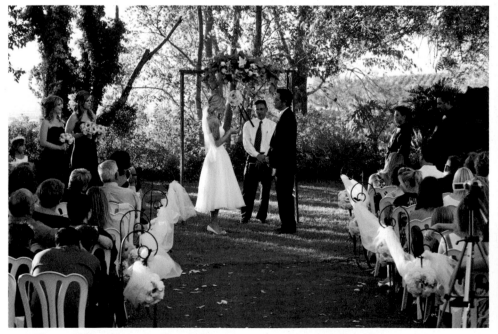

12.4 The wedding ceremony is a perfect time to place the main subjects in the center of the frame, as I did here with Nicole and Glenn. Taken at ISO 800, f/5, and 1/320 second.

For example, the center composition of Figure 12.3 helped to hide the wedding offici-ant who ended up behind the bride and groom and not next to them. This keeps the couple as the center of attention.

There is a natural spot at the end of the aisle where you can shoot from, which will give you a nicely balanced, centered composition. This works with all focal lengths and is a good spot to use for many parts of the wedding ceremony, including the vows and the first kiss, as well as catching the newlyweds as they walk up the aisle together for the first time as husband and wife.

Using leading lines

Leading lines in your composition lead the viewer's eye from the corners of the image towards the main subject. These can be lines created from other elements as in Figure 12.5, or real lines as in Figure 12.6.

© Kenny Kim

12.5 The lines created by the pews leading up the center aisle and the lines created where the ceiling meets the walls all draw the eye towards the center of the frame and to the couple getting married. Taken at ISO 1000, f/4, and 1/60 second.

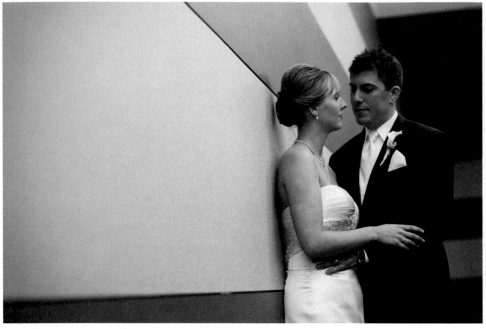

© Kenny Kim

12.6 This image uses the lines present on the wall to draw the eye from the corners into the frame and to the couple. It also uses the rule of thirds to place the couple one-third of the way in from the right. Just because you use one composition rule doesn't mean it can't be combined with others. Taken at ISO 1000, f/2, and 1/125 second.

During the wedding ceremony, look for lines that already lead the eye toward the subject and use them in your composition, but when it comes to the portraits or images that you can set up, look for the lines and then place the subjects in the right spot.

For example, in Figure 12.6 it would have been possible to place the couple at any point along the wall, but that would not have taken full advantage of the built-in leading lines. Look to the right of the couple and you will actually see another set of lines created by the wall behind them leading in from the right side.

Add to that the line leading down from the ceiling above the groom, and you have no choice but to look at the couple no matter where your eyes started out.

Using different focal lengths

One of the easiest ways to change your composition is to use different focal lengths. Using a good zoom lens that covers a wide range of focal lengths will let you recompose the same scene very quickly and can allow you to go from a wide-angle view to

a close-up view in less than a second. Lenses like the 24-70mm f/2.8 and the 70-200mm f/2.8 are staples of the professional wedding photographer.

Because the wedding ceremony moves very quickly, it is not always possible to move around to get the best angles. Figures 12.7 and 12.8 were both taken from roughly the same spot, but by switching from a wide-angle to a telephoto lens I was able to capture two distinct views of the same scene.

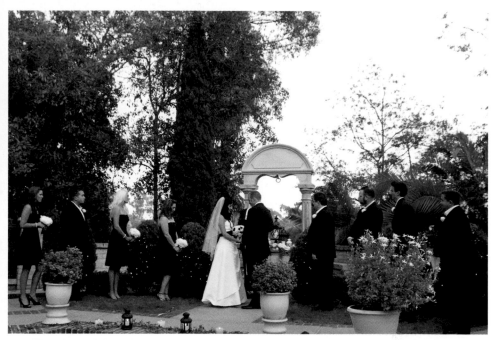

12.7 The view of the whole wedding party. Taken at 25mm focal length at ISO 250, f/4, and 1/60 second.

Many professional wedding photographers carry two cameras — one with a telephoto lens (70-200mm) and one with a wide-angle lens (24-70mm) — because it is easier to change cameras than it is to change lenses. This allows you to recompose the image by just picking up the other camera and going from a wide shot to a close-up in seconds.

Both Figures 12.7 and 12.8 still use the rule of thirds in their composition. Notice how the wedding party is placed roughly one-third into the frame from the bottom in Figure 12.7, and the bride's face is one-third down from the top and one-third in from the left side in Figure 12.8.

Keep in mind that one of the big differences in using different focal lengths is how your subjects are perceived compared to their surroundings.

When using a wide angle, the objects in the foreground appear larger and even more distant from the background, creating a feeling that they are larger than life.

 See Chapter 1 for some examples of using different focal lengths.

Shooting Weddings

Shooting weddings is tough work. Don't let anyone tell you different. On the positive side, it is easy to plan a course of action, a plan of attack if you will.

12.8 A close-up of the bride as the couple takes their vows during the wedding ceremony. Taken using a focal length of 300mm at ISO 400, f/2.8, and 1/80 second.

Weddings move really quickly, but they move in a very specific way, and because you know when things are going to happen, you can plan ahead.

The bride

There is very little that happens at a wedding that the bride is not a part of. The relationship between wedding photographer and bride is a very special one. The bride trusts you to capture and preserve the memories of her very special day (see Figure 12.9).

She needs to trust and believe that you are going to get her the images that she wants. You need to be part friend, part spectator, and part director, and you need to understand what it is that she wants.

The relationship with the bride starts at the very first meeting and grows quickly through the engagement shoot and any other pre-wedding meetings.

When it comes to the day of the wedding, she needs to think of you as her friend, as you will most likely be spending more time with her on the wedding day than any other single person. Keep in mind that nothing at the wedding happens without the bride.

Getting ready

No wedding album is complete without images of the bride and groom getting ready for the big day. Many of these photos will take place in the bride or groom's dressing room (see Figure 12.10).

These areas are usually not the best places for photos, but that can be helped if you do the following:

12.9 The bride photographed using the mirror on the wall while she was getting ready for the big day. Taken at ISO 200, f/5, and 1/30 second with an off-camera flash used to add fill light.

▶ **Clean up the room.** It is important to remove everything that will distract from your images. This can include all that extra furniture, from the ugly chairs to those horrible photos on the wall. It can also include all the boxes, bags, and clutter that the bride or groom has brought with them.

Pay close attention to the background and remember that if the item in the composition isn't helping your image, then it is hurting it. Take a quick photo of the room before you move all the stuff out of the way; it will help you to get everything back in the proper place when you are done.

▶ **Pick the right lens.** I like to use a wide-angle lens in these situations, as it helps me capture the whole scene and especially the activity around the bride.

The downside of the wide-angle lens is that subjects too close to the edge can seem to be distorted, especially if you use a fish-eye lens. It is also possible to get in close without being in the way by using a longer lens like the 70-200mm.

▶ **Watch the background.** There are times when you just can't move all the items that are distracting. When this happens, it is important to change your angle and try to minimize the items in the background.

It is also a good idea to shoot using the widest aperture you can, as this will blur the background or use a flash to light the foreground and let the background be dark and out of focus

▶ **Use any mirrors.** I know it might be cliché but a standard shot of the bride shows her reflected back in a mirror. The same rules

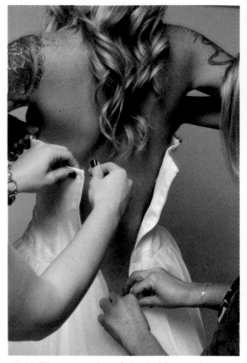

12.10 Photographs of the bride getting ready wouldn't really be complete without an image of her getting helped into her dress. Taken at ISO 200, f/5, and 1/30 second with an off-camera flash used as fill lighting.

of composition apply and it is especially important to watch the background, as you might end up in the photo.

Wedding portraits

There are two opportunities during the wedding that are made for taking portraits: the time before the ceremony and the time right after the ceremony. Traditionally the groom doesn't see the bride till the beginning of the ceremony, and that means that taking portraits of the bride and groom together is done after the ceremony and before the reception. This does not offer you a lot of time to take some of the most important photographs.

There is a new trend in wedding photography where the portraits are done before the ceremony, and instead of the first-look shoot happening while the bride is walking down the aisle, it is set up by the photographer (see Figure 12.11).

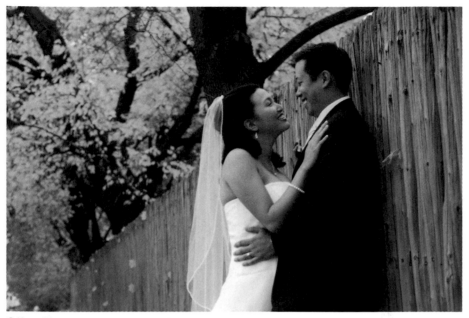

© Kenny Kim

12.11 With more time on his hands, photographer Kenny Kim was able to shoot this portrait of the bride and groom before the wedding in a location near to the ceremony. This allowed him to set up the shot exactly the way he wanted it. Taken at ISO 400, f/5.6, and 1/250 second.

The main advantage to having the portraits done before the ceremony is that you have more time.

This allows for different setups and locations (see Figure 12.12) and will take some of the pressure off the photographer and the couple, and because it is right after the couple has prepared, everyone looks great. The makeup is perfect and not a hair is out of place.

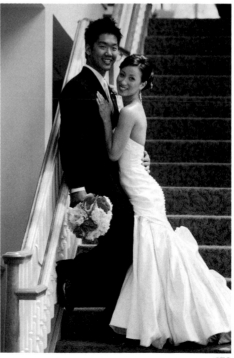

© Kenny Kim

12.12 A casual portrait photograph of the bride and groom before the wedding ceremony. The extra time allowed for a little more experimentation and different locations. Taken at ISO 800, f/4.5, and 1/350 second.

If the couple would still rather have their photos done after the ceremony, offer a gentle reminder that it will mean time away from their guests and from celebrating.

When shooting the portraits, you have now switched roles from event photographer to portrait photographer, and all the points covered in Chapter 9 now apply.

Group shots

Weddings are not just about the bride and groom but also about their family and friends. This means that the photographs taken are not just of the bride and groom but can involve a lot of people, from the entire bridal party to all of the extended family that made the trip for the wedding. Here are a few tips to make taking those photos a little easier.

▶ **Start big.** The easiest way to shoot a series of group shots is to start with the biggest group first, and then as people are not needed, they can leave until you are left with the bride and groom. By putting the bride and groom in the middle, you can build the group around them.

▶ **Less is more.** One of the dirty little secrets about photographing weddings is that you don't need that many group shots. If you can get the whole family in one photo, ask the couple if separate shots of the bride and groom with each cousin are still necessary.

▶ **Get a list.** Make sure that you know whom the bride and groom want in the group photos. This can be a touchy subject and it is easier to just take a photograph even if you know it will never be purchased or used, just so that there are no hard feelings. The bride and groom should have a list of the groupings that they want, and you need to go over the list before the shooting starts. It is up to you as the photographer to explain that the number of different groupings directly impacts how long the photos will take.

▶ **Get up high.** Shooting down at a group is much easier and will create a better photo (see Figure 12.13). The subjects tend to raise their chins a little when looking up, and there's a better chance of evenly lighting all the faces. Make sure that each person can see you and the camera. If they can't see the camera, then the camera can't see them.

These group shots can be taken anytime: before the ceremony, after the ceremony, or during the reception. Make sure that the bride and groom know when you are planning on doing these shots so that the people involved can be told and will be there. Nothing wastes time like trying to hunt down that one cousin that didn't know when the photos were going to be taken.

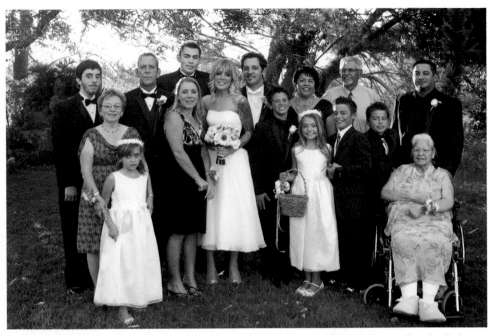

12.13 Gathering the family around the bride and groom and then using a simple chair to get some height allowed me to capture everyone with nice, even lighting in a pleasing group shot. Taken at ISO 100, f/4, and 1/45 second with an external flash to add fill light.

Ceremony

The wedding ceremony can go by quickly, especially for the photographer trying to capture the whole event. The ceremony can be the most difficult time for a photographer because you are expected to capture the whole event and at the same time be unobtrusive. If the ceremony is taking place in a dimly lit church, you are usually not allowed to use a flash and there are no second chances to get any of the shots.

Here are a few tips on how to get the best shots even in low light:

▶ **Use the widest aperture.** One of the easiest ways to get the most light to reach the camera's sensor is to use the widest aperture available on your lens. If your lens can open up to f/5.6 then use f/5.6, but to really be able to shoot successfully in low light you will need to invest in some *fast glass* — that is, a lens with a maximum aperture of f/2.8 or wider. These lenses allow you to work in low-light conditions and not have to drop the shutter speed or increase the ISO too much.

▶ **Increase the ISO.** One of the biggest advances in digital photography has been the ability to use high ISOs with relatively low noise (see Figure 12.14).

It is important to know how high you can push the ISO on your camera and still get a good, low-noise image. The more you can push the ISO, the less light you need to make a good exposure and capture the scene.

▶ **Select the best shutter speed.** There are moments in the ceremony when things don't move very quickly and you can get away with using a slower shutter speed and still get a sharp image. You need to watch for these moments and practice changing the shutter speed up and down.

▶ **Practice handholding the camera or bring a tripod.** When using the slower shutter speeds, it is important that you don't have any camera movement, as that will cause the images to blur.

© Kenny Kim

12.14 A view from the back of the church captured the majesty of the church and the wedding. Taken at ISO 1600, f/4, and 1/80 second to make sure enough light reached the sensor to make a proper exposure.

Practice handholding the camera or bring a tripod for those slower shutter-speed moments. When handholding the camera, make sure that your hands are under the lens supporting it and not on top pushing down. I also make sure that I turn my body slightly to one side and lock the arm that is supporting the lens against my body giving the camera as much support as possible.

An outdoor wedding ceremony, surrounded by nature and brightly lit by the sun, can present a whole different challenge. One part of the scene is brightly lit and another is in deep shadows. Digital cameras have a real problem exposing for this, either underexposing the dark parts or overexposing the bright parts. The best solution is to move and try to recompose the image in a way that the light hits the scene more evenly.

Plan ahead for each of the special moments in the ceremony and picture in your mind how you want the image to look. The following is a guide I use for the main wedding moments; it keeps me on track during the ceremony.

▶ **Processional.** Every wedding ceremony starts with the processional, where the wedding party walks down the aisle. I like to position myself so that I can capture them as they come towards the altar. The most important shot of the processional is that of the bride making her entrance (see Figure 12.15).

Work on getting her reaction to her groom and the guests at the wedding. If you are working with another photographer, make sure that one of you is focused on the groom, to get his reaction as he sees his bride for the first time.

▶ **Special readings.** Many wedding ceremonies have special readings, blessings, prayers, or sometimes songs. Knowing when and where these are happening will let you get into position beforehand so that you can capture the

12.15 The bride being escorted down the aisle at the beginning of the wedding ceremony, photographed from behind the altar using a long lens. Taken at ISO 800, f/4, and 1/320 second.

moment and not be left scrambling. If the wedding has a wedding program, make sure you grab a copy; it will have all the important moments listed.

▶ **Vows.** The vows are what the ceremony is all about. This is the most important part of the wedding and needs to be considered carefully. Try to capture both the bride and groom with a telephoto lens; this allows you to get in close and capture their emotion. Know when the vows are taken during the ceremony so that you have the right lens already mounted.

▶ **Ring exchange.** I like to focus on the hands as the rings are slipped on to their fingers. I compose these images by filling the frame with the hands, and sometimes this means moving in closer and still using a long lens.

► **Special moments.** Many weddings have those special moments, like the breaking of the glass in Jewish weddings (see Figure 12.16) or the lighting of a unity candle. Ask the couple if their wedding will have any of these symbolic moments; if it does, you will want to capture them.

► **First kiss.** Right before the couple walk down the aisle as husband and wife for the first time, there is the first kiss. This can be from very tame to completely wild; it all depends on the couple.

If you are in position at the end of the aisle you will not only be able to capture the kiss, but also the bride and groom walking together up the aisle as newlyweds.

12.16 Many Jewish weddings end with the groom smashing a glass under foot. Knowing this was about to happen, I positioned myself in such a way as to show the foot and the glass underneath it. Taken at ISO 125, f/6, and 1/160 second.

Reception

The reception is when the bride and groom finally get to relax and have some fun; for the wedding photographer, there is still a lot to do and some of the most important shots of the whole day are still to come. Some of the important moments in the reception are:

► **Dances.** This can be the first dance, the father-and-daughter dance, or the mother-and-son dance. The most important part of capturing any dance is in the timing. Wait for the moments when you can capture the emotion on the dancers' faces, and keep your focus on their eyes (see Figure 12.17).

It is also a good idea to use a longer lens for some of the images so that you can get in close without intruding on the moment. Using a lens like the 70-200mm will allow you to recompose the scene without getting in the way.

© Kenny Kim

12.17 The young couple has their first dance. They were placed one-third of the way into the frame using the rule of thirds, and the camera was tilted slightly, creating a leading line from the bottom-right corner towards the dancers. Taken at ISO 400, f/4, and 1/60 second.

▶ **The toasts.** There comes a time at most wedding receptions when the best man and maid of honor deliver toasts to the newlywed couple. If it is possible to compose the image with both the person doing the toasting and the newlyweds, then that's the first shot, but it is also a great idea to take close-ups of the person making the toast and the couple's reaction to the toast.

This is another great time to use a zoom lens that lets you go from a wide shot to a close-up shot without having to change lenses or take your eye away from the viewfinder.

▶ **The cake cutting.** The cake cutting and sharing the first bite is, of course, more about the intimacy between the couple than the cake. Plan ahead and make sure you are in position to capture the cake and the couple with a nice clean background. Clear the cake table of any clutter and start by shooting with a wider look and then zoom in on their faces during the feeding. Let the couple know that you are there and have them slow down so you can get the shots you need.

The wedding plan

The phrase "knowledge is power" could have been created to describe wedding photography. The more knowledge you have about the day, about the ceremony and about the order of events, the easier it will be to get the shots you need. The best way to get this information is to collaborate with the wedding couple about what happens and when it happens. If the couple is going to do a walk-through of the wedding site, see if you can tag along. It will give you a great overview of the ceremony site and ideas of what to expect when you are photographing the wedding.

Many weddings have a wedding planner that will keep things moving along, from before the bride shows up to hair and makeup to after the newlyweds drive off to start their life together. It is a good idea to speak with the wedding planner and make sure that they know how long you will need for the family and individual portraits and to get information about the wedding plan. Knowing when and where each of the following takes place will help you with your selection of backgrounds, lenses, and even where to shoot. Most weddings follow a simple order:

▶ Wedding party arrives

▶ Hair and make-up begin

▶ Bride and groom get ready

▶ Pre-ceremony portraits, as seen in Figure 12.18

▶ Guests arrive

▶ Wedding party gets into place

▶ Processional

▶ Bride walks down aisle

▶ Ceremony begins

▶ Special readings

▶ Vows, as seen in Figure 12.19

▶ Ring exchange

▶ Any special ceremony moments

▶ Bride and groom's first kiss

▶ Ceremony ends

▶ Bride and groom walk up aisle

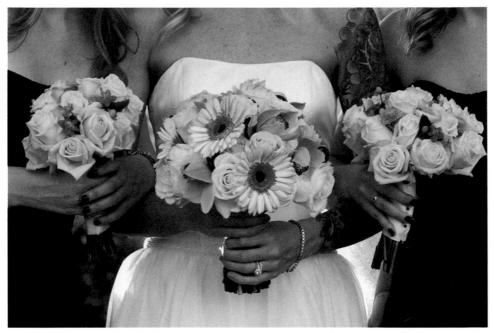

12.18 The bride and her bridesmaids link arms and display their separate flowers. Taken at ISO 800, f/4, and 1/400 second.

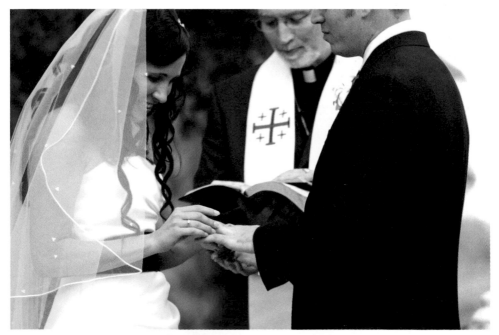

12.19 I used a long lens to get in close as the bride slipped, or tried to slip, the ring on the groom's finger. Taken at ISO 400, f/2.8, and 1/50 second.

▶ Pre-reception portraits

▶ Reception begins

▶ First dance

▶ Dinner

▶ Toasts

▶ Dancing

▶ Garter toss

▶ Bouquet toss

▶ Cake cutting

▶ Bride and groom depart

Make sure you know where and when all the events are going to take place.

Composition Tips

Weddings can fly by at a rapid rate and unless you are prepared, you will miss something. Because you don't get any second chances, here are a few quick tips to help you get the best shots you can:

▶ **Change focal lengths.** Using a zoom lens lets you take a variety of shots from the same position. Take advantage of that. You can shoot a wide-angle and close-up shot without ever having to move. This is especially true when shooting during the ceremony, when you want to make sure you don't distract the guests.

▶ **Watch the background.** Watch the background for distracting elements and if necessary, use a shallow aperture to minimize the background, making the subject pop.

▶ **Change your orientation.** Try to shoot both landscape and portrait orientation when shooting each part of the wedding. This gives you and the happy couple plenty of options when it comes to picking out prints and putting together the wedding album.

▶ **Shoot RAW.** There are no second chances when shooting weddings, and sometimes the mix of light can cause the white balance to be off and the images to have a colorcast. While it is possible to now fix the white balance of JPEG images in postproduction, shooting RAW makes it much easier to correct mistakes and fix color problems in postproduction.

▶ **Plan ahead.** Every wedding has a plan, lovingly put together by a wedding plan-ner or the bride herself. Make sure you know what the plan is because it is this plan that will show you what you will be shooting, where you will be shooting, and when it will happen.

▶ **Carry two cameras.** When it comes to shooting weddings, it is sometimes bet-ter to have two cameras, each with a different lens, and just change cameras than it is to keep changing the lens on a single camera. If you do use two camera bodies, make sure the clocks are synchronized so that when you sort the photos later, they will be in order when sorted by capture time.

▶ **Carry extra memory cards and batteries.** There is no good time to run out of space on your memory cards or let your batteries run out, but when working a wedding, this is a nightmare. Carry extras and then pack a couple more.

Wildlife and Animal Photography

There are ample opportunities to photograph animals, from household pets to majestic lions, if you know where to look. Special photo safari tours get you up close with wildlife, or you can just hang out with your dog in a park. The zoo is one of my favorite places to photograph; in a matter of hours I can photograph a wide variety of animals and still be home in time for dinner. Photographing animals in captivity means dealing with fences, glass barriers, and fake backgrounds, but there are ways to make your shots look like the ones in the nature magazines.

Shasta is a trained service dog and was a great model who held pose after pose for me. I had her sit up on a rock that gave me a background without any distractions. She was placed using the rule of thirds and I left space for her to move into. Taken at ISO 400, f/5.6, and 1/60 second.

Composition Considerations

When it comes to shooting animals, both the domestic and the wild kind, it is very important to capture personality. This is one of the reasons that I always try to focus on the eyes of my subject (see Figure 13.1).

But before that can happen, there are some things you can do to remove unwanted objects from your composition, especially when shooting at zoos or in other man-made environments.

Remove fences and barriers

Thousands of people take photographs at zoos and animal parks every day, and most of them look like Figure 13.2: a great animal trapped behind a fence or in a cage. There is no point in talking about where in the frame to place the animal or what to focus on when the barrier between you and the animal ruins the composition of your shot.

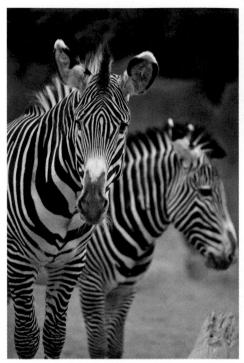

13.1 These zebras were shot at the zoo over a fence with a path in the background. The focus is on the eyes, the zebra is placed with space to spare and also fills the frame well, and the background doesn't distract at all. Taken at ISO 400, f/11, and 1/125 second.

There are two main types of barriers used in zoos that can really ruin your shots. The first is a thick glass wall and the second is a heavy chain link fence or cage.

Glass wall

The glass wall barrier creates two different problems. The first is that the glass reflects, so if you are not careful, you end up taking a rather odd-looking self-portrait. The second is that the glass can cause a color tint to your photograph, depending on the color of the glass. The colorcast is best removed in postproduction by adjusting the white balance. I recommend that you shoot using the RAW file type so that the white balance correction is easier.

To minimize the reflection from the glass, you need to place your lens as close to the glass as possible (see Figure 13.3). This cuts down on the reflection and allows you to get a better shot. The main problem is that with your lens right up against the glass, there is very little you can do about the angle; it needs to be straight on so that no light can get between the edge of your lens and the glass wall. Look for shady areas where the light isn't striking the glass straight on and remember to turn off your flash. The flash will just bounce off the glass and will do more to hurt your chances than it will to help.

It also pays to wait until the subject isn't right up against the other side of the glass because many lenses do not allow you to focus that closely and as you step back away from the glass trying to get the shot in focus, the reflections will return.

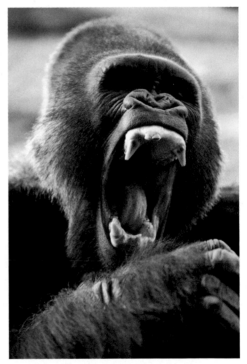

13.2 This jaguar was standing out in the open. Unfortunately, no matter how perfect the big cat looked or how long she was going to stand there, it would never be a great photograph because the cage obstructed the shot. Taken at ISO 400, f/11, and 1/125 second.

13.3 I have never been this close to a silverback gorilla without the safety of the glass and I don't think I ever will be. I shot this with the lens actually pressed right up against the glass and waited for him to do something — in this case, a yawn. I actually shot this on high-speed advance and the minute he started to move, I pressed the shutter release button. Taken at ISO 400, f/2.8, and 1/400 second.

Fence or cage

Shooting through a fence or cage is a lot easier than it appears and is one of my favorite tricks when shooting at the zoo. Some people still don't believe that some of the shots I have taken at zoos were through fences and not out on safari. The secret is to use a longer lens and a wide aperture. This allows you to use a shallow depth of field that not only blurs the background, making the subject stand out, but also makes the objects that are right in front of your lens really blur out of focus, making them virtually disappear.

One thing that you need is patience, because you need to wait until there is enough distance between the fence and the subject for this to work. Then you need to use a longer focal length and focus through the fence at the animal. It really is that simple. If you look at Figure 13.4, you can't see the fence, but it was there because I have never been that close to a lion outside of a zoo.

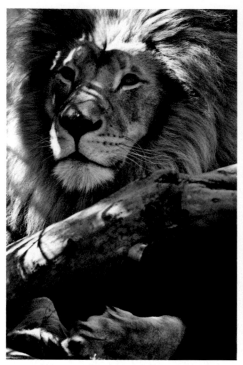

13.4 I had to wait until the lion stopped pacing and sat down far enough inside the cage to let me make the fence disappear. The only problem is that you can see the cage as shadows on the lion's fur on the left side. But the fence between the lion and me is gone. Taken at ISO 200, f/2.8, and 1/125 second.

Watch the background

After dealing with the barriers in front of the subject, it is time to discuss the background. Many photographers are too focused on the main subject of their image and forget to look at the background (see Figure 13.5). The background when shooting wildlife is key, especially when shooting in a public location like a zoo. Nothing ruins a shot as quickly as having a tourist in the background.

The only real solution is to look closely at the angles and shoot where there is nothing in the background that screams zoo or enclosure. Many times this means that you have to be patient and wait till the animal is where you need it to be. I also like to see if changing my height will have any effect on the background; I will crouch low and shoot up, hoping for more sky in the background, or I will see if there is a vantage point where I can look down on the subject, capturing more of the ground inside its enclosure and not the fence.

13.5 After what seemed like an eternity, the jaguar from Figure 13.2 went and laid down under a tree, allowing me to make the fence disappear; however, because the tree had a protective fence around it, the background was ruined. You can also see the fence in the back and even though I used a shallow depth of field to remove the front fence, it wasn't enough to remove the rear fence completely. Taken at ISO 200, f/2.8, and 1/1000 second.

The hardest background to shoot is when the fencing goes all around the animal. If you avoid seeing it in front but it is in the background, then the illusion that you were shooting in the wild is ruined. On a positive note, if you use a shallow aperture to remove a front barrier, then the background will also be blurred, so try to wait until the animal is between the two and not close to either one.

Fill the frame versus leave a little space

When shooting wildlife, it really helps to fill the frame with your subject because when you look at the images later, the animals will seem farther away than you remember. Many times I have returned from shooting only to end up cropping the image a little more in postproduction because I wanted the subject to really fill the frame, and even though I thought I was in close, I wanted to be in even closer.

 Do not put yourself in danger by trying to get too close to a wild animal. No photo is worth your safety.

The problem is that many cameras do not show you the full image through the viewfinder. This means that you see 94 to 96 percent of the scene that the sensor captures, and that extra space around the edge can make a difference. Check your camera's manual and see if the viewfinder on your camera shows you 100 percent of the scene.

When shooting a moving animal or one that looks like it is about to move, leave some space in front of the subject so that it looks like your subject will have some place to go (see Figure 13.6). If the photo is cropped too close, then your subject will look like it has no place to go and will be trapped. This makes the composition looked cramped and awkward. It is a great time to break out that old rule of thirds and keep one of the thirds, the one in front of the animal, empty. This will not only balance the composition, but will also give your subject some space to move.

13.6 I was out shooting in a park one day when I saw this bird walking along a fence. These two photos show the difference between leaving room in front of the bird and leaving space behind the bird. Which one looks better to you? I like the one where there is space in front of the bird but you may like the other one. Taken at ISO 200, f/2.8, and 1/1000 second.

NOTE If the animal is photographed on the way out of the frame it can also give the feeling of speed as if the photographer was unable to keep up with it.

Focus on the eyes

When it comes to photographing animals, as with shooting people, you need to focus on the eyes (see Figure 13.7). If the eyes aren't in focus, then the rest of the photo won't matter. Now, there are times when it is impossible to see the eyes, as with birds in flight or animals running by. But even when that is happening, you need to focus on the eyes or where the eyes would be if they could be seen. One thing to keep in mind is to try to shoot at eye level with the subject. Now, when it comes to giraffes or birds sitting in tall trees, this is impossible, but when it comes to your pet dog or

13.7 I made sure that the focus point was directly on the left eye of this tiger as she approached the fence. It is the look in her eye that keeps my attention right on her face. Taken at ISO 400, f/5.6, and 1/250 second.

cat, get down on their level as in Figure 13.8; it will bring your viewer into the image and help to create that emotional impact that you want from your images.

Another reason I always focus on the eyes is that the eyes let you know what the animal is about to do and will give you an idea of which way the animal will move. If you see the flick of movement towards the right, chances are the animal is about to go in that direction.

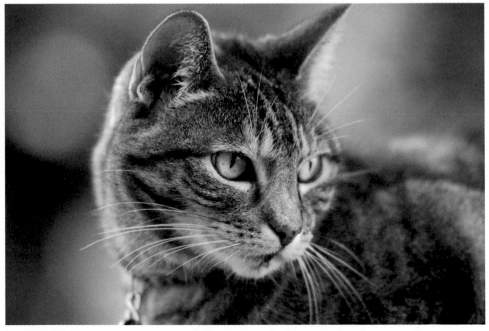

13.8 From big jungle cat to domestic house cat, the idea remains the same: Focus on the eyes. This was shot with a very shallow depth of field and while the right eye is in sharp focus, the left eye is not. Taken at ISO 200, f/2.8, and 1/1000 second.

Shooting Wildlife and Animal Photographs

I've talked about what to focus on and where in the frame to place your subject, and the importance of checking the background, but I haven't actually discussed finding and shooting the wildlife. Most people think that to shoot wildlife you need to take a trip to Africa, India, or South America, but there are also opportunities to shoot wildlife in your own backyard. I live in southern California, and we have raccoons, skunks, rattlesnakes, seals, and birds. In my neighborhood, there is even a flock of wild parrots.

Setting up a bird feeder in the backyard can give you a wide range of photo subjects without you ever leaving the yard. My favorite wildlife subject happens to really enjoy hanging out in my backyard. You can see her in Figure 13.9.

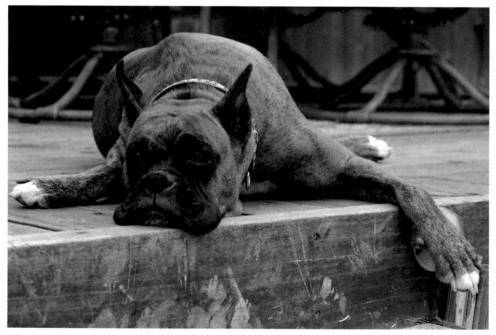

13.9 My dog Odessa loves to hang out on the deck while I'm photographing in the backyard. This quick shot of her still follows the basic composition rules by filling the frame with her and focusing on the eyes. Boxers' faces have a great range of expression; here she just looks bored with all the photo antics going on. Taken at ISO 200, f/4, and 1/250 second.

Most wild animals that probably live around your neighborhood don't really want to be seen by humans. But leave out the right type of food, and you will have visitors to your yard.

Another method is to just go out and sit in the yard every day and try not to move. Let the wildlife get used to you in a nonthreatening way. This is great practice in patience. Different times of the year will have different animals, with most activity starting in the spring and decreasing in the fall.

If you get serious about shooting wildlife and animals, you are going to have to invest in some camera gear and lenses. When starting out and shooting in the backyard or the park or even the zoo, it is possible to get away with any lens, but if you want to fill the frame with animals that just don't get that close, you are going to need some good telephoto lenses like a 400mm f/2.8 or a 600mm f/4, and these lenses cost a lot of money.

Another option when starting out is to get a 70-200mm f/2.8 lens and a teleconverter. A teleconverter is a specialized lens that goes between the lens and the camera and increases the focal length, turning a 200mm lens into a 400mm lens. While teleconverters are not inexpensive, they do cost less than a 400mm or 600mm lens. The downside is that they reduce the maximum aperture available.

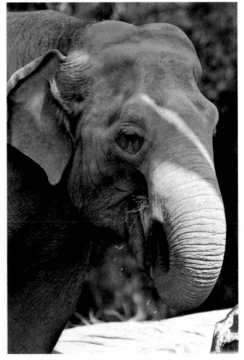

When shooting wildlife and animal photographs, try to capture some animal behavior. This isn't always as easy as it sounds but it can make the difference between a good photo and a great photo. When shooting at a zoo, find out when the feeding times are, as it is a sure bet that you can get some action eating shots like in Figures 13.10 and 13.11.

To capture the action takes patience and watching the animal through the viewfinder. When it came to the giraffe in Figure 13.11, I set up my camera so that the angle of the shot would limit the distraction of the background.

I zoomed in as close as possible to the giraffe, focused right on the eye, waited till he took a mouthful of food, and then I shot. I shot using the high-speed advance

13.10 I filled the frame with this elephant eating by using a 200mm lens with a 2x teleconverter attached, making it the equivalent of a 400mm lens. I waited until he had taken the straw and started to eat before shooting. Taken at ISO 400, f/5.6, and 1/250 second.

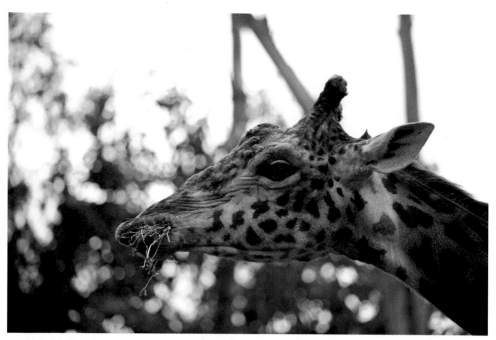

13.11 I was at the zoo early enough to catch the giraffe feeding. By waiting until the giraffe grabbed a bite of food and raised his head to eat, I was able to catch the giraffe with a mouth full of food. Taken at ISO 200, f/2.8, and 1/1000 second.

on my camera and took five photos in quick succession. This ensured that I got one shot with the food and mouth positioned the way I wanted.

When shooting wildlife, don't forget about those wild animals you live with, your pets. They make some of the best models for animal photography. They are easily accessible, and you know and understand their personality. It is this personality that you strive to capture with every frame (see Figure 13.12). If you are photographing someone else's pet, talk to them and ask what it is that separates their pet from the rest.

Actually, when it comes to all wildlife photography, the real goal is to capture the emotions in your subject. The best way to do this is to practice and learn. Go on an animal photo safari or wildlife workshop. There are many great wildlife photographers who take the time to teach and lead workshops.

Two that I recommend are Juan Pons and Moose Peterson. Juan leads the Wild Nature tours (www.wildnaturetours.com) and is one of the founders of the Digital Photo Experience (http://dpexperience.com) where he writes on all photo subjects but specializes in nature and wildlife. Moose runs the Wildlife Photographers Base Camp (www.moosepeterson.com), which offers a great learning experience and covers everything from field ethics to getting involved with biologists.

13.12 Shasta is one very playful dog, and after an hour of sitting and posing, she started to rebel and show some of that independent spirit. I made sure I was on her level and kept the focus on her eyes. She is one pretty upside-down dog. Taken at ISO 200, f/2.8, and 1/1000 second.

Composition Tips

Here are some tips that will make your wildlife and animal photography easier.

▶ **Keep your eye to the viewfinder.** If you are looking down at your sensor checking the last photo or checking your settings, that's when the action will happen. It never fails. Keep your eye to the viewfinder and make sure you know your camera and your gear.

▶ **Patience.** Wildlife and animal photography takes a lot of patience. You have to wait for that once-in-a-lifetime shot. You can't hurry it along or force it to happen. When I shoot at the local zoo, I have been known to spend hours at the same exhibit waiting for the right moment, and it has usually paid off. There have been days when nothing happened, but that's the beauty of the zoo; you can come back again the next day.

▶ **Watch the background.** The background can make or break a photo. Make sure that you wait until your subject is against the background you want and there are no distractions that will draw your viewer's eye away from the main subject.

▶ **Go early or stay late.** Animals tend to be more active in the early hours of the day or the hours around sunset and less active in the middle of the day. Plan on getting an early start to the day or shooting in the late afternoon or evening if you want to get the best shots. Plus you get the benefit of the great light available during that golden hour.

▶ **Use a shallow depth of field.** A shallow depth of field can make the physical barriers between you and the animal seem to disappear by causing the extreme foreground to blur completely out of focus.

▶ **Use a shallow depth of field to make your animals pop.** A shallow depth of field can also help to make the animal seem to pop right off the background because everything else will blur heavily.

▶ **Leave space.** Give the animal a little space in the frame to move. This makes the subject less cramped and confined.

▶ **Watch the eyes.** As when shooting people, make sure the eyes are in focus. Make sure that your focus point is on an eye, and if tracking a moving animal, keep the focus point on the eye.

▶ **Do your research.** The more you know about your subject, the easier it will be to get that great shot. This is especially true when shooting in the wild and you have to actually track down the animals yourself. When shooting in a zoo or animal park, it still pays to know which animals are active and when, as it can help you plan your day and the order in which you want to shoot your subjects.

▶ **Follow the rules.** This applies to the rules at zoos and the rules in the wild. Check before you shoot, as many zoos and animal parks have limits on what you can and can't do with the images. Many of the rules are not only there to keep the animals safe, but also to keep visitors safe.

▶ **Be safe.** When out shooting wildlife, especially in the wild, it is important to be safe. Don't get too close to anything that could cause you harm — the photo just isn't worth it. Some animals are far more dangerous than they seem at first glance, and others might even go unnoticed until you are in their comfort zone. Many animals don't like people and will hide or run away if startled, but others will attack.

Creative Composition

This chapter is going to cover a variety of different composition tips and situations, from looking for and photographing patterns and textures, to dealing with shapes and black-and-white photography, as well as abstract images where it is really difficult to apply the regular rules. As with every image you compose, it is up to you, as the photographer, to decide what stays and what goes, and while that is easier to do with the standard guidelines, at times it is fun and rewarding to break the rules.

The pattern created on this wall is actually two staircases going in two directions. Because the sun was high overhead, there were no long shadows and no depth to the image, but the pattern created by the edge of the stairs was interesting. Taken at ISO 200, f/7.1, and 1/1250 second.

Patterns

Patterns are areas that are made up of repeating objects, shapes, or even colors. Patterns can be difficult to photograph because if they are too regular, they may seem boring and stagnant. As a result, the viewer's eye moves over the image very quickly and does not linger on any part for too long — not exactly what you want. Look for both man-made and natural patterns; if you start to look closely, you will see that there are patterns everywhere and those patterns bring order to an otherwise chaotic scene.

▶ **Regular pattern.** A pattern is created when you see ordered rows of similar objects, especially when the pattern extends out of the frame on all sides. You immediately think that the pattern goes on forever in all directions. Take the wrestling masks in Figure 14.1. The pattern is in many colors but the shapes are all the same, and while it is fairly interesting, your eyes and brain can't really decide on what to focus on. There is no real subject to the photo other than the pattern.

14.1 The wrestling masks were all hanging in neat rows on the side of the booth during a street fair. The regular pattern is created from the shapes of the masks. Taken at ISO 200, f/4.5, and 1/400 second.

▶ **Irregular pattern.** I know it seems like an oxymoron to say *irregular pattern*, but bear with me for a moment. This is a scene with repeating elements, but some other element creates voids in the pattern somewhere in the scene. Still, while this cannot be called a regular pattern, there is enough visual information in the scene for your brain to fill in the missing pieces. Note that a scene with an irregular pattern will be strengthened by having elements all the way to the edge of the frame and sometimes even past it.

▶ **Break the pattern.** Look for a break in a pattern to add some tension to your image. This break causes the viewer's eye to stop and take notice of the irregularity.

If you look at Figure 14.2, the knobs are all exactly the same distance apart and have the same color scheme. There is nothing in the pattern that holds your attention. If you cover up the half of the image with the piece of paper, see if there is anything that catches your eye. If you find yourself looking at the bottom edge of the photograph to where there is one red slider visible in a series of white sliders, it is because that is a break in the pattern. Humans always tend to see the breaks in the pattern, more than the actual pattern.

14.2 The pattern created by the knobs on the soundboard is broken by the data sheet. This draws the viewer's attention to the piece of paper as the eye travels over the pattern. Taken at ISO 100, f/5, and 1/60 second with an external flash.

A different shape or color, or something that doesn't belong at all, could create the break in the pattern (see Figure 14.3). Once the pattern is broken, it becomes more noticeable because of the contrast that it creates

▶ **Textures.** When you see a really large pattern from far away, it can start to look like a texture. This is when the individual pieces that create the pattern are lost and you use the overall look instead.

There is a real difference between man-made and natural patterns that you should be aware of. A man-made pattern tends to be perfect, giving the viewer's eye nothing to stop on; as a result, the pattern becomes a background that is easily skipped over.

14.3 I photographed these red bell peppers at a street corner grocery in New York City. It is the missing bell pepper that makes the image interesting. I composed the image with the missing bell pepper at the Rule-of-Thirds intersection to help with the composition. Taken at ISO 100, f/5, and 1/13 second.

Where the Pattern Ends

Another way to use a pattern is to photograph the area where the pattern ends. This isn't quite the same thing as a break in the pattern, but is more like an abrupt end to it. While it might seem that the pattern goes on forever, nothing lasts forever, including any pattern you might see. By including the edge of the pattern, you create a natural stopping point for the viewer's eye.

Shapes

Most photographs are made up of shapes, but at times, the shapes themselves can be the subjects. Photographing shapes doesn't always lend itself to traditional rules when it comes to composition. When the photo is about shapes, the shapes need to fit together in a way that makes the viewer want to take a second or even third look.

The composition still needs to draw the viewer's eye in and have it spend some time within the frame. The image in Figure 14.4 is one of my favorite photographs for both the simplicity of the image and the clean composition.

I tried to balance the solid buildings with the light clouds, all against a solid blue sky. The curve of the building is further enhanced by the lines of the tiles. Had I just focused on the building and filled the frame with it, the composition would have created a feeling of heaviness and would have been off balance.

14.4 The gentle curves of the building are a nice contrast to the clouds. Taken at ISO 100, f/5.6, and 1/500 second.

When you look through the viewfinder or use the LCD on the back of your camera to start composing an image, it can be difficult to see all the shapes involved. When I looked down and saw the dandelion in Figure 4.5, I wasn't seeing the circle and lines — I just saw the pesky weed.

Only by getting down close and really looking did I start to see that the construction was actually a very delicate group of straight lines creating a ball. By composing the image with this in mind, I've allowed your brain to fill in the rest of the circle suggested by the tiny network of straight lines.

There are shapes in everything and sometimes you just need to look at a scene in the right way. Some of the most common shapes in images are:

14.5 The dandelion is a study in fine lines creating a soft circle. I used a Nikkor 105mm Macro lens to get this extreme close-up. Taken at ISO 400, f/4.5, and 1/80 second.

▶ **Circles.** Your eyes will follow a curve and when that curve is full enough, you will see it as a circle. Circles are very useful for surrounding other elements and keeping the viewers eye inside the image. Think of the spokes of a bicycle tire as they radiate outward from the hub, and then suddenly the tire stops them and the eye starts to travel back around. When looking for circles in nature, look at flowers, the rings in trees, and even the curve of a rainbow.

▶ **Rectangles.** These are usually objects created by people and not typically found in nature. The frame that is the basis for your image is a rectangle, which makes it easy to divide into smaller rectangles. If you think of the Rule of Thirds as creating nine rectangles from one, it becomes easier to see how rectangles can fit into your compositions.

▶ **Triangles.** Triangles are a little bit more difficult to find, as the shape is usually there but for some reason tougher to see — at least it is for me. Take a look at Figure 14.6; can you see the triangle? It is created by the road as the two diagonals converge. The shape of a triangle can be created with just two of the lines present; the third line is implied.

14.6 The road heading toward the horizon makes a triangle, with the top of the triangle directed at the vanishing point. Taken at ISO 200, f/8, and 1/800 second.

Black-and-white Images

Black-and-white images have a timeless quality and are often referred to as classic or ageless. When you remove the color from a photograph, the lines, shapes, and textures all have to work without the support of color, and this makes them more important in your composition.

You need to practice "seeing" in black and white so that when you recognize an image that will work well without color, you can photograph it with the best composition possible. Here are some things to look for:

▶ **High contrast.** Black-and-white images work best if you have a wide range of tones from black to white and not just a few shades of gray. The blacks should be very black and the whites should be very white. This is harder to capture with a digital camera than you might think, because the sensor has a difficult time capturing the details in the brightest part and the darkest part if they are very different; this is why the fine details in the shadows and highlights might be lost, especially as you can't see small changes in color easily.

▶ **Strong composition.** Use the Rule of Thirds and leading lines (see Figure 14.7) to draw your viewer's eye to the subject. Place the strongest subjects on the intersecting points. Try to ignore how the colors in the scene move your eye; don't allow them to dictate your composition because the color is not going to be in your final image.

▶ **Work without color.** Even though the image has no colors, this doesn't mean that you can ignore the different shades of light and dark. In fact, these shades actually become more important.

For example, that bright-red, eye-catching car is now just dark gray, and that light-blue car is a much lighter gray, drawing the eye to it. Remember that the eye is drawn to the lightest part of the image.

14.7 The Brooklyn Bridge was a great image to convert to black and white. The strong lines and clear sky made the support wires stand out, and because the color is gone, there are no distracting color elements to detract from the composition. Taken at ISO 100, f/11, and 1/80 second.

Just because the image is no longer in color doesn't mean that color is not implied; for example, you live in a color world and if you see an image with a sky in it, you know the sky is blue even if it is rendered in gray. But what happens when you don't know what the color is supposed to be, as in Figure 14.8?

There is no way to tell from the black-and-white image that the lettering on the door was dark red or that the door was painted blue. The pattern that was painted on the door would make you believe that the door was painted red because that pattern is reminiscent of the layout of bricks, and bricks are red.

Keep in mind that not every image will work as well when rendered in black and white, especially if the composition was based on color to begin with.

14.8 The colors of the graffiti on the door really stood out to me, but when I converted the image to black and white, it just didn't hold up. Taken at ISO 100, f/5.6, and 1/125 second.

When photographing people for a black-and-white composition, the same rules that dictate portrait composition hold true.

You should still make sure that the focus is on the eyes (see Figure 14.9), but you no longer have the color of the eyes to hold your viewer's gaze.

 For more information on portrait composition, see Chapter 9.

14.9 Black-and-white portraits are very common. I photographed Mia in a black dress and went with a high-contrast look. Taken at ISO 100, f/9, and 1/250 second with studio strobes.

Converting Color to Black-and-White

With digital cameras, you no longer have to decide if you are going to shoot color or black-and-white when you load the film into the camera. Today the digital darkroom allows you to convert images from color to black and white so that you can see exactly what the outcome will be. You can experiment with your images to see what makes a strong black-and-white picture.

There are a lot of programs available for creating black-and-white images from your color files; my favorite is called Nik Silver Efex Pro, and I used it for all the black-and-white images in this chapter. It allows you to fine-tune your color-to-black-and-white conversion, and is available from Nik Software at www.niksoftware.com.

Abstract Images

Abstract images are a lot of fun to set up and shoot, but they present a unique challenge when it comes to composition, because the idea behind the image is to show something that is not actually recognizable as anything specific. Look at the two images in Figures 14.10 and 14.11; can you tell what they are?

Okay, so the leaf isn't very difficult, but the actual pattern is intricate, creating an abstract piece as opposed to one that is a straight representation. Abstract images work because of the shapes and colors in the design rather than the actual subject matter.

In Chapter 3, I talked about not tilting the horizon line because it will be noticeable. However, in Figure 14.10, that is exactly what I did.

I used a macro lens to get in close without burning myself, and while watching the flame through the viewfinder, I started to turn the camera and my head along with it until I had this angle. Then I shot a lot of photos at various shutter speeds to get the soft look I was going for. The composition is completely dependent on color — with the various shades ranging from yellow in the brightest areas to very dark red and black in the darkest areas — to define the shape and feel of the flame.

When I was shooting the leaf in Figure 14.11, I placed the focus point one-third of the way in from the top and one-third of the way in from the left in a spot that should be familiar now as one of the Rule-of-Third points. The focus and brightness of the lines in that area keep drawing the eye back, as everything seems to flow from there.

14.10 This is an image of a flame shot at an off-angle where the horizon line is tilted 45 degrees. Taken at ISO 200, f/8.5, and 1/320 second.

14.11 This is a close-up of a leaf, with the design creating an abstract image. Taken at ISO 400, f/4.5, and 1/80 second.

Composition Adjustments in Postproduction

Gone are the days of darkrooms, chemicals, and enlargers. With today's digital cameras, the developing, editing, and printing are done with computers and specialized software.

The five programs described in this appendix all allow you to adjust the composition of your image. This is not a complete overview or even a list of all the tools that these software can offer you for perfecting your compositions, but an overview of their respective crop tools. Cropping is the quickest way to adjust the composition of an image, and this book is about composition after all.

Being able to crop your images is nothing new — photographers using enlargers in the darkroom did it all the time — but now there are many more tools available for digital photographers.

Adobe Photoshop

Adobe Photoshop was released over 20 years ago and photo editing has never been the same. Photoshop has grown into a huge program that can do just about everything a photo editor could want. There are three separate parts to Adobe Photoshop: Bridge, Camera Raw, and Photoshop. You can crop your images in both Camera Raw and Photoshop.

Adobe Camera Raw

Adobe Camera Raw — or as it is usually known, ACR — is the part of Adobe Photoshop that translates camera-specific RAW files into a format that Photoshop can use. ACR allows you to edit the image before it is even opened in Photoshop, and one of the editing choices is the ability to crop the image.

The Crop tool is located at the top of the screen, and is the sixth tool in from the left (see Figure AA.1); you can also access it with the shortcut key, C.

AA.1 The Adobe Camera window showing the Crop tool

Once the Crop tool is activated, you can just draw a crop box on the screen. The parts of your image that will be cropped — that is, the area outside the crop box — turn a dark gray (see Figure AA.2). This lets you immediately see what the cropped image will look like.

ACR doesn't stop there; it also allows you to change the crop depending on the ratio of the sides and by straight measurements. You can access these cropping options in two ways: Click on the little down arrow underneath the Crop tool, or right-click in the image area when the Crop tool is active (see Figure AA.3). The Custom Crop dialog box allows you to enter the crop dimensions directly in Adobe Camera Raw (see Figure AA.4)

AA.2 The Adobe Camera Raw window showing the selected crop area

AA.3 You can either click on the arrow underneath the Crop tool or right-click on the image to make a crop based on the standard ratios in the pop-up menu.

Once a crop box is created, you can adjust its size and shape by using the handles at the corners of the box, and you can move the entire box around by just left-clicking inside of the box and moving it around.

It is also possible to just enter the lengths of the height and width in the custom crop box. For example if you want the image to be a 5 × 7 then you would enter the dimensions directly.

AA.4 In the pop-up menu shown in Figure AA.3, select Custom… and use the Custom Crop dialog box to manually enter the desired crop.

The crop doesn't actually happen until you open the file in Photoshop. Because this is all happening in the RAW file, the image is never actually changed, so it is possible to come back later, open the file in ACR again, and do a different crop.

Photoshop

Photoshop can help you do so many different things to your images, from adjusting the exposure to removing people from a group. There are many ways to change a photo's composition in Photoshop, but the easiest is to use the Crop tool.

The Crop tool in Photoshop is very similar to the Crop tool in ACR (see Figure AA.5). When it is selected, you just draw the area you want to save and press Enter (see Figure AA.6).

To help you visualize the new composition, there are some settings that you can change in Photoshop to make the cropped area stand out more. These settings appear on the top of the screen when a crop selection has been made. You can change the opacity of the area that is going to be cropped to solid black, to make it easier to see the resulting image (see Figure AA.7).

AA.5 The Crop tool is selected in this toolbar of Adobe Camera Raw.

AA.6 The crop area in Photoshop

AA.7 You can adjust the area outside of the crop by changing the opacity in the menu.

There is one more Photoshop feature that is very useful for analyzing your image's composition: the guide's overlay. It is possible to turn the grid into a rule-of-thirds grid. To do this, follow these steps:

1. **Open Preferences in the Photoshop menu.**

2. **Click on Guides, Grid & Slices (see Figure AA.8).**

AA.8 The Guides, Grid & Slices menu in Photoshop Preferences

3. **In the Grid section, in the Gridline Every box, type** 33.333 **and select percent.**

4. **Close Preferences.**

5. **Click the Grid/Ruler button (shown with its drop-down menu in Figure AA.9), select Show Grids, and you will see a rule-of-thirds grid.**

This allows you to see where the lines in the rule of thirds intersect. This will let you look at your image with the grid overlaid on your image.

AA.9 The grid overlaid on the image

Adobe Photoshop Elements

Adobe has created a consumer-level version of Photoshop, its landmark photo-editing software. Adobe Photoshop Elements, now in its eighth edition, is a scaled-down version of Photoshop with a reduced set of editing tools and options. To crop an image using Photoshop Elements:

1. **Select the image you want to adjust.**

2. **Select the Crop tool (see Figure AA.10).**

3. **Click and drag the Crop tool over the area you want to crop.**

4. **Press Enter.**

The Recompose tool is new in Photoshop Elements, and while it doesn't give you full control over your image, it will change the composition of your image. The Recompose tool is located under the Crop tool; just click and hold on the Crop tool and then choose the Recompose tool.

The Recompose tool is only available in Photoshop Elements.

AA.10 The Photoshop Elements interface showing the Crop tool

The Recompose tool allows you to select the elements of your image that you want to preserve and the elements that you want to remove. You can then adjust the composition by using the handles on the sides of the image (see Figure AA.11).

This technology works really well, but isn't perfect yet. If you use it, and it doesn't work well, just try it again.

While Photoshop Elements will never be as powerful or as complete an editing package as Photoshop, it does offer a great deal of editing power for less than $100.

AA.11 Using Photoshop Element's Recompose tool

Adobe Photoshop Lightroom

Adobe Photoshop Lightroom, or Lightroom as it is commonly known, is a full-featured software package designed to help with all aspects of photography postproduction.

Lightroom is composed of five separate modules: Library, Develop, Slideshow, Print, and Web. The module that is important when it comes to adjusting your composition is Develop, which has the Lightroom Crop tool.

In my opinion, Lightroom has the most advanced Crop tool in all the software packages and is my favorite to use. There are two reasons why the Crop tool is so powerful in Lightroom: Multiple overlays let you fine-tune your composition, and you can crop while in the Lights Out mode, which gets rid of the extraneous display options.

You can access the Crop & Straighten tool in the Develop mode by pressing the R key or by clicking the Crop Overlay icon on the right side of the screen, as shown in Figure AA.12.

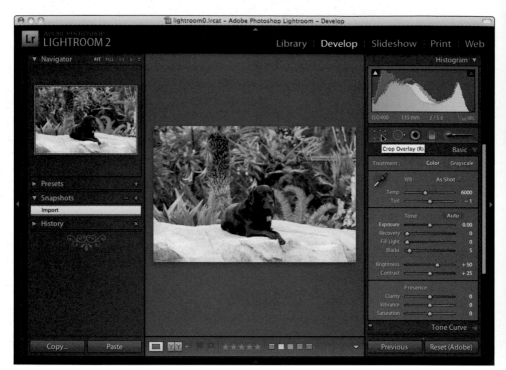

AA.12 The Lightroom interface showing the develop module with the Crop tool selected

Lightroom then overlays a crop grid on your image with a rule-of-thirds grid already in place, and opens the Crop & Straighten options panel.

The Crop & Straighten options panel allows you to control the aspect ratio of the crop and even use preset crop ratios for standard outputs; it also offers a way to enter custom ratios (see Figure AA.13). You can adjust the crop overlay by grabbing one of the eight adjustment handles and changing the size of the crop box.

Lightroom is very different from the other editing programs when it comes to moving the crop around the image. In Lightroom, the cropped area stays centered and the image moves relative to the crop area. This can be very disconcerting the first couple of times you try it, especially if you are used to working with other editing programs. However, after a while it feels natural and because the crop doesn't move, you get to see your newly composed image in the middle of the screen (see Figure AA.14).

AA.13 The Lightroom Crop tool menus

Where Lightroom really excels is in its ability to quickly display the crop over-lay without any of the other panels vis-ible; to do this, simply press Shift+Tab.

You can actually darken the screen to make the image stand out (as in Figure AA.15) by pressing the L key twice; to get back to the regular view, press the L key again.

One more thing that makes Lightroom so good for cropping is the ability to change the overlay grid. When you press O repeatedly, your grid options change in the following order when in the Crop & Straighten mode:

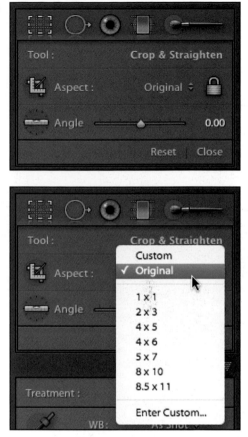

▶ **Thirds:** Divides the area using the rule of thirds.

▶ **Golden Ratio:** Divides the area using the *Golden Mean Equation*, a ratio used to produce aestheti-cally pleasing results.

▶ **Diagonals:** Turns the golden mean by 45 degrees and creates a new set of intersecting lines for use in your composition.

▶ **Triangle:** Divides the crop area using a set of equal triangles, which is very use-ful in seeing any leading lines.

▶ **Golden Mean:** This is the circular pattern showing the mathematical representa-tion of the Golden Mean.

▶ **Grid:** This is a basic grid pattern that is more useful for straightening your image than actually cropping it.

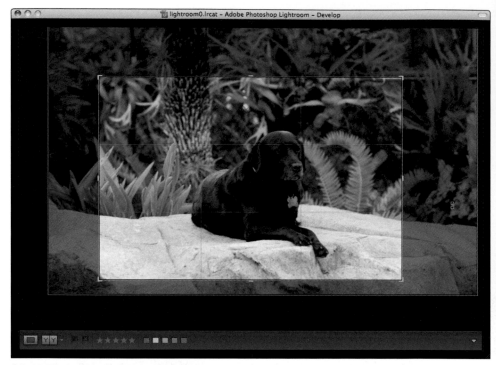

AA.14 The crop overlay in Lightroom

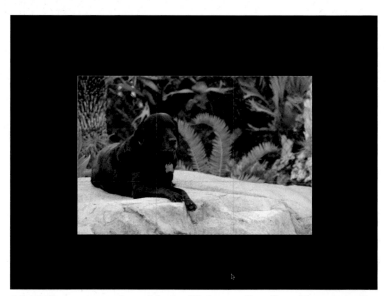

AA.15 The crop overlay with the "lights out" so that the crop really stands out

You can rotate all the grid overlays by pressing Shift+O.

These overlays can really help you fine-tune the composition and even show you the relationship between the different composition rules. It is also possible to remove the overlay grid or have it visible only when adjusting the crop. In the View menu, select Tool Overlay, and then choose Auto Show (see Figure AA.16).

This hides the grid until you move the image or adjust the crop (see Figure AA.17). All these tools make cropping in Lightroom that much more powerful when adjusting the composition in postprocessing.

AA.16 The Lightroom overlay menu

AA.17 The Crop tool overlay

Apple Aperture

Apple created Aperture as a tool for photographers and is currently shipping version 3. Aperture is very similar in function to Lightroom. But while the programs are both designed for professional photographers, they don't do things in the same way. To crop an image in Aperture, do the following:

1. **Select the image you want to crop.**

2. **Double-click the image to open it.**

3. **Click the Crop button located on the bottom of the screen.** The Crop menu opens on the screen.

4. **Click and drag to create a crop box, and adjust it as needed.**

5. **Press Return to apply the crop.**

One of the nice features of the Aperture Crop tool is the ability to turn the guide on or off using the Crop dialog box. The Crop dialog box appears when you activate the Crop tool or press the shortcut key C.

When the guide is turned on, a rule-of-thirds grid overlays the crop window.

The Crop dialog box gives you the capability to crop by inputting the width and height of the desired crop as shown in Figure AA.18. It also shows the size of the resulting crop in megapixels.

AA.18 The Aperture interface showing the Crop tool and Crop dialog box

One new feature of Aperture 3 is that it displays an overlay of which focus point was used to take the photo (see Figure AA.19). This is a great way to learn what works and what doesn't. This tool is very easy to use and can be turned on so that it automatically shows the focus point when an image is opened.

AA.19 The Aperture display showing the focus point used when taking the photo

Apple iPhoto

Apple iPhoto is part of the iLife software suite, and while it is intended for the general user, it does have a great set of tools for editing images, including a very useful Crop tool. To access the Crop tool in iPhoto, just do the following:

1. **Select the image you want to crop.**

2. **Click Edit.**

3. **Click the Crop tool on the toolbar at the bottom of the screen (see Figure AA.20).**

AA.20 The Crop tool overlay in Apple iPhoto

4. **Crop the image.** Once you have adjusted the crop, you can just click the Crop button again to apply the crop, or you can click the Apply button.

5. **If you decide to start over or just not crop the image, you can click the Cancel button.**

As with all the software discussed in this appendix, iPhoto has options to help with the composition created by the crop. In this case, it is the ability to constrain the crop. As you can see in Figure AA.21, there are many options accessible when you click on the dimension of the image, but instead of just giving you the dimensions, iPhoto also shows you the suggested usage for the image. These options include images created for iPhone, DVD, Book, Postcard, and so on.

One really helpful feature when cropping in iPhoto is the rule-of-thirds grid that appears automatically when adjusting the size of the crop or moving the crop selection around (see Figure AA.22). This allows you to see where the intersecting lines are when adjusting your composition.

AA.21 The Crop options menu in iPhoto

1024 × 768 (Display)
4256 × 2832 (Original)
2 × 3 (iPhone)
3 × 5
4 × 3 (DVD)
4 × 3 (Book)
4 × 6 (Postcard)
5 × 7 (L, 2L)
8 × 10
16 × 9 (HD)
16 × 20
20 × 30 (Poster)
Square
Custom...

Constrain as landscape
Constrain as portrait

Constrain: 4256 × 28... Cancel Apply

AA.22 The rule of thirds overlay in iPhoto

How to Use the Gray Card and Color Checker

Have you ever wondered how some photographers are able to consistently produce photos with such accurate color and exposure? It's often because they use gray cards and color checkers. Knowing how to use these tools helps you take some of the guesswork out of capturing photos with great color and correct exposures every time.

The Gray Card

Because the color of light changes depending on the light source, what you might decide is neutral in your photograph, isn't neutral at all. This is where a gray card comes in very handy. A gray card is designed to reflect the color spectrum neutrally in all sorts of lighting conditions, providing a standard from which to measure for later color corrections or to set a custom white balance.

By taking a test shot that includes the gray card, you guarantee that you have a neutral item to adjust colors against later if you need to. Make sure that the card is placed in the same light that the subject is for the first photo, and then remove the gray card and continue shooting.

> **TIP** When taking a photo of a gray card, de-focus your lens a little; this ensures that you capture a more even color.

Because many software programs enable you to address color correction issues by choosing something that should be white or neutral in an image, having the gray card in the first of a series of photos allows you to select the gray card as the neutral point. Your software resets red, green, and blue to be the same value, creating a neutral midtone. Depending on the capabilities of your software, you might be able to save the adjustment you've made and apply it to all other photos shot in the same series.

If you'd prefer to made adjustments on the spot, for example, and if the lighting conditions will remain mostly consistent while you shoot a large number of images, it is

advisable to use the gray card to set a custom white balance in your camera. You can do this by taking a photo of the gray card filling as much of the frame as possible. Then, use that photo to set the custom white balance.

The Color Checker

A color checker contains 24 swatches that represent colors found in everyday scenes, including skin tones, sky, foliage, etc. It also contains red, green, blue, cyan, magenta, and yellow, which are used in all printing devices. Finally, and perhaps most importantly, it has six shades of gray.

Using a color checker is a very similar process to using a gray card. You place it in the scene so that it is illuminated in the same way as the subject. Photograph the scene once with the reference in place, then remove it and continue shooting. You should create a reference photo each time you shoot in a new lighting environment.

Later on in software, open the image containing the color checker. Measure the values of the gray, black, and white swatches. The red, green, and blue values in the gray swatch should each measure around 128, in the black swatch around 10, and in the white swatch around 245. If your camera's white balance was set correctly for the scene, your measurements should fall into the range (and deviate by no more than 7 either way) and you can rest easy knowing your colors are true.

If your readings are more than 7 points out of range either way, use software to correct it. But now you also have black-and-white reference points to help. Use the levels adjustment tool to bring the known values back to where they should be measuring (gray around 128, black around 10, and white around 245).

If your camera offers any kind of custom styles, you can also use the color checker to set or adjust any of the custom styles by taking a sample photo and evaluating it using the on-screen histogram, preferably the RGB histogram if your camera offers one. You can then choose that custom style for your shoot, perhaps even adjusting that custom style to better match your expectations for color.

Glossary

Adobe RGB A color space created by Adobe Systems to more closely match the output of inkjet printing devices. See also *color space*.

AE lock A setting for locking the exposure on a camera. Pressing a camera's AE lock button locks the current exposure and lets you recompose the scene without changing the exposure.

AF (autofocus) lock A setting for locking the focus on a camera. You can lock the focus either by pressing the Shutter Release button halfway down or, on some cameras, pressing the AF button. When the focus is locked, the camera can be moved, but the focus doesn't change. The focus stays locked until the shutter is released or you press the Shutter Release button. This allows you to recompose the scene without changing the focus.

ambient light The natural light in a scene, also referred to as available light.

angle of view The amount of the scene in front of a camera that a specific lens can capture.

aperture The opening in a lens that light passes through before reaching the sensor in a camera. You can adjust the aperture by changing the f-stop, which controls the diaphragm. Aperture is expressed as f/number — for example, f/5.6. Since the f-number is a fraction, f/8 is a smaller opening than f/4 and f/2 is a bigger opening than f/4.

Aperture Priority mode A mode where you set the aperture and the camera sets the shutter speed.

artificial light Any light that you introduce into a scene.

autofocus A setting where the camera automatically adjusts the focus, depending on which focus sensor you have selected. You start the autofocus on most dSLRs by pressing the Shutter Release button halfway down.

autofocus illuminator A built-in light that illuminates the scene, allowing the camera to achieve focus when not enough ambient light is present.

bounce light Light that is bounced off a surface before hitting the subject to create a more flattering light source. This is used mainly with a dedicated flash unit that you can aim at a wall or ceiling.

buffer A camera's built-in memory that is used as temporary storage before the image data is written to the memory card.

bulb A shutter speed setting that keeps the shutter open as long as the Shutter Release button is held down.

camera shake The small movements of a camera that can cause blurring, especially when the camera is being hand-held. Slower shutter speeds and long focal lengths can contribute to this problem.

CCD An acronym for Charge-Coupled Device, a type of image sensor found in some dSLRs.

center-weighted metering A metering mode on a camera's built-in light meter. With center-weighted metering, the entire scene is metered, but a greater emphasis is placed on the center area.

CMOS An acronym for Complementary Metal Oxide Semiconductor. This type of image sensor is found in some dSLRs.

color space A description of the range of colors that can be displayed or recorded accurately by the current device. See also *Adobe RGB*.

color temperature A description of light color using the Kelvin scale. See also *Kelvin*.

colorcast An overall look or predominant color that affects an entire image. Colorcasts are usually caused by an incorrect white balance setting. See also *cool* and *warm*.

colored gel filters Colored light modifiers that, when placed between a light source and a subject, change the color of the light hitting the subject.

compression A process for reducing image file size by either removing information (lossy compression) or writing the information in a form that can be recreated without any loss of quality (lossless compression).

Continuous Auto Focus mode A mode in which a camera continues to refocus while the Shutter Release button is held halfway down. This is the best focus mode for moving subjects. Also known as Artificial Intelligence Focus (AI Focus) on Canon cameras.

contrast The difference between the highlights and the shadows of a scene.

cool A descriptive term for an image or scene that has a bluish cast.

dedicated flash A flash unit that works with a camera specifically in the camera's hot shoe.

depth of field Also called DOF. This is the area of acceptably sharp focus in front of and behind the focus point.

diaphragm An adjustable opening in a lens that controls the amount of light reaching the sensor. Opening and closing the diaphragm changes the aperture.

diffused lighting Light that has been scattered and spread out by being bounced off a wall or ceiling, or shot through a semi-opaque material, creating a softer, more even light. Diffused lighting can also come from sunlight shining through clouds.

digital noise See *noise*.

equivalent focal length An adjusted focal length for digital cameras based on the focal length of film cameras. The focal lengths of lenses attached to cropped sensors in a digital camera need to be translated from the 35mm film camera standard due to their reduced size. The fast way to determine the equivalent focal length is to multiply the focal length by 1.5 for Nikon DX cameras. Other cameras will need different multipliers.

exposure The amount of light that reaches a camera's sensor.

exposure bracketing A method in which you take multiple exposures, some below and some above the recommended exposure.

exposure metering Using the light meter built into a camera to determine the proper exposure. See also *metering modes*.

f-stop A measure of the opening in a diaphragm that controls the amount of light traveling through a lens. See also *diaphragm*.

fast A description referring to the maximum aperture of a lens. Lenses with apertures of f/2.8 and higher are considered fast lenses. See also *slow*.

fill flash A method where you use a flash to reveal details in shadow areas that would usually be lost.

filter A glass or plastic cover that goes in front of a lens. You can use filters to alter the color and intensity of light, add special effects such as soft focus, and protect the front elements of the lens.

flash A device that produces a short, bright burst of artificial light. The word *flash* can be used to describe the unit producing the light or the actual light.

Flash Exposure Compensation An adjustment that changes the amount of light produced by a flash, independent of the exposure settings.

flash sync The method by which a flash is fired at the moment the camera shutter is opened, usually *First curtain* or *Rear curtain* flash.

flat A description of an image or scene that has very little difference between the light values and the dark values. The term *flat* also describes an image or scene with low contrast.

focal length The distance from the optical center of a lens when it is focused at infinity to its focal plane (sensor), described in millimeters (mm).

focal plane The area in a camera where the light passing through the lens is focused. In dSLR cameras, this is the image sensor.

focus The adjustment of a lens to create a distinct and clear image.

focus lock A setting where the focus is set and does not change, even if you recompose the scene.

front lighting A method of lighting where the main light is placed directly in front of the subject.

high contrast A description of an image or scene where the highlights and shadows are at the extreme differences in density.

high key A description of a photograph with a light overall tone.

histogram A basic bar graph that shows the number of pixels that fall into each of the shades from pure black to pure white. The histogram view on most dSLRs shows the values of the red, green, and blue color channels as well as the overall tone of the image.

hot shoe The mount on top of a camera's viewfinder that accepts flash accessories. Each camera manufacturer produces different flash units, and those that are made for one brand of camera do not work on another brand's camera body.

image rotation The ability of a camera to recognize the orientation in which a photo was taken and to display the image in the correct orientation when viewing it on the LCD.

ISO An acronym for International Organization for Standardization, an international body that sets standards for film speeds. The standard is also known as ISO 5800:1987 and is a mathematical representation for measuring film speeds.

ISO sensitivity A measure of the light sensitivity of image sensors in digital cameras; the ISO sensitivity is rated using the standards set for film. Each doubling of the ISO makes the sensor twice as sensitive to light, meaning that for practical purposes, an ISO rating of 200 needs twice as much light as ISO 400.

JPEG An acronym for Joint Photographic Experts Group. This is the most commonly used and universally accepted method for image file compression. JPEG is a lossy form of compression, meaning that information is lost during compression. JPEG files have a .jpeg or .jpg file extension. See also *lossy*.

Kelvin A unit to measure color temperature, abbreviated as K. The Kelvin scale used in photography is based on the color changes that occur when a theoretical black body is heated to different temperatures.

LCD An acronym for Liquid Crystal Display. This is the type of display used on most digital cameras to preview photos and display menus and shooting data.

light meter A device used to measure the amount of light in a scene. You can use the readings from the light meter to determine what settings produce a proper exposure. All dSLR cameras have a built-in light meter that reads the intensity of the light being reflected back from whatever is in the scene.

lossless A form of file compression that allows the original data in an image to be reconstructed without losing any of the information. This is useful when you want to ensure that no changes are made to the data in the image file. See also *compression*.

lossy A form of file compression that reduces the file size of an image by removing data. The file is not an exact match to the original file but is close enough to be usable. This form of compression suffers from generation loss, meaning that repeatedly compressing the same file results in progressive data loss and image degradation. See also *compression* and *JPEG*.

low key A description of a photograph with a dark overall tone.

Manual exposure mode A camera mode where the photographer determines the exposure by setting both the shutter speed and the aperture.

megapixel A term for the number of pixels that a digital camera sensor can capture; 1 megapixel is equal to 1 million pixels.

memory card A removable device on which image files are stored.

metering modes The method a camera uses to determine what light to use in the metering process. See also *center-weighted metering*, *scene metering*, and *spot metering*.

middle gray A tone that represents 18-percent reflectance in visible light. All reflective light meters, including the one in your camera, are calibrated to give an average reading of 18-percent gray.

noise Extra unwanted pixels of random color where only smooth color should be in a digital image. Noise is created when the signal from an image sensor is amplified to match the ISO characteristics of film. The higher the ISO in a digital camera, the more noise is created. Noise is also created when you take long exposures.

noise reduction A type of software or hardware used to reduce unwanted noise in digital images. See also *noise*.

normal lens A lens that produces images in a perspective close to that of the human eye.

overexposure A condition where you allow more than the recommended amount of light to reach a camera's sensor, causing the image to appear too light and with less detail in the highlights.

panning A method that involves moving a camera in the same direction and speed that the subject is moving, resulting in an image where the subject is in acceptable focus while the background is blurred.

pixel A contraction of the words *picture elements* that describes the smallest unit that makes up a digital image.

prime lens A lens with a single focal length (that is, not a zoom lens).

Program Auto mode A mode where a camera sets the shutter speed and aperture to achieve the correct exposure. You can adjust these settings to gain more control over the exposure.

RAW A file type that stores image data without any in-camera processing. Every camera manufacturer has a different RAW file format. RAW files need to be processed before you can use them.

Rear-curtain sync The ability to fire a flash at the end of the exposure instead of at the beginning. This freezes the action at the end of the exposure.

red eye A condition that occurs when photographing people with a flash that is too close to the lens. The light is reflected from the person's retina (which is covered with tiny blood vessels, thus the red appearance) back toward the camera's lens.

red-eye reduction A flash mode that fires a short burst of light just before the photograph is taken, causing the subject's pupils to contract and lessening the amount of light that can be reflected back.

reflector Any surface that can be used to redirect light. Specialty reflectors for photography come in different sizes, shapes, and colors and are designed to reflect light onto the subject.

resolution The number of pixels counted either vertically or horizontally in a given area.

Rule of Thirds A method for dividing an image into thirds. This method uses two imaginary vertical lines placed one-third of the way in from either side, and two imaginary horizontal lines placed one-third in from the top and bottom, to create a grid of nine equal areas. You can then place your subject where the lines intersect.

saturation The intensity of a specific color or hue.

scene metering A metering mode that takes the whole scene into account. Each camera manufacturer has a different method for metering; check the manual for the method used in your camera. See also *center-weighted metering, metering modes,* and *spot metering.*

self-timer The ability of a camera to take an exposure after a predetermined amount of time when you have pressed the Shutter Release button.

sharp A term used to describe a well-focused image.

shutter A movable cover that controls the amount of light that is allowed to reach a camera sensor, by opening for a specific length of time designated by the shutter speed.

Shutter Release button The button that you use to move the camera shutter out of the way so you can take a photograph.

shutter speed The amount of time that a camera shutter is open and allowing light to reach the image sensor.

Shutter Speed Priority mode A mode where you set the shutter speed and the camera sets the aperture.

side lighting A method of lighting where the main light source is to the side of the subject.

silhouette An image or scene where the subject is represented by a solid, black object against a lighter background.

slow A term referring to the maximum aperture of a lens. Lenses with a maximum aperture of f/8 are considered very slow. See also *fast.*

spot metering A metering mode where the only area that a camera uses to meter the light is a small area in the center of the scene.

stop A term of measurement in photography that refers to any adjustment in the exposure. When stop is used to describe shutter speed, a one-stop increase doubles the shutter speed, and a one-stop decrease halves the shutter speed. When stop is used to describe aperture, a one-stop increase doubles the amount of light reaching the sensor, and a one-stop decrease halves the light reaching the sensor.

telephoto lens A lens with a focal length that is longer than normal.

tonal range The shades of gray that exist between solid black and solid white.

top lighting A method of lighting where the main light is placed above the subject.

tungsten light A light source that produces light with a color temperature of approximately 3200K.

underexposure A condition where you allow less than the recommended amount of light to reach the camera sensor, causing the image to appear too dark and with less detail in the shadows.

variable aperture lens A lens that changes the maximum aperture depending on the focal length.

warm A descriptive term for an image or scene that has an orange or red cast.

white balance An adjustment to the colors that a camera records to match the lighting of a scene.

wide-angle lens A term that refers to lenses with shorter-than-normal focal lengths.

zoom lens A lens that has a range of focal lengths.

Index

Index

Guides to go.

Colorful, portable *Digital Field Guides* are packed with essential tips and techniques about your camera equipment. They go where you go; more than books—they're *gear*. Each $19.99.

978-0-470-56508-7

978-0-470-45405-3

978-0-470-52127-4

978-0-470-53490-8

978-0-470-58207-7

978-0-470-64863-6

Also available

Canon EOS Rebel XSi/450D Digital Field Guide • 978-0-470-38087-1
Nikon D40/D40x Digital Field Guide • 978-0-470-17148-6
Sony Alpha DSLR A300/A350 Digital Field Guide • 978-0-470-38627-9
Nikon D90 Digital Field Guide • 978-0-470-44992-9
Nikon D300 Digital Field Guide • 978-0-470-26092-0
Canon 50D Digital Field Guide • 978-0-470-45559-3

Available wherever books are sold.

WILEY
Now you know.